aaron rose

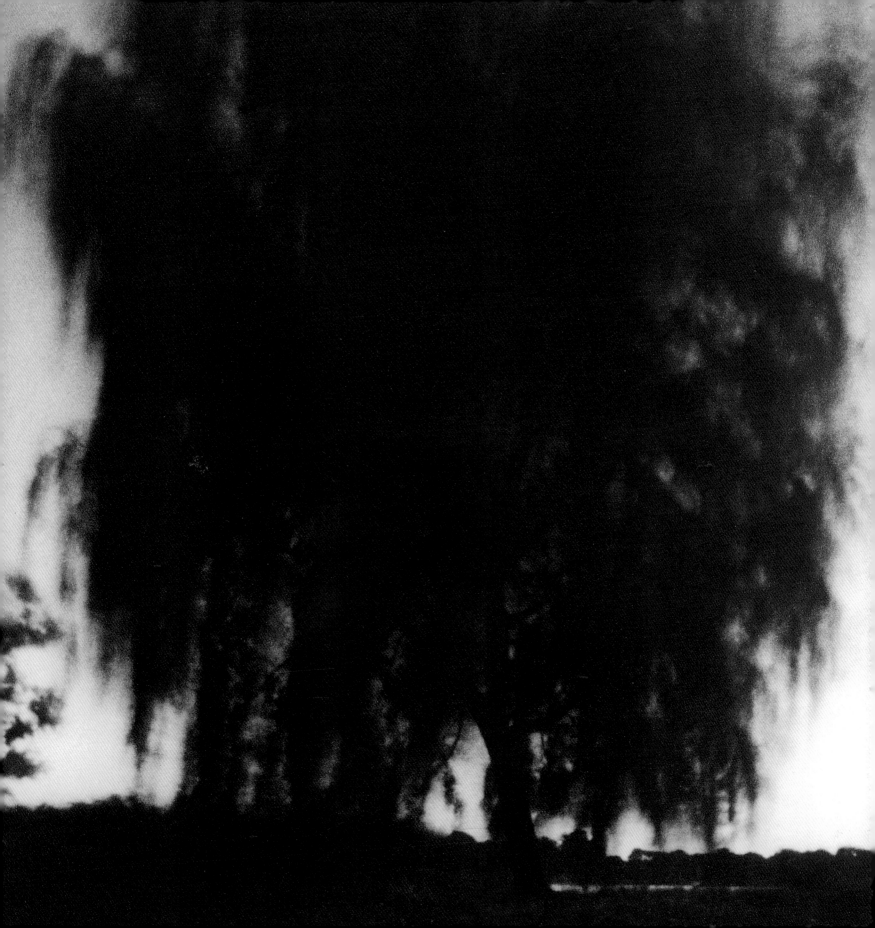

aaron rose

PHOTOGRAPHS

Essay and interview by Alfred Corn

HARRY N. ABRAMS, INC., PUBLISHERS

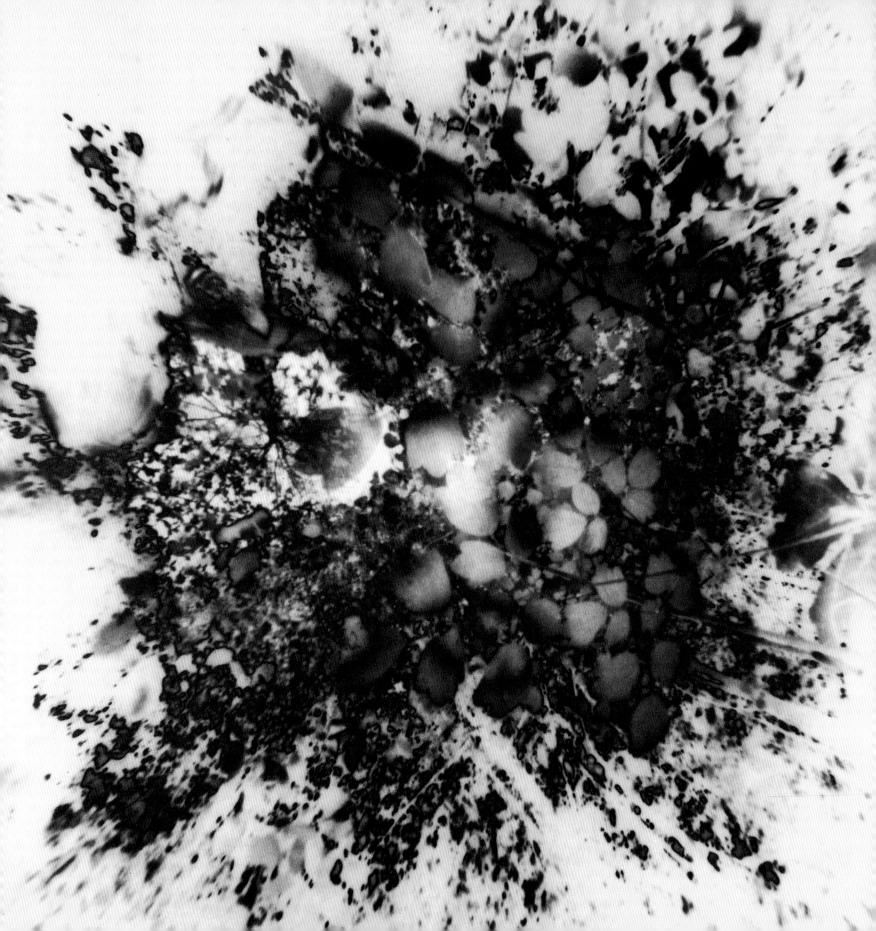

CONTENTS

the perpetuity of light

aaron rose occasionally describes himself as "the last photographer," meaning either that the technology he uses is about to be superseded by electronic images, or that his contemporaries bring less energy and devotion than he does to the art they practice. Of course, this elegiac stance may be more purely circumstantial, the product of many years spent working outside the bright spotlight of critical acclaim. Even so, he must believe that his status as an artist working on the margins of public attention contributed to his originality. The story of American literature, visual art, and music is remarkable for the number of major figures who came out of no academy or programmatic school. Instead, these artists were "homemade," committed to the striking singularity of their goals and techniques, and to a vision at odds with the aesthetic norms of their day.

Rose began, off and on, pursuing photography as an art in the late 1950s, but there was no individual show of his work until four decades later. His friends included a number of artists and photographers, with the result that he eventually became known to other peers, collectors, and curators. In 1997 Lisa Phillips, then curator at the Whitney Museum of American Art, included five Rose photographs in the Whitney Biennial. The following year, the Paul Kasmin Gallery in New York City mounted Rose's first solo exhibition, which attracted favorable attention from *The New York Times* and the most important journals dealing with new art. A second show at Kasmin in 1999 added to the critical estimate of Rose's achievement; the period of his working on the margin of contemporary art had yielded to a new phase of public recognition. Now in his sixties, and with an inventory that lists more than twenty-five thousand photographs, Rose no longer need be wary that public appreciation will deflect him from becoming what he is, a startlingly original artist who has produced a major oeuvre.

He lives in New York City's SoHo, in a five-story loft building to which he moved in the 1960s, before the Cast-Iron District of Manhattan had become a haven for artists in search of affordable studio space. Rose purchased the building with the proceeds of a sale of ancient tools he had collected during the previous decade. He took charge of renovations himself, acquiring the skills of carpenter, plumber, and electrician in order to make the building habitable. Renting out the lower floors of the property provided him with an

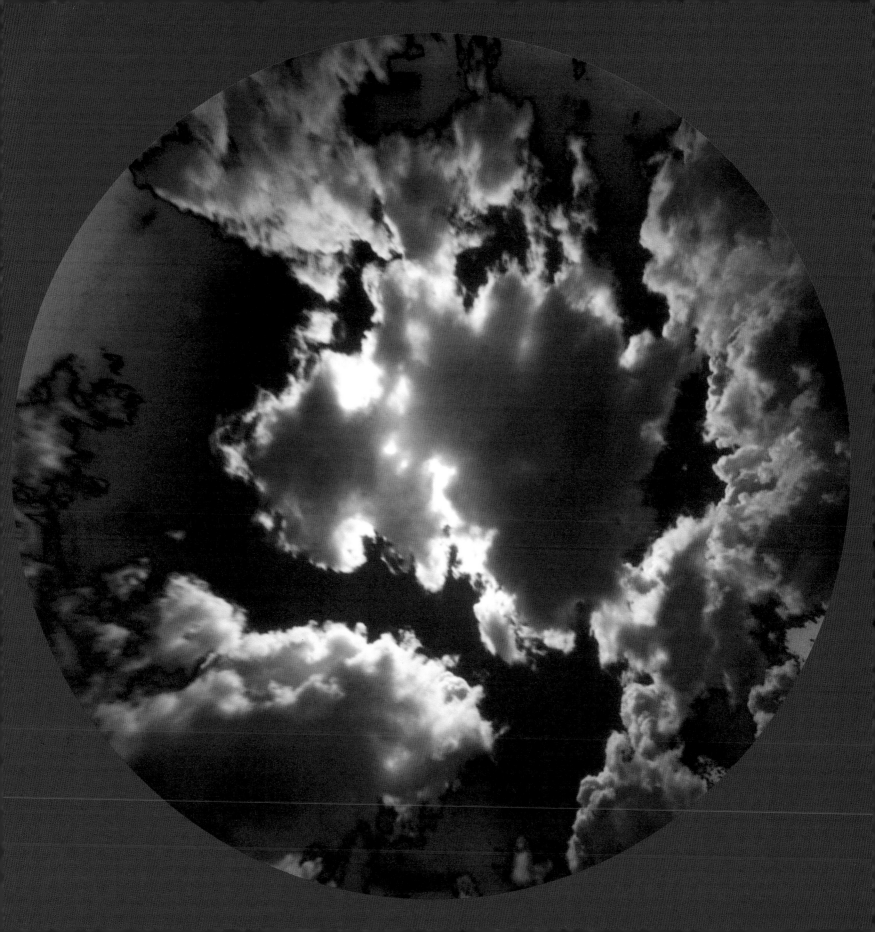

income sufficient to pursue the art of photography without having to find a market for the works produced. His experience in collecting museum-quality tools had prepared him for the study and acquisition of old cameras, as well as the recovery of early techniques for developing photographic negatives. He has become a self-taught chemist, using processes that often involve the element of gold as an ingredient — which has led critics discussing his work to invoke the archaic and mystical practice of alchemy. Because Rose's developing solutions react according to purely scientific principles, "alchemy" is apt only as a metaphor. Yet the metaphor has a useful content to the extent that his pictures mutate the base metal of visual reality into some quintessence of form, light, and tone, the result ideal and incorruptible. Considering Rose's resurrection and recycling of lost or near-lost photographic equipment and techniques, we can describe him as an artist whose contemporaneity arises from a radical return to origins.

Although he insists on the scientific basis of what he does, the loft space where Rose works breathes an atmosphere of mystery. Old cameras perched on tripods stare out at the visitor through lenses mounted on accordion-style bellows. From the ceiling several reflective spheres — green, silver, and gold — hang suspended. At the windows an untrammeled profusion of house plants and a few transparent glass objects absorb the ambient light. He remarks that his loft space has become an analogue to the structure of the camera: Light enters through an opening on one side, passes through a glass membrane, and strikes photosynthetic leaves. (Rose even goes so far as to describe *himself* as a camera, or at least the optical apparatus as one, consisting as it does of adjustable lens, internal chamber, and light-registering retina.)

In one corner of his loft Rose has constructed a medium-sized darkroom, its close confines a contradiction to the loft principle of open space and unrestricted movement. The shelves of the darkroom hold a wide array of little bottles, each carefully labeled with the name of a chemical element, compound, or reagent.

The darkroom seems too small to contain, or contain comfortably, an occupant who spends long hours there several days a week. Rose is a large-boned man, visibly strong and vigorous, with receding, silver-gray hair. He gives the impression of pent-up energy and is seldom immobile for more than a few seconds. He speaks in a booming voice that has kept a Brooklyn intonation and many turns of phrase dating back to his childhood in New York City's most idiosyncratic borough.

■　●　■　●　■

For a brief period in the 1960s, Rose made his living as a commercial photographer, and he has known other photographers whose work falls in the buffer zone of reportage, somewhere between commercial and aesthetic terrains. He acknowledges, then, that photography's relationship to aesthetic categories may be close or distant. You can point out a basic distinction between the "art photograph" and "reportage" without denying that the methods of the latter can be used to make compelling works of art. Reportage, with its documentary aims and commitment to the human subject in action, depends on a level of technology capable of guaranteeing rapid exposure of the negative. The option of catching human activity at full speed sets it apart from the earliest photographic works, which could be realized only by long exposures; daguerreotype portraits required the sitter, in effect, to make a still life of himself. The loss of vivacity — of movement, breath, agency — troubles us when we look at these portraits and must have troubled some of the early portraitists. Those unwilling to make a compact with the freeze-dry aspect of the medium turned to subjects that were themselves already immobile. The stillness of the photographic image took nothing away from such subjects, and, moreover, conferred on them the permanence, the relative immortality, intrinsic to works of art.

The history of the art photograph is, then, concerned more with immobile or nearly immobile subjects: still life, landscape, architectural studies, cityscapes without

the human figure. When the figure is used, it is almost always the nude – in repose, with the face concealed or partly concealed, so that the human body takes on the less personal form of landscape. By a complementary act of the imagination, art photography's landscapes and still lifes often assume, in turn, the contour and softness of the nude. In this instance, the photographer has *added* to the life of the subject by infusing it with an ancillary dimension of humanity.

Important early discoveries for Rose were the Metropolitan Museum of Art's chinese porcelains and the photography of Edward Weston and Paul Strand. If we can see that the carefully calibrated curves and smooth glazes of Chinese porcelains are abstractions of the human body, then we can also interpret Strand's studies of sand and driftwood or Weston's silken, convoluted peppers as purley formal counterparts to the nude. This same will to discover physiological analogies in non-human subjects animates many of Rose's photographs. Though he has done figure studies, the human body also preoccupies him through visual metaphors established in his pictures of other subjects. In particular, the shells, leaves, and glass objects he has photographed reflect a concern for human anatomy perhaps more intimately and quintessentially than his standard figure studies.

When photographing a shell, Rose takes the special approach of focusing on the inside instead of the outside surface. Consider the first shell photograph in this collection: Instead of an exterior view of the shell, it depicts a grooved opening into the shell's interior – which, counter-intuitively, is the main source of light in the picture. Rose achieves that effect by placing the camera aperture close to the mouth of the shell for a protracted exposure so that illumination comes through its translucent walls more than from any other source. His approach reverses expectations for that particular subject matter, in which the shell's recesses are normally the darkest part of the photograph. Apart from its originality as an image, this picture (like others in the series) contains an important metaphoric suggestion. An open-

ing, an aperture, an orifice, should be regarded not as an entrance into darkness but instead as a movement toward illumination. The metaphor has a relevance to the human body, but also for the construction of the camera, which, in simplest terms, is an enclosure equipped with a light-admitting aperture. We will see farther on that many of Rose's pictures embody analogies to the structural components of the camera. And the circle of equivalence is completed by the reflection that, after all, the camera is itself an analogue to the human eye, with dilating and contracting pupil, focusing lens, and light-sensitive retina.

＊　＊　＊　＊　＊

Seeing necessarily involves the deployment of living tissues, delicate muscles, a steady supply of enabling nutrient chemicals, and barely measurable electrical impulses conveyed through minute neurons. Based on active physiological functions, it stands in direct opposition to death, a truth that returns us to the dilemma of photography's inescapable fixity, its frozen immobility. Rose addresses this problem in the ways discussed above, but also from another angle: his work process, the idiosyncratic methods employed to arrive at the final print. These methods can't be deduced, or not entirely, from an untutored inspection of the pictures themselves. In Rose's description of his experience during shooting sessions, he dwells on his immersion in events occurring on site during exposure of the negative. He responds primarily to light, but also to the color range, the approach and withdrawal of clouds, changes in wind speed, ambient sound, and perceptible fragrances. Human perception attains this level of concentration only when enery transforms itself into sensitivity. Having set up and completed thousands of shooting sessions with a sharply refined degree of attention, Rose has developed a precise sense of when to close the camera aperture – from the standpoint of proper light exposure, certainly, but also in relation to a purely experiential gauge. The process of being an active participant

during the exposure has for him a value in itself, and he sees the resemblance between that process and the meditative practices of Buddhism. The contemplative tradition instills an alert attention to surroundings, and to the interaction between them and one's own body and breath. Rose's supervision of the exposure involves precisely those observations and functions.

For Rose, each photograph is a résumé of a particular day, a particular locale, a particular series of changes in light. Because we weren't present during the shooting session, only a part of this information is available to us, and yet awareness of the contemplative activity behind the genesis of these works influences our response to them. Road markers in a quest conducted over several decades, they ask us to understand them as visual documents representing an intense engagement with the life of things.

One category of Rose's subject matter more than others hints at that process, and by a paradox it is not his nature series but his architectural studies of New York City. Shot from elevated locations so that the human figure is excluded, these photographs portray the geometrical complexity of buildings and the improvised "landscapes" of city rooftops. Suppressing the dimension of depth so that buildings at different distances are collaged together, Rose arrives at images recalling analytic Cubism or Constructivist abstraction. Because he uses pinhole cameras for these photographs, the shots require long exposures. The first result is that shadows go out of sharp focus as the angle of sunlight shifts. Recalling that the sun was the first "clock," we immediately understand how, in Rose's architectural studies, the passage of time is encoded in the image itself. It's apparent that Rose stood for a certain number of minutes or perhaps as much as an hour on the roof of a building in lower Manhattan, taking it all in — the jumble of stone and metal grids, the traffic noises, the declining sun — while his experience was being inscribed into patterns of light and darkness.

The results are similar to several cityscapes that Steiglitz produced late in his career, also taken from high vantage points. With both artists, the standard "take" on New York as a hyperactive anthill yields to a more meditative perspective. The city retains its grandeur but in the key of mystery — a melancholy mystery, perhaps. After all, New York, apart from being a world capital, is Rose's hometown, the scene of early struggles to earn his living without the normal resources of family and advanced education. The great museums of New York were Rose's art academy and its architecture a potent embodiment of functional form. He has said that he regards the city as an organic structure following laws not essentially different from those that produce the form of a shell or the cantilever of a leaf. No accident, then, if we find similarities in the grooved façades of the skyscrapers he photographs and some of his shell pictures. In order to be perceived as an organic construction, a building needs to be removed from its ordinary, workaday context, and so Rose's shots are taken high up, above the street and pedestrian crowds. The result is an exploration in structural form, but his urban rooftops and stone elevations may also remind us of those cliffside Indian villages in the Southwest, long ago abandoned to the elements by their builders. Under such circumstances architecture gives up its function as a dwelling place and becomes instead the record of human aspiration toward monumental form, a form now moving toward the condition of natural geological features like promontories, precipices, and canyons.

Man-made, monumentally large, the city holds a special status among Rose's preferred subjects. It seems more external than the others, and it has no counterpart in the structure of the human eye or the camera. The straight lines and vertical upthrust of the skyscraper lend it a masculine aura that contributes to its function in Rose's metaphoric system. The eye and the camera are above all *receptive* apertures. Rose's buildings "insert" themselves into these openings, a collaboration that results in the picture. In the history of Western art, a recurrent metaphor invoked to characterize the production of artworks is the sexual subjugation — sometimes a violent subjugation — of a subject from the external

world (construed as female) by the shaping imagination of the individual artist (construed as male). At the beginning of each of his "periods" Picasso would always paint a figure study of a woman done in the new style he was developing. When De Kooning painted his "Woman" series of abstractions, he was inscribing himself in this same tradition. What we see in Rose's cityscapes is the contrary approach, with *subject* construed as projectively masculine and artist as receptively feminine. That perspective follows from the structure of the eye and the camera, but also highlights a psychological truth about Aaron Rose in particular, who was separated from his mother at birth, and who spent his childhood in an orphanage and foster homes. After the difficult circumstances of his early life, the first positive response to an artwork he recalls is an encounter with the sensuous curves and high gloss of classical Chinese porcelain, which he describes as "milky." The discovery of art's potential for solace and transcendence coincided with the discovery of an art thoroughly imbued with a feminine principle. The conception of the artist as receptive rather than dominating belongs more to Asian than Western tradition, and I have already remarked on the similarities between Rose's contemplative photo-exposure process and Buddhist meditative practice.

. . . ● ■

When Aaron Rose takes as his subject outdoor scenes beyond the city limits, he joins a long line of distinguished photographers of nature. The early part of tradition includes Carleton E. Watkins, Alfred Stieglitz, and Pictorialists such as Alvin Langdon Coburn and J. Craig Annan, and continues with Paul Strand, Ansel Adams, and contemporaries like Eliot Porter and Scott Mutter. In addition to natural scenes involving trees, fields, and geological features, Rose chooses a startling subject none of these earlier nature photographers took up: the universe of stars. We might cite Sir John Herschel's astronomy photographs as a precedent, but in that instance the aim was to produce detailed images of individual heavenly bodies. Rose has a more conceptual interest in his subject. The stars recorded in his Milky Way series appear in minimal detail; to identify them exactly would be almost impossible, even to experts in astronomy. The viewer perceives these stars as points of light only, but light is of course the origin of all photographic process. To remind us of the method of arriving at his image, Rose vignettes these pictures in a circular aperture, which stands for the telescopic apparatus used to capture them. (In fact, he mounted a homemade camera on a telescope base when he made these pictures). Anyone familiar with the data-gathering techniques of astronomy knows that photographing stars requires a tracking device whose movement keeps pace with the apparent motion of the heavens. In Rose's star pictures (which were taken at a small observatory in the mountains of Colorado), process is registered, paradoxically, by sharpness rather than blurring of the images. If the telescope were immobile, the stars would leave curved tracks on the negative.

In the developing process for the Milky Way series, Rose works some of his most striking chemical magic. Pink, orange, and lavender tones color the prints, produced by chemical compounds Rose has learned to blend and control. Given that the heaven of stars appears to us almost entirely in black and white, Rose's decision to use color here is striking. Perhaps these unusual tones appear most prominently in the star pictures as an incidental reminder that the ultimate source of all chemical elements is incandescent matter heated to unimaginable temperatures at the stellar core. These works stand as well for magnitude in the order of time, considering that the light recorded in them has been traveling tens of thousands of years before reaching the earth and the telescope lens. The very fact of our inability to comprehend time and distance on this scale is humbling, and, if we have minds properly attuned, expressive of the fundamental mystery of our universe's origins. Heidegger said the most important question for philosophers was the one first posed by Leibniz: Why should there be being rather than nothing? We ask our-

selves that question most trenchantly when looking at the stars and thinking about the incalculably vast continuum of time and space. Even without traveling to Colorado, we can view Rose's Milky Way pictures in a speculative context. These exposures of light itself situate the epistemological dilemma within purely photographic parameters: Is light best understood as an independent object or a process requiring the action of energy as it meets the interface of human vision? In what sense can the universe be said to exist apart from its human perceivers?

Aaron Rose has returned many times to certain subjects: starlight, crystal and glass, trees and foliage. In analytic terms, these subjects may be regarded as an investigation of the basic structural components of photographic technology. The fundamental ingredient of light passes through a glass lens into a box made of wood, where it meets the photosensitive "leaf" of the negative. It is as though Rose has found in the external world a metaphoric counterpart to the camera. But lenses and film operate *within* the structure of the camera, and Rose has used that purely structural interiority as a metaphoric point of departure for works that are themselves more concerned with psychological interiority than the external world. His pictures based on glass reflections are the most abstract he has produced, so much so that in many instances we would be unable to identify the subjects if they were not labeled. Mimesis has gone over almost entirely into formal expression, hence the resemblance to the work of New York Abstract Expressionists like Jackson Pollock or Franz Kline. When reproached for not painting pictures that represented nature, Pollock once retorted, "I *am* nature." He meant that human consciousness, which includes emotion and the will to achieve formal balance, is a second nature that art may represent along with its depiction of external realities. In order to arrive at these highly abstracted images, Rose has used some of his most daring approaches to the treatment of the negative. It's no coincidence that the developing process takes place in a small dark space one can regard as the architectural

counterpart to psychological interiority. Closed off from light and the world outside, the mind expands and becomes dominant; second nature replaces the first, and the drive toward expressive form overrides photography's mimetic aspect.

Considering that the camera is a mechanical analogue to the human eye, we should regard Rose's preoccupation with light, glass, wood, and leaves as an investigation of a sense organ also provided with an aperture for light, a lens, a casing, and a photosensitive plate. In this framework, the human retina finds a counterpart in leaves, which Rose photographs most often from beneath. But the down-from-under vantage point is the one most closely resembling the retina's orientation toward light in the process of seeing. Rose's translucent leaves are often shown with prominent veining, a reminder of the complex net of capillaries and neurons that permeate the human retina. Veining in foliage appears in an appealing pattern that resembles both painterly abstraction and the tracery composing Gothic stained-glass windows. And what is a rose window if not a metaphoric image for a spiritual "eye" through which the light of revelation may arrive?

■ ● ■ ● ■

It is by virtue of their analytical content, then, that Rose has chosen to develop his main subject series. He says that he likes to take a series as far as it will go, making the comparison to music's theme-and-variation form or the myriad inventiveness of Bach's *Art of the Fugue*, which sends one musical subject through dozens of permutations and reconfigurations. He sometimes works on more than one series at a time. Outdoor shooting sessions require favorable weather conditions and so have to be suspended for varying periods. Rose's own emotional shifts also affect the choice of subjects for a given day. No doubt an insight reached or technical discovery made during the development of one subject can sometimes be adapted for another. Artistic and imaginative endeavors are seldom conducted with a prim sense of

organization; rigor wouldn't have been likely to produce pictures as freely inventive as these gathered here.

 ▪ ● ▪ ● ▪

In the later phase of his career, Rose has for the most part dispensed with lenses in favor of the pinhole camera, or camera obscura. His Sun and Cloud series, meanwhile, constitutes a pictorial counterpart to this primitive photographic process. Because the sun is also one of the stars of the Milky Way galaxy, the series is really a subcategory of Rose's star pictures; but the sun's size and brilliance present special problems for the photographer, and its cultural associations differ from those connected to the stars. Early mythology often referred to the sun as "the eye of heaven," establishing an analogy between the circle of burning light overhead and the circular pupil of the eye, with the roles of light emission and absorption reversed. We can also find in this image a correspondence to the aperture of a camera, again, in reverse. Instead of absorbing light, the solar disc emits it, thereby becoming a photographic subject just like the aggregates of stars Rose photographed from the Colorado observatory. Because the naked sun produces too much light to be photographed conveniently, Rose shoots it through an intervening layer of cloud. When these clouds are notably dark, they add an inevitable suggestion of tragedy and mortality. Considering that Rose is on the point of entering his seventh decade, the current prominence of the Sun and Cloud series in his work needs no explanation. On the other hand, some of his cloud pictures radiate an emotion compounded of tranquility and joy, so that his skyscapes seem to represent a fortunate site — the Great Good Place far above the labor, disappointment, and suffering of earthbound experience.

 ▪ ● ▪ ● ▪

Rose contrasts photographing a subject and developing exposed film with the comment, "And then you've got the other part of the process, which means taking it into the darkroom where everything goes." There's nothing exaggerated in hearing a metaphoric prefiguration of death in the phrase, "the darkroom where everything goes." The process of making a photograph is binary: first the exposure and then the development of a negative whose light areas change to dark, and dark areas to light, as the final positive print appears. In the exposure process, external nature plays a greater role; in the developing process, the artist's desires and decisions almost entirely determine the outcome. The shift at this point is from receptivity to something more active.
To the extent that we are defined by the order of nature, change and eventual extinction dominate experience. To the degree that we can enter the order of art, we elude that extinction. In the present instance, the darkroom amounts to something like a tomb from which Aaron Rose emerges, holding the part of himself he has freed from the impermanent order of nature. That remains true despite the fact that every step of the process occurs according to natural laws that optics and chemistry can adumbrate — every step except for the unfathomable process of making decisions, which no science up to now has been able to analyze and codify perfectly. That mystery remains partly hidden within the psyche of Aaron Rose, where it waits for the investigation and analysis that art criticism can bring to the discussion. Since critical discourse is itself a further extension of the life that art works embody, perhaps Aaron Rose will find some reassurance in the knowledge that exploration of the terrain has at least begun.

 — ALFRED CORN

shells

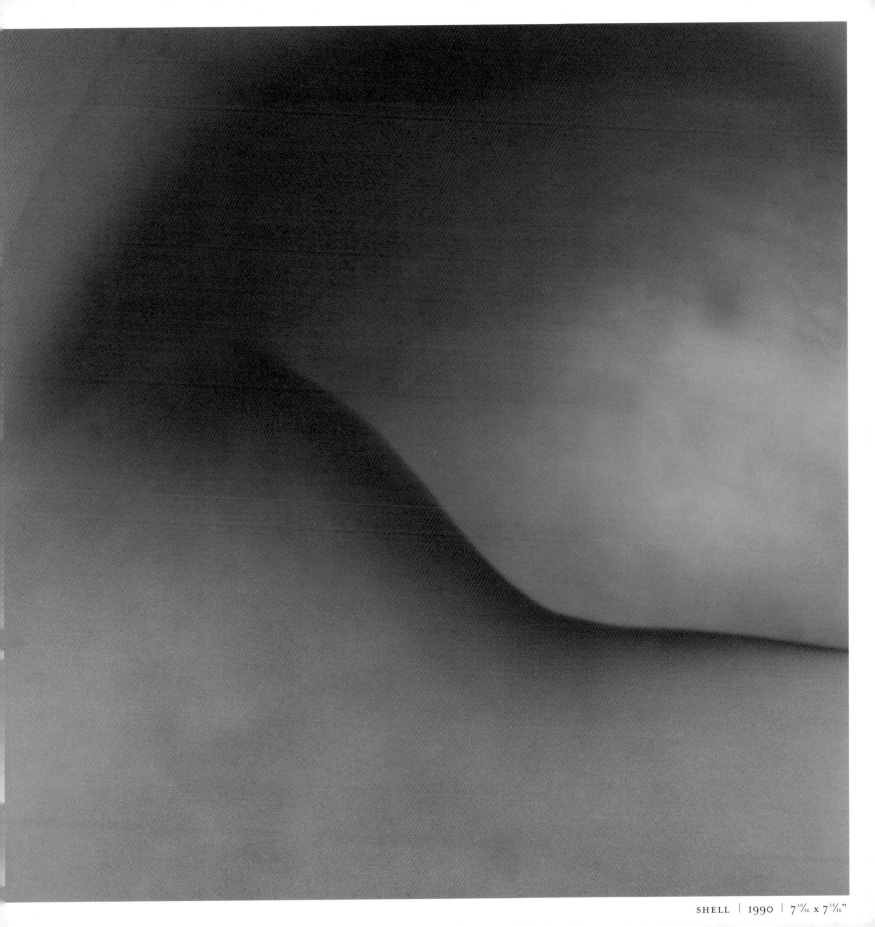

SHELL | 1990 | 7¹⁵⁄₁₆ x 7¹⁵⁄₁₆"

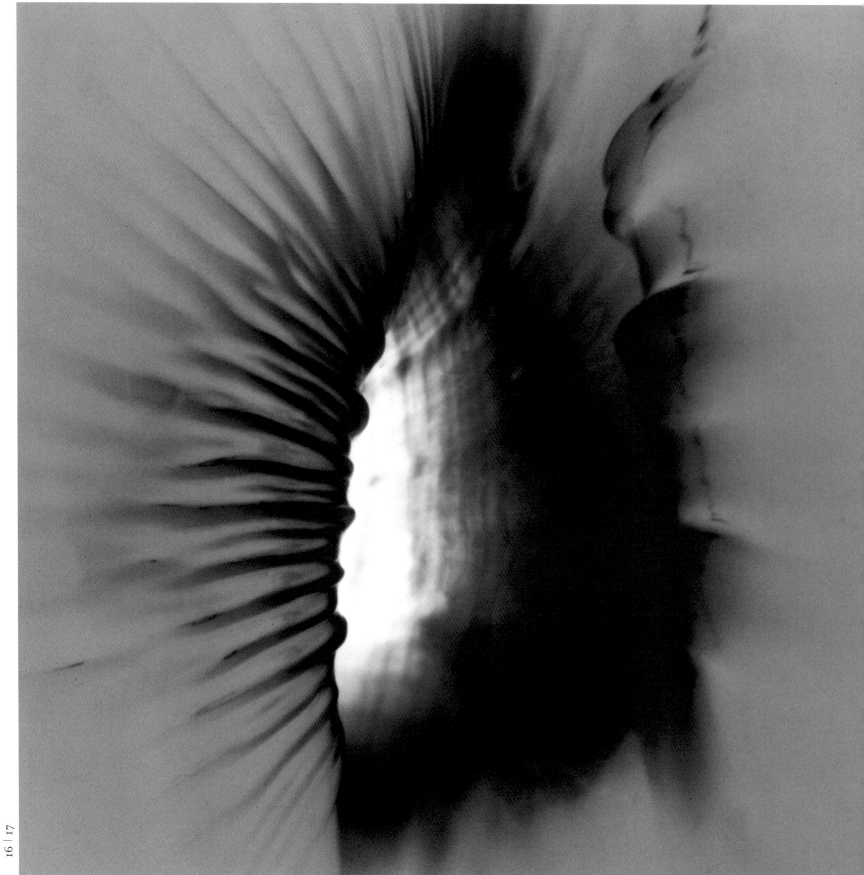

SHELL | 1991–2 | 7⅜ x 7⅜"

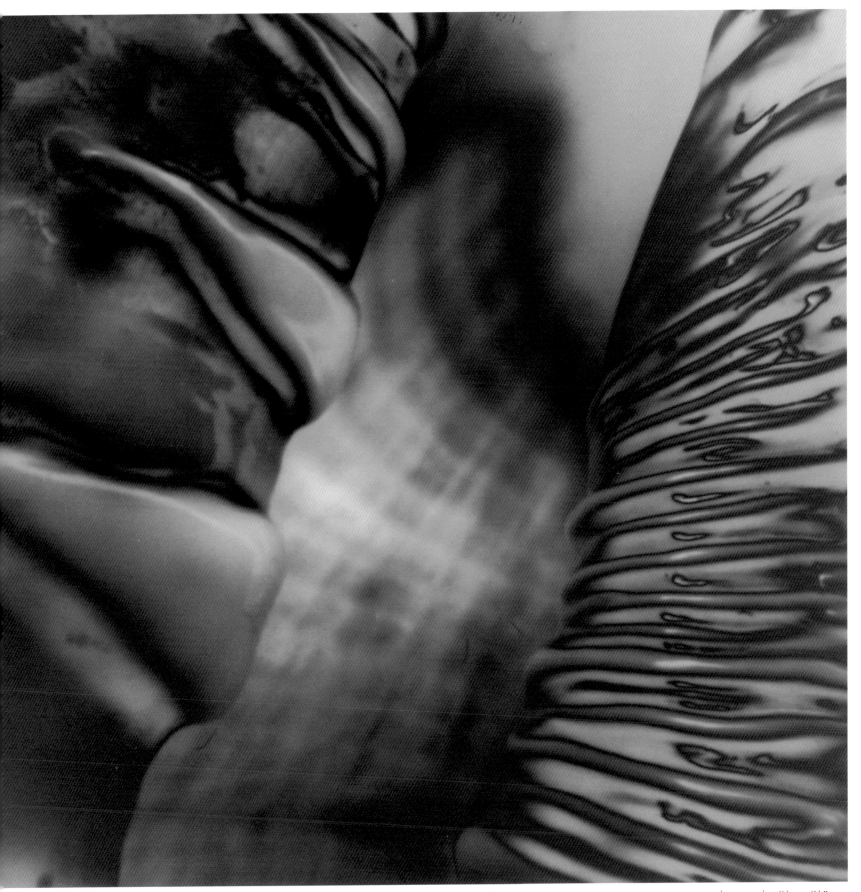

SHELL | 1990 | $7\frac{15}{16}$ x $7\frac{15}{16}$"

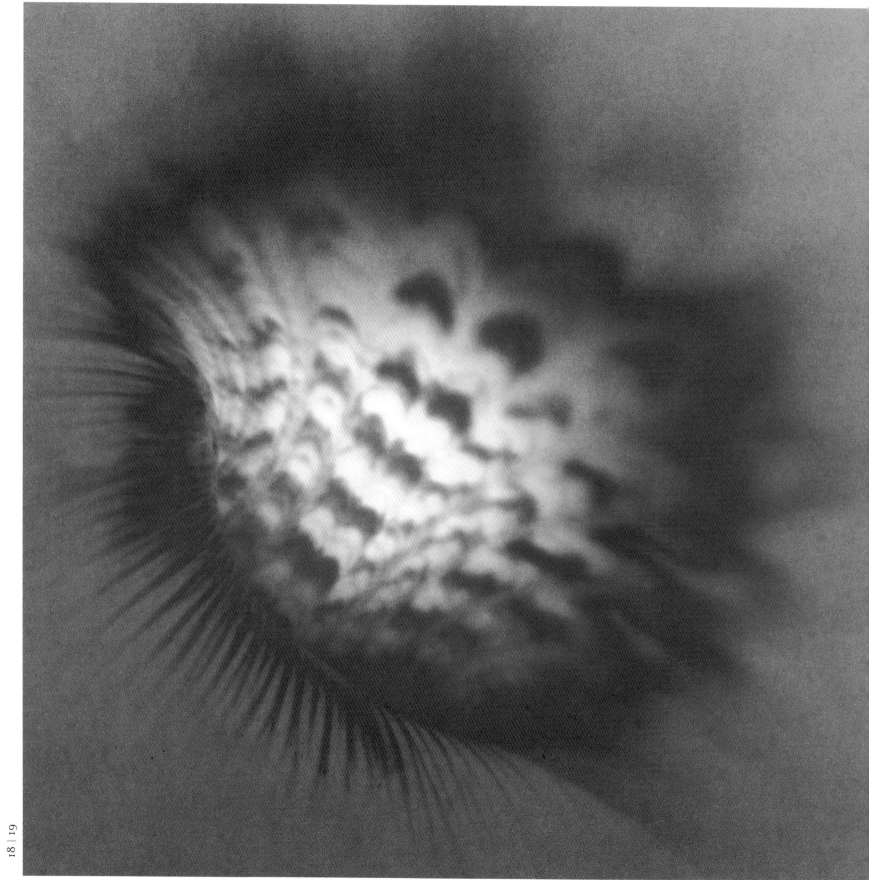

SHELL | 1991–92 | 7⅜ x 7⅜"

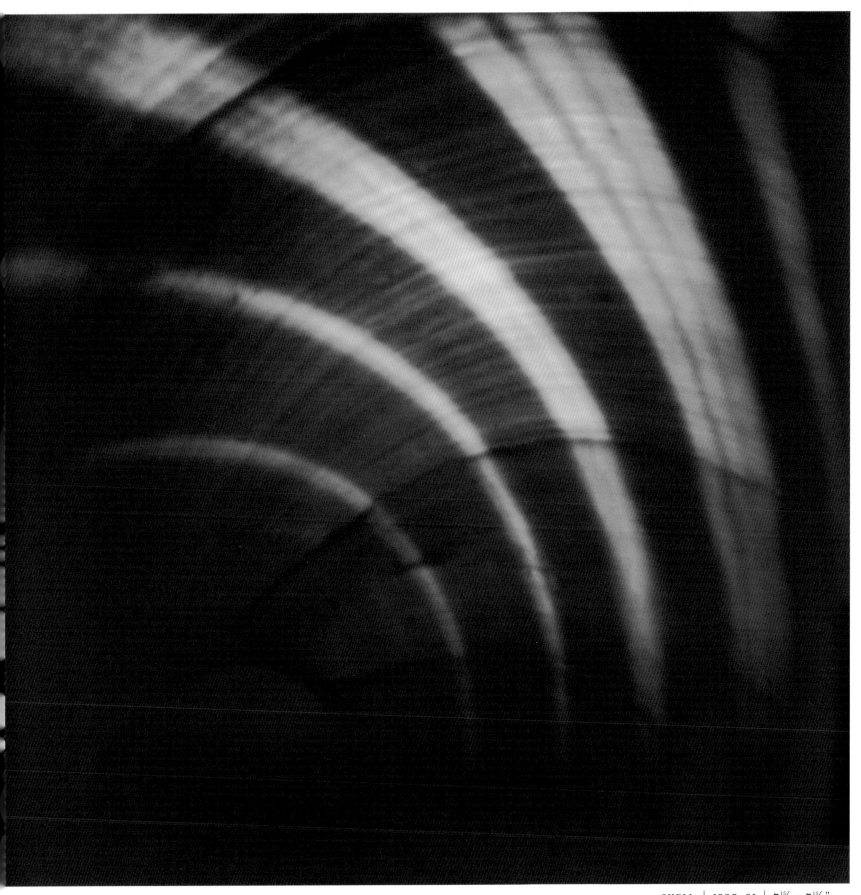

SHELL | 1990–91 | 7 15⁄16 x 7 15⁄16"

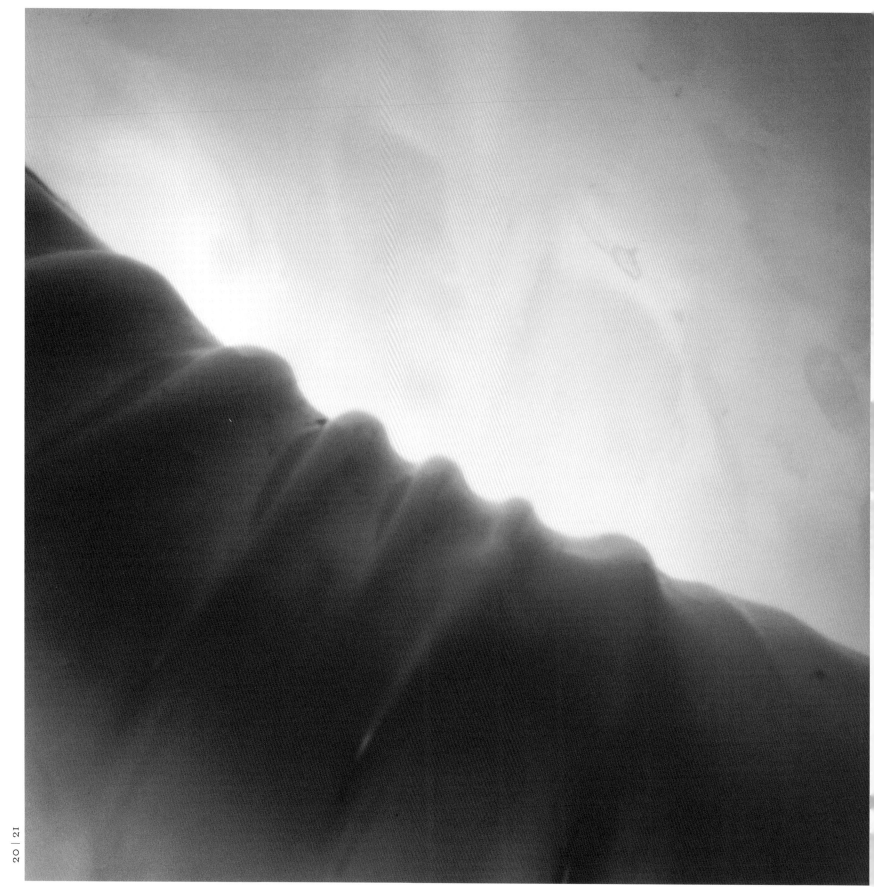

SHELL | 1990–91 | 7 $\frac{15}{16}$ x 7 $\frac{15}{16}$ "

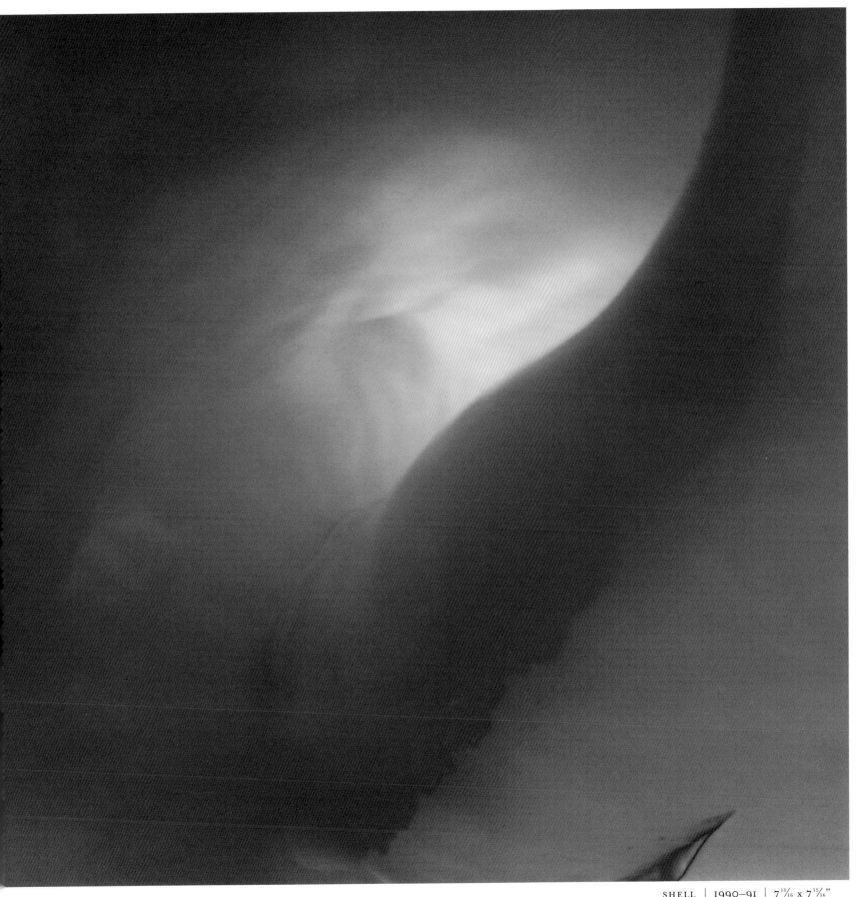

SHELL | 1990–91 | 7 15/16 x 7 15/16"

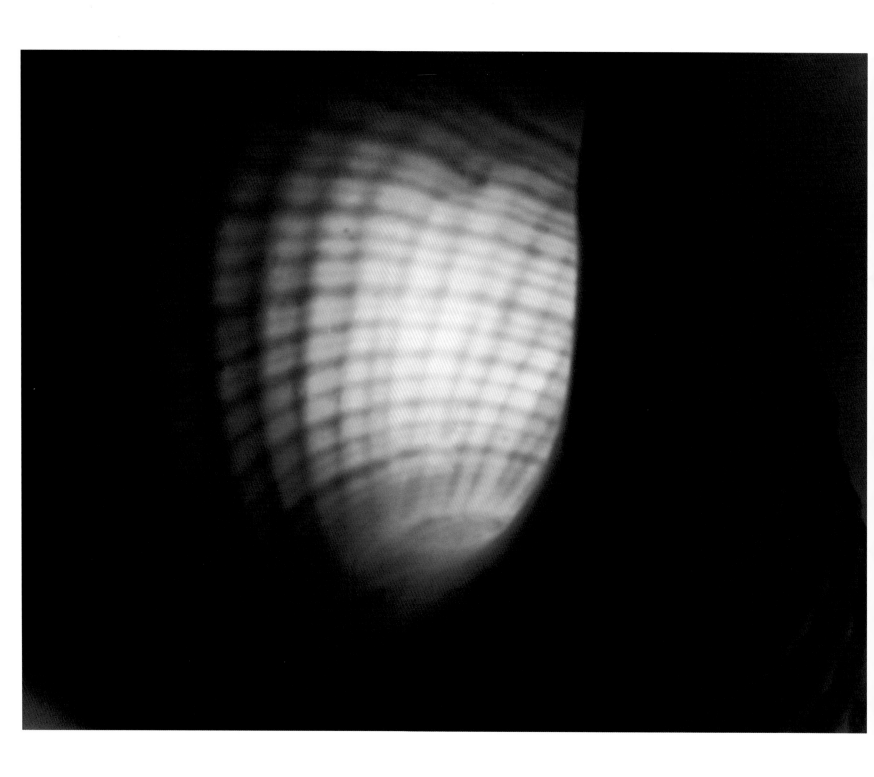

SHELL | 1990–91 | 9 x 7"

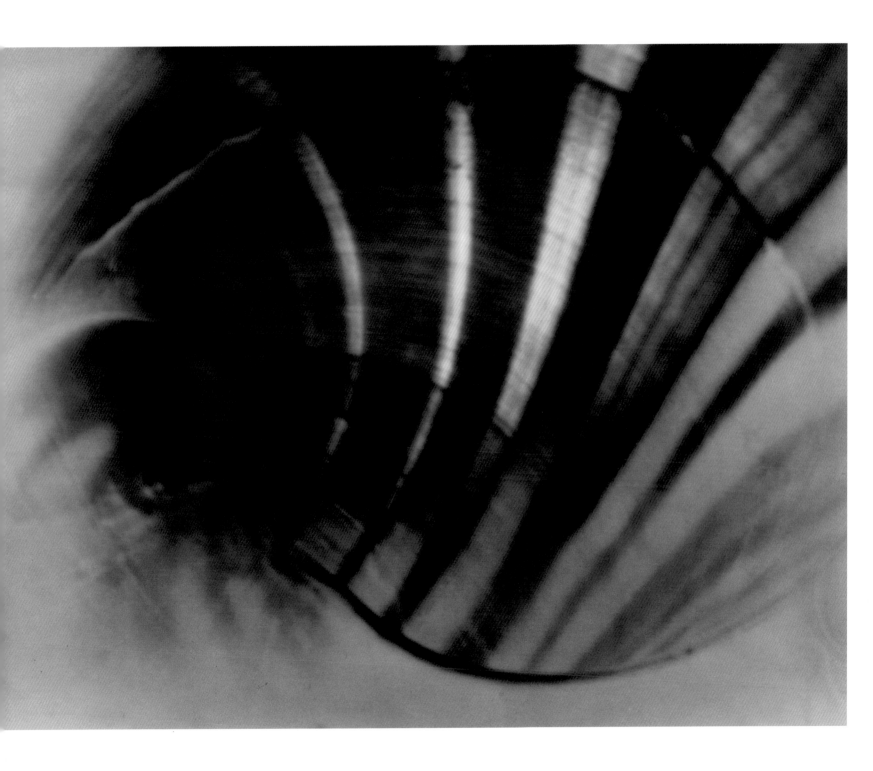

SHELL | 1990–91 | 8^{15}⁄$_{16}$ x 7"

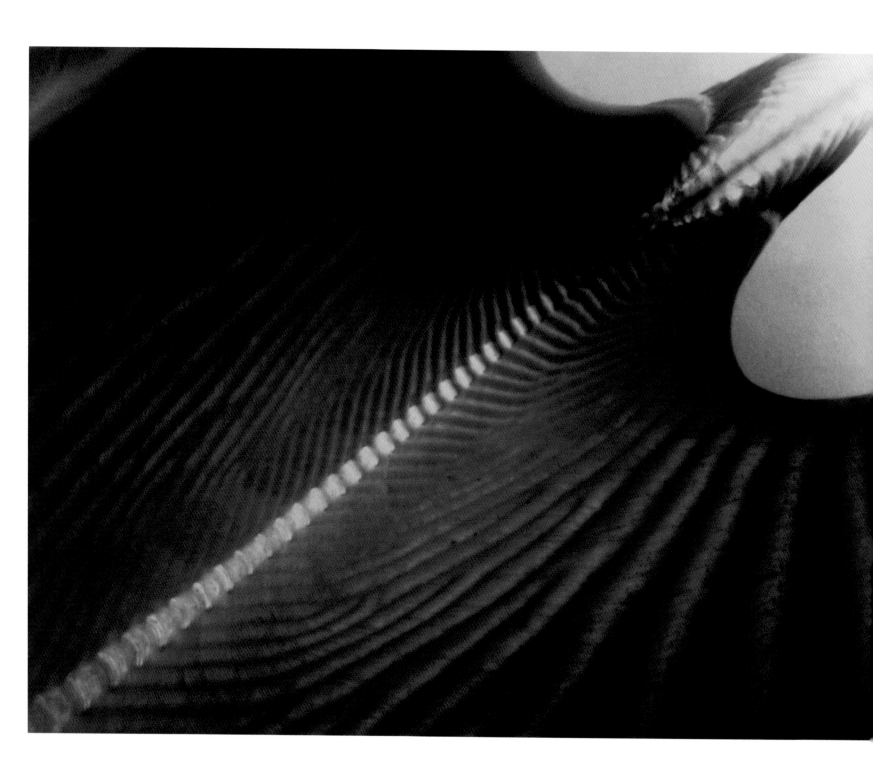

SHELL | 1990–91 | 9 x 7"

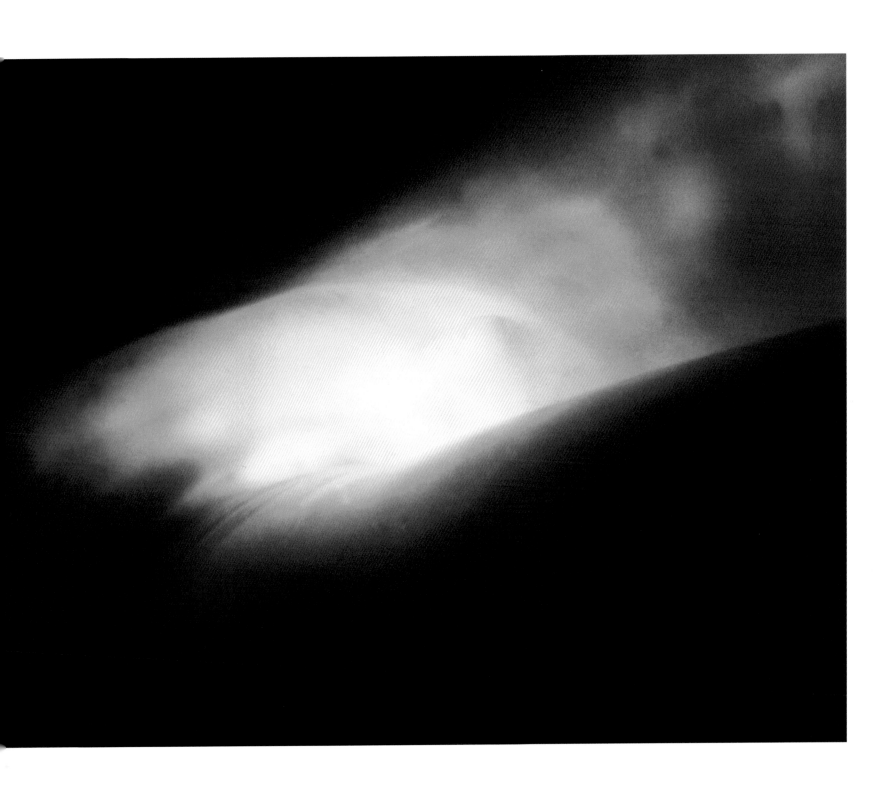

SHELL | 1990–91 | 9 x 7"

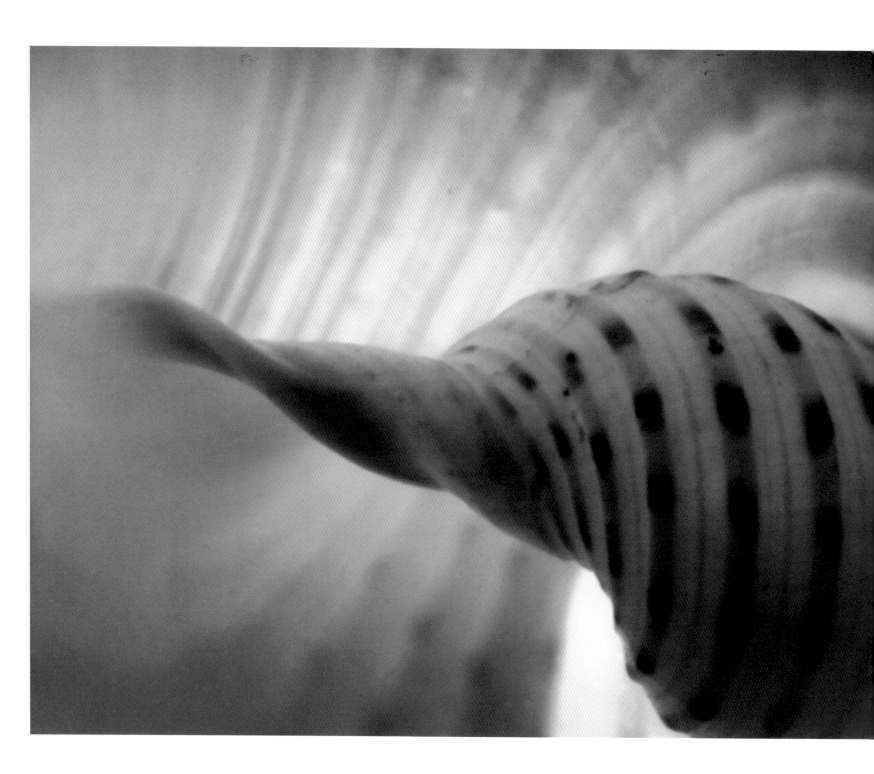

SHELL | 1990 | 8¼ x 6½"

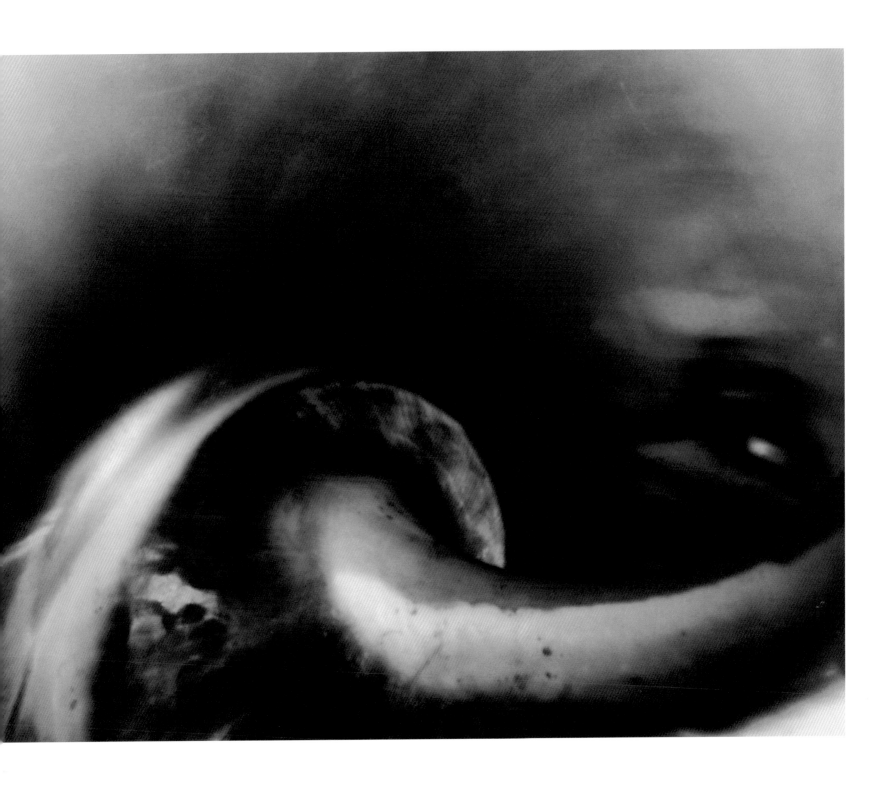

SHELL │ 1990–91 │ 8¹⁵⁄₁₆ x 7"

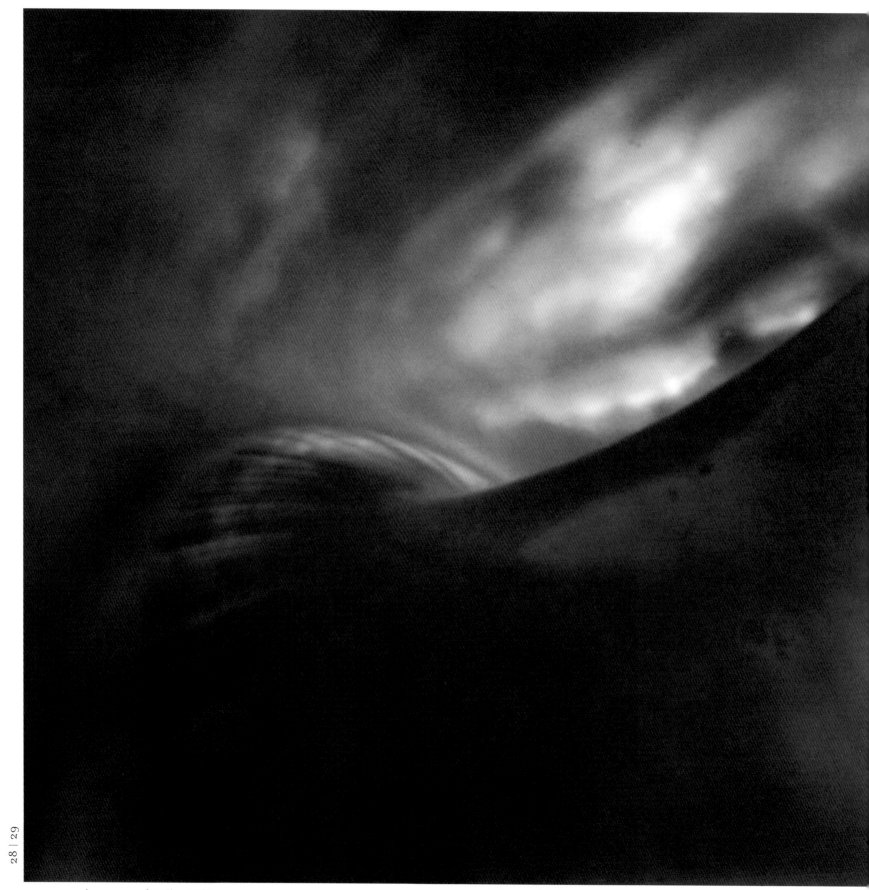

SHELL | 1990–91 | 7 $^{15}\!/_{16}$ x 7 $^{15}\!/_{16}$"

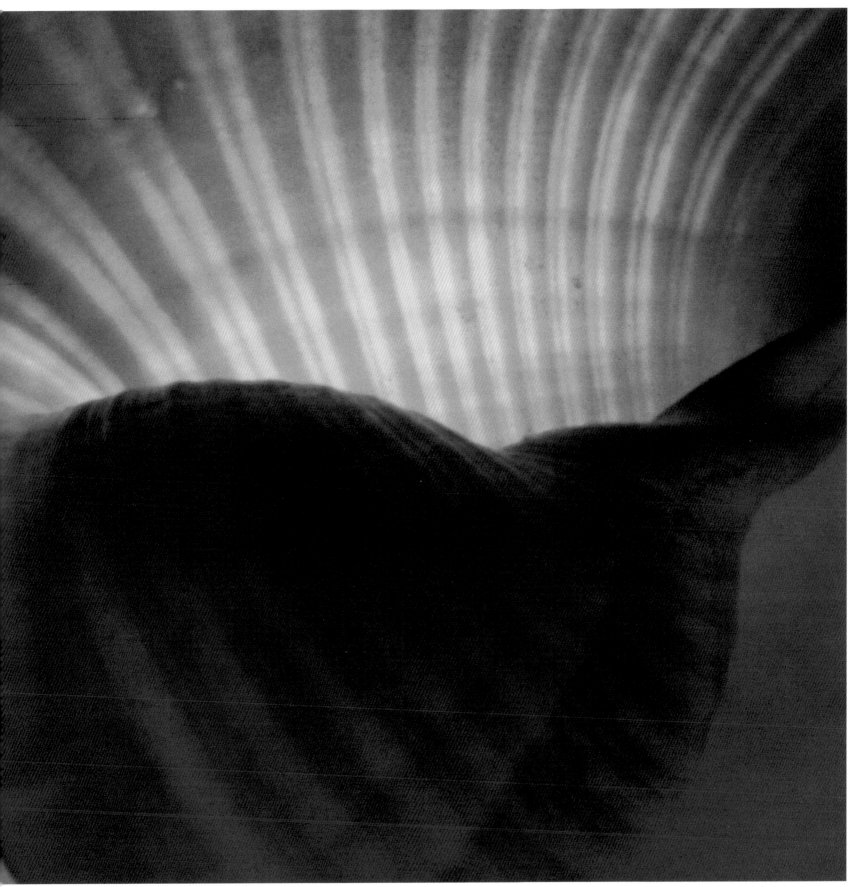

SHELL | 1990 | 7¹⁵⁄₁₆ x 7¹⁵⁄₁₆"

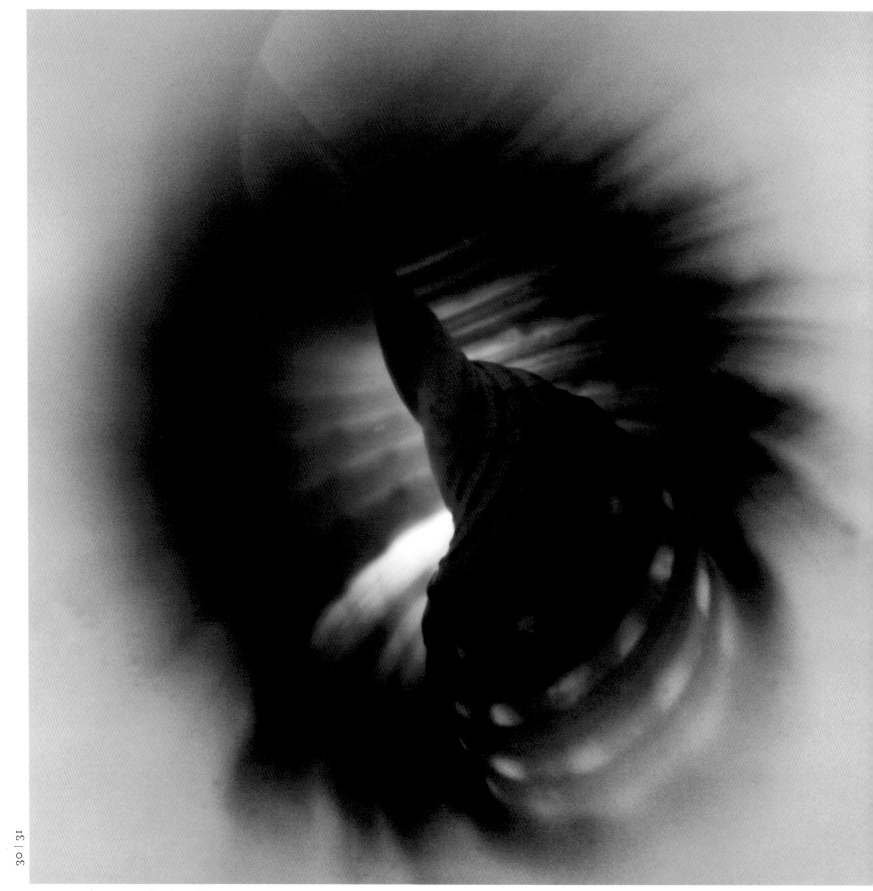

SHELL | 1991–92 | 7⅜ x 7⅜"

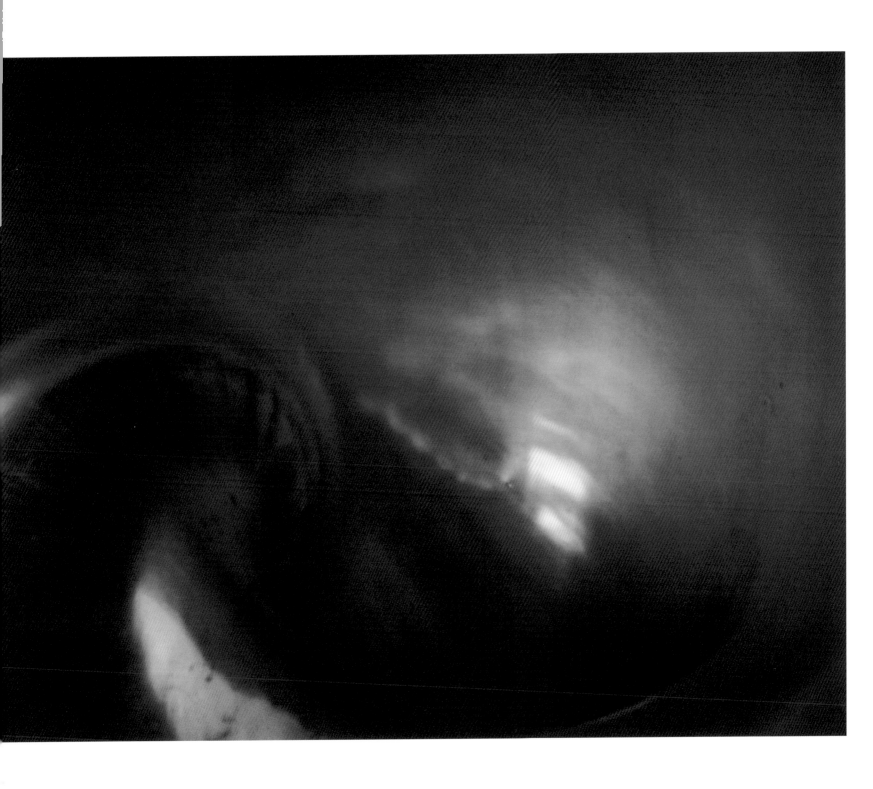

SHELL | 1990–91 | 9 x 7"

new york city

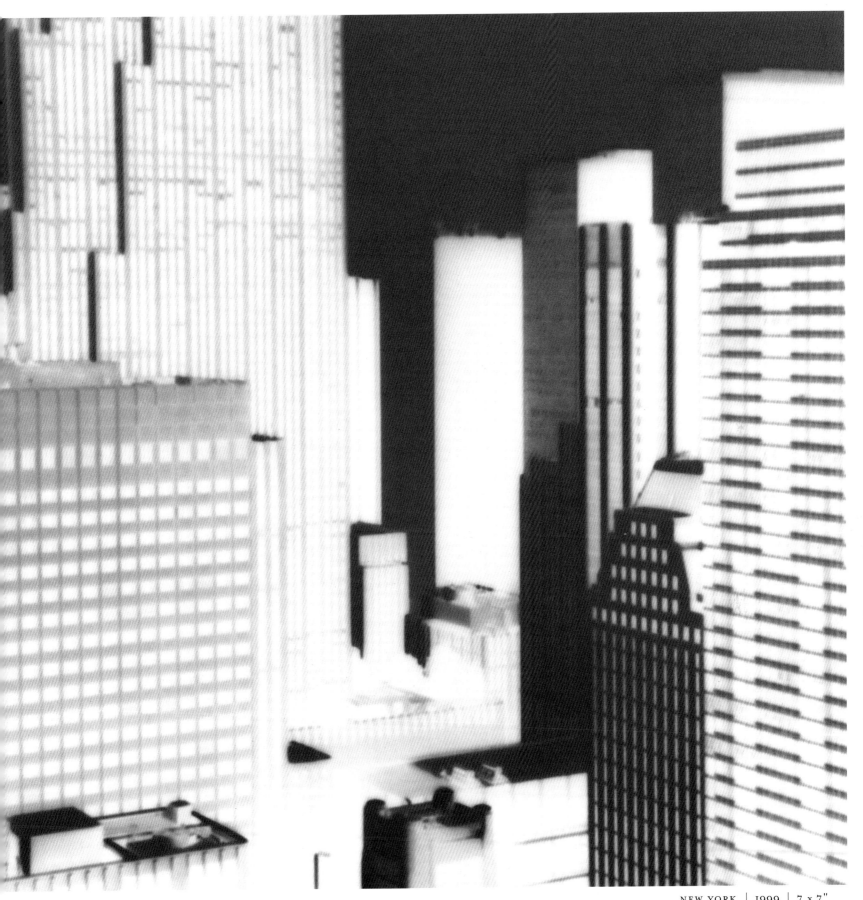

NEW YORK | 1999 | 7 x 7"

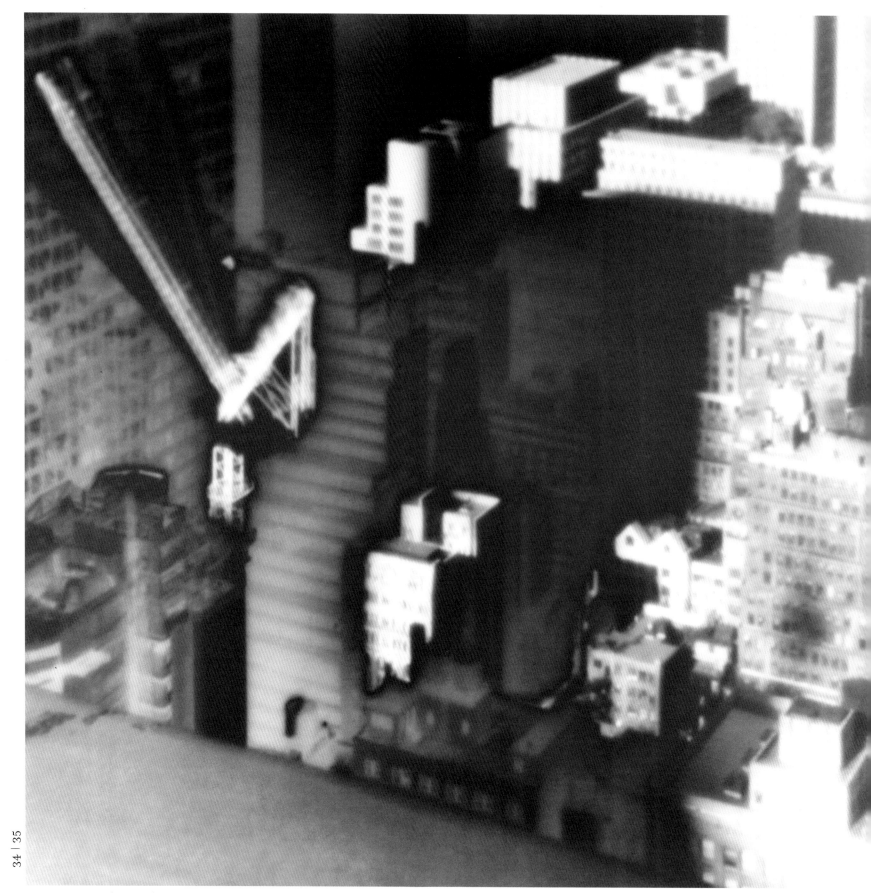

NEW YORK | 1999 | 7 x 7"

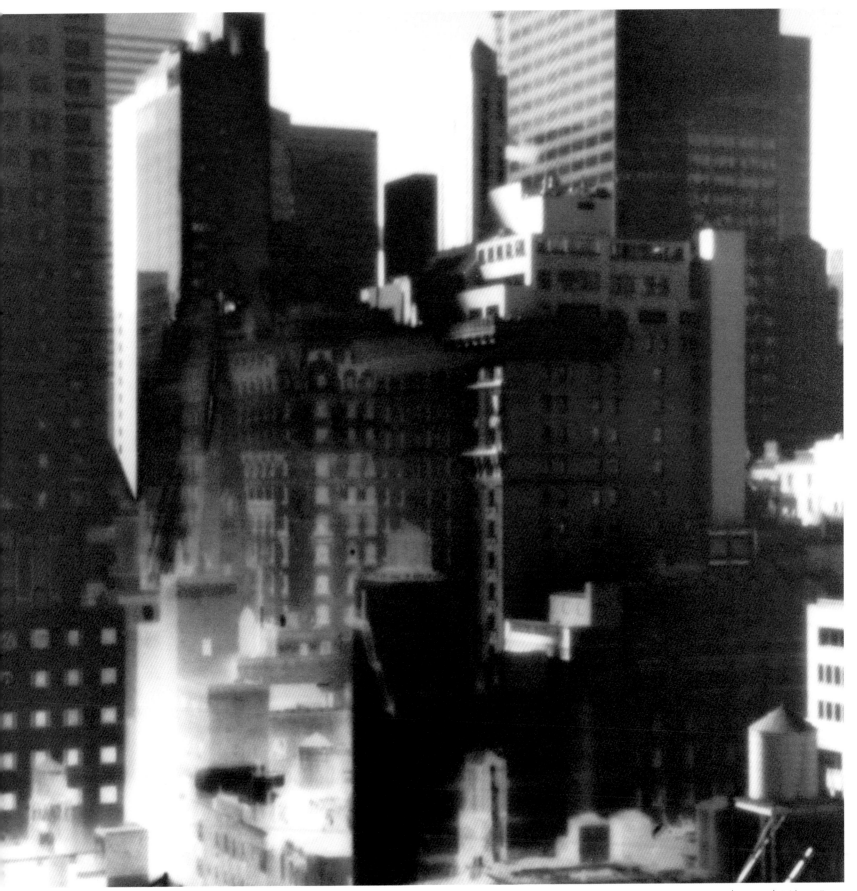

NEW YORK | 1999 | 7 1/16 x 7"

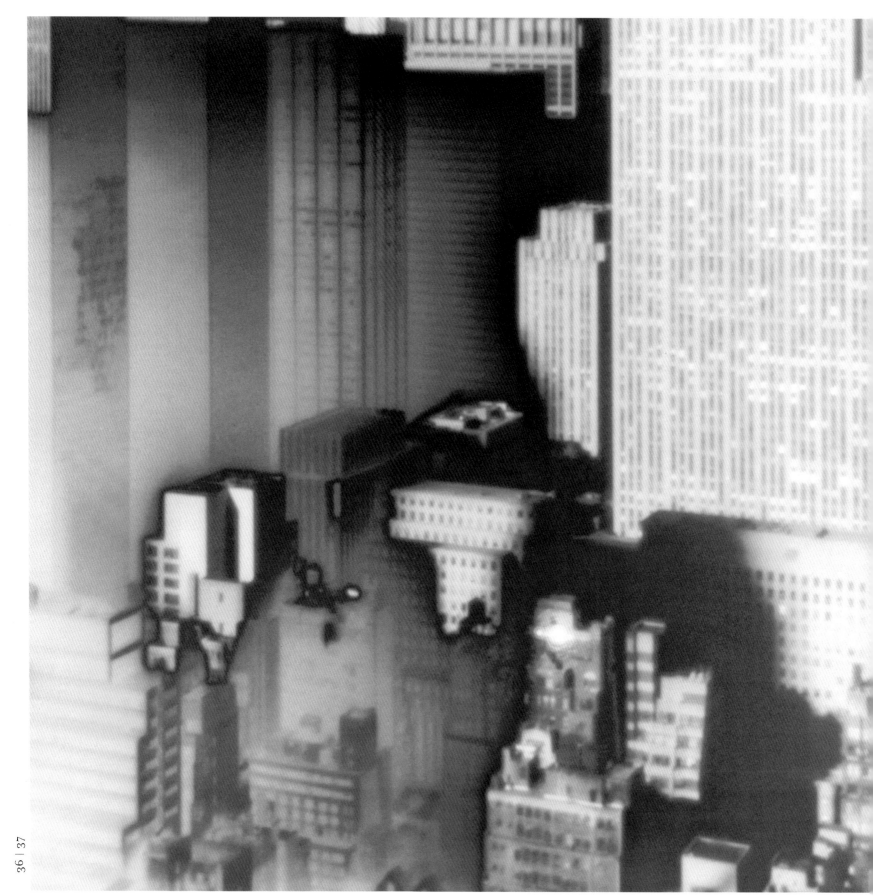

NEW YORK | 1999 | 7 x 7"

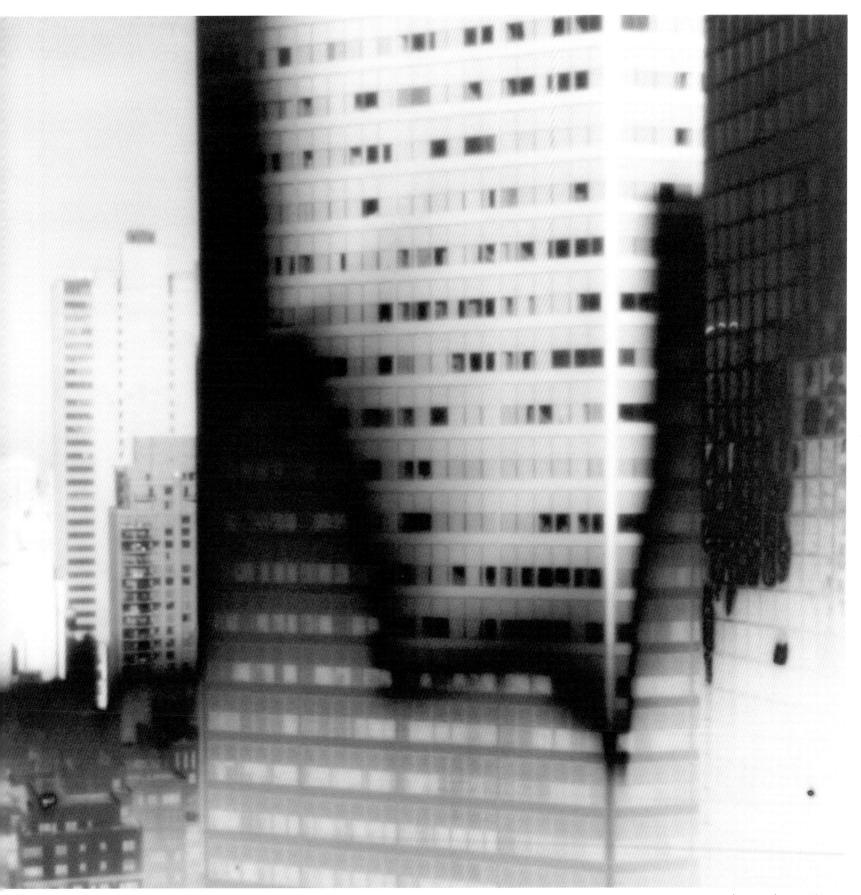

NEW YORK | 1999 | 7 x 7 1/16"

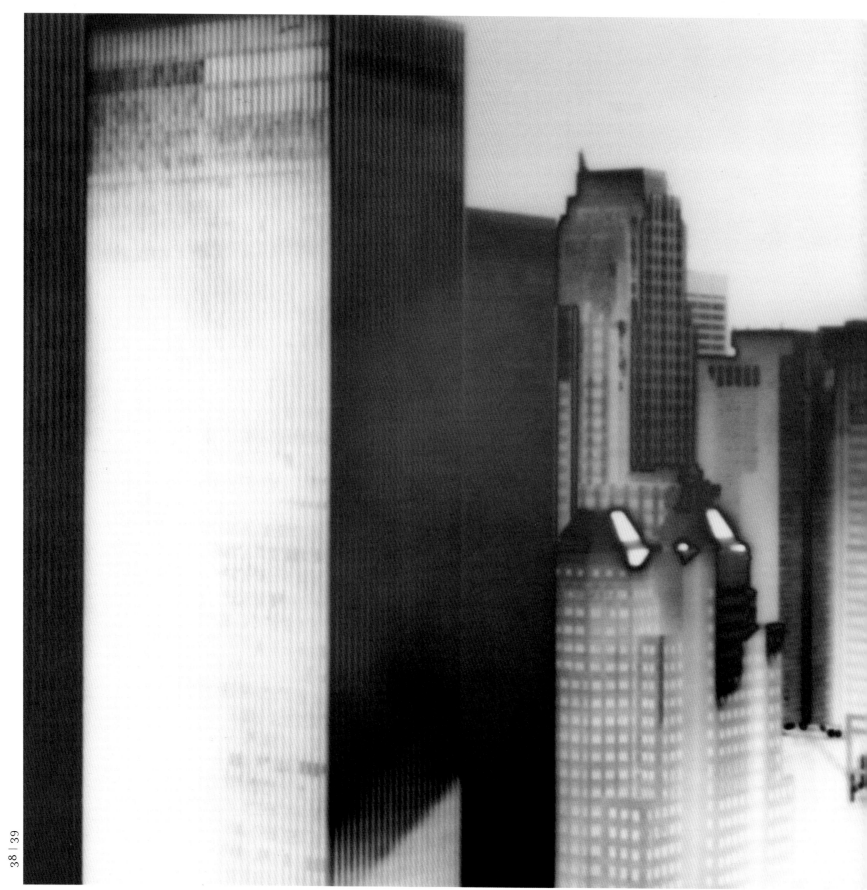

NEW YORK | 1999 | 7 x 7 1/16"

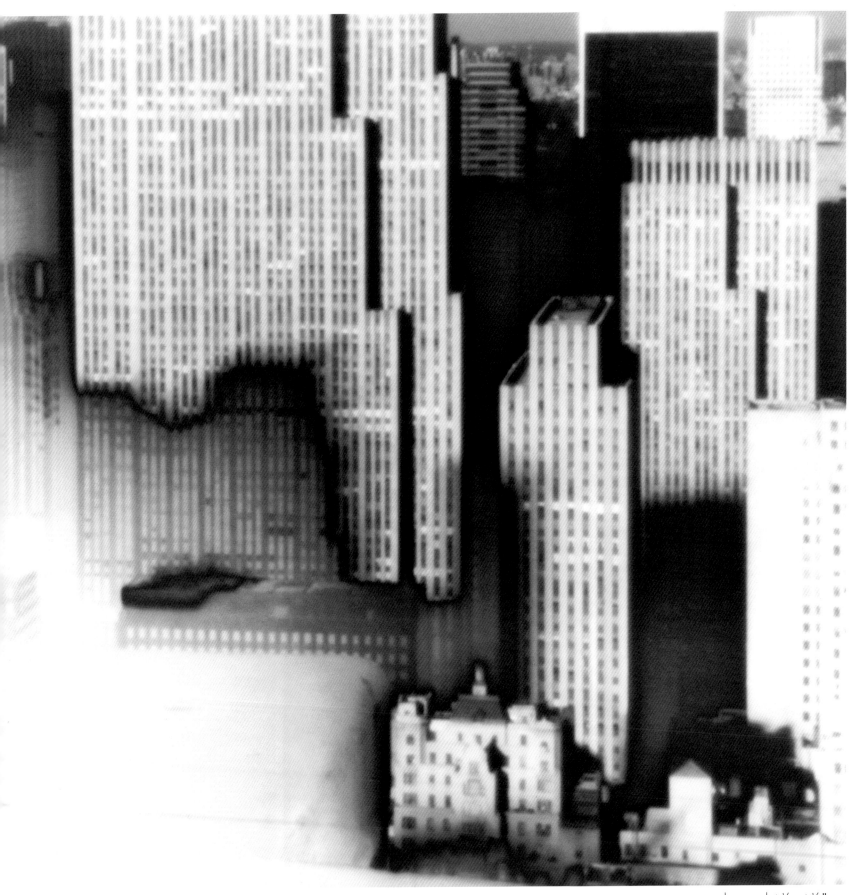

NEW YORK | 1999 | 7 1/16 x 7 1/16"

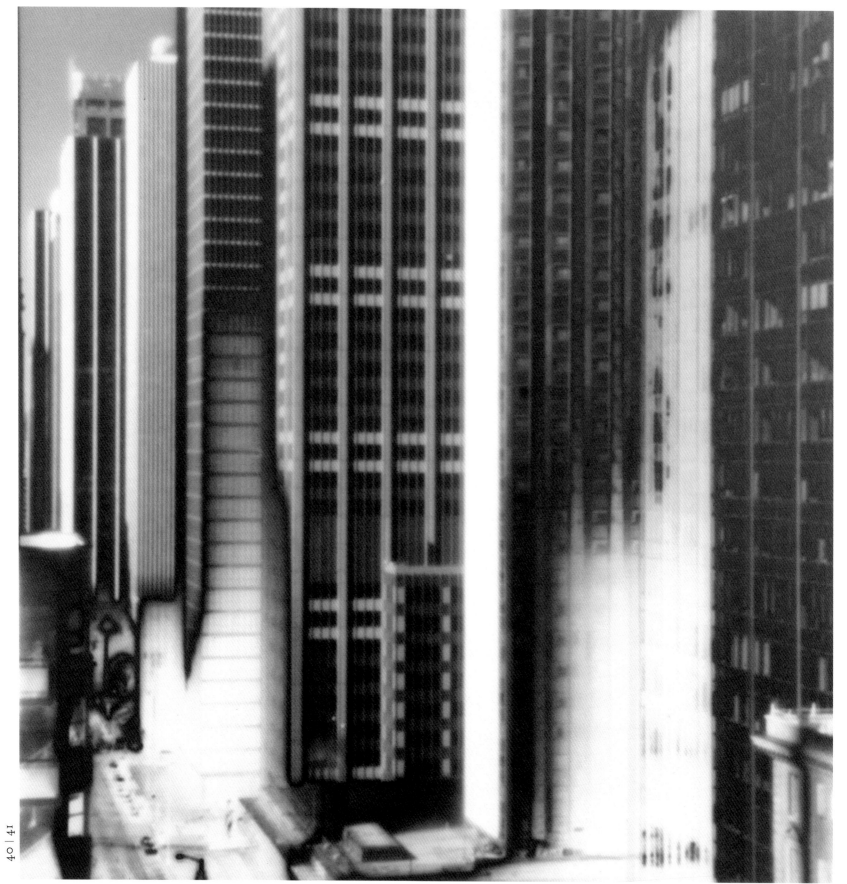

NEW YORK | 1999 | 7 x 7¹⁄₁₆"

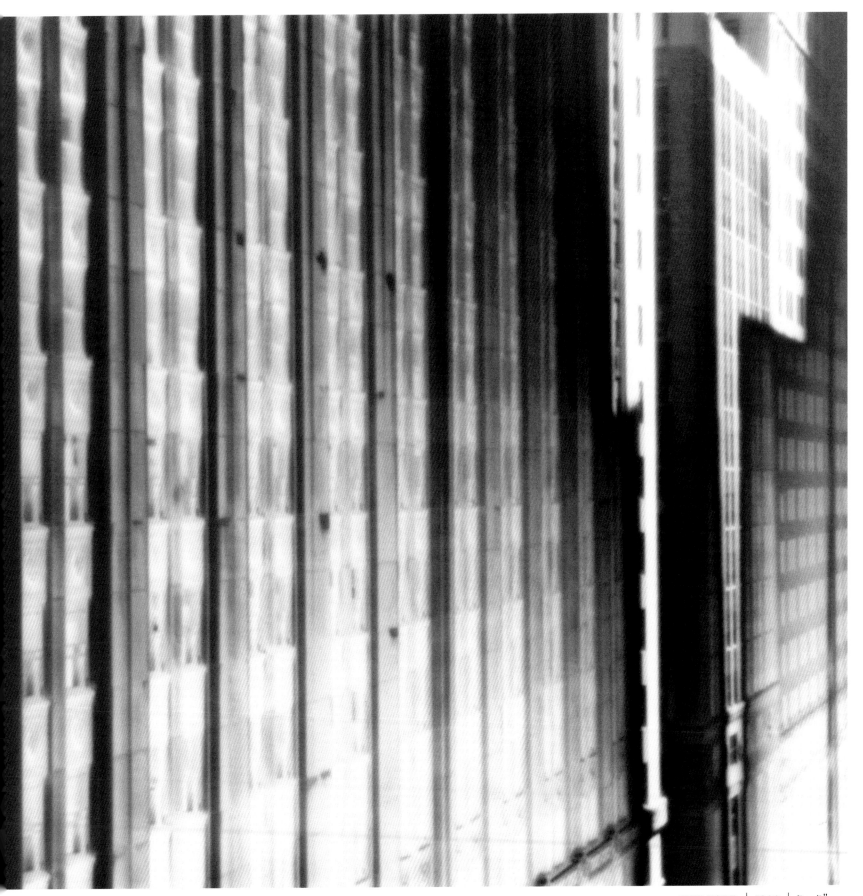

NEW YORK | 1999 | 7 x 7"

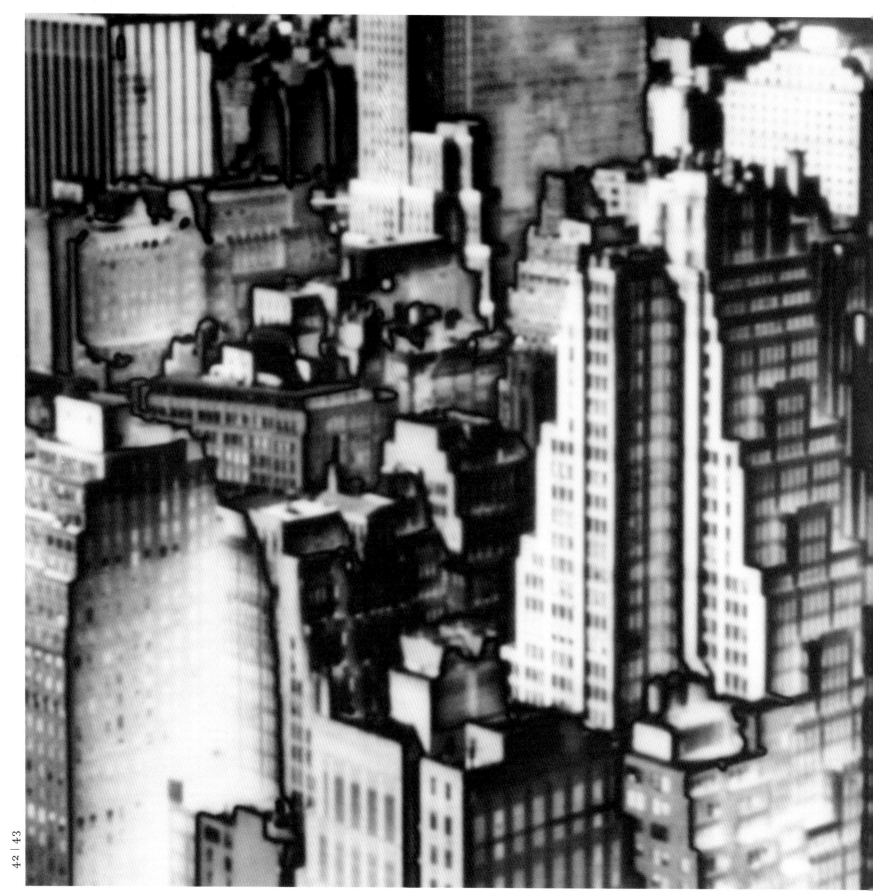

NEW YORK | 1999 | 7 x 7 1/16"

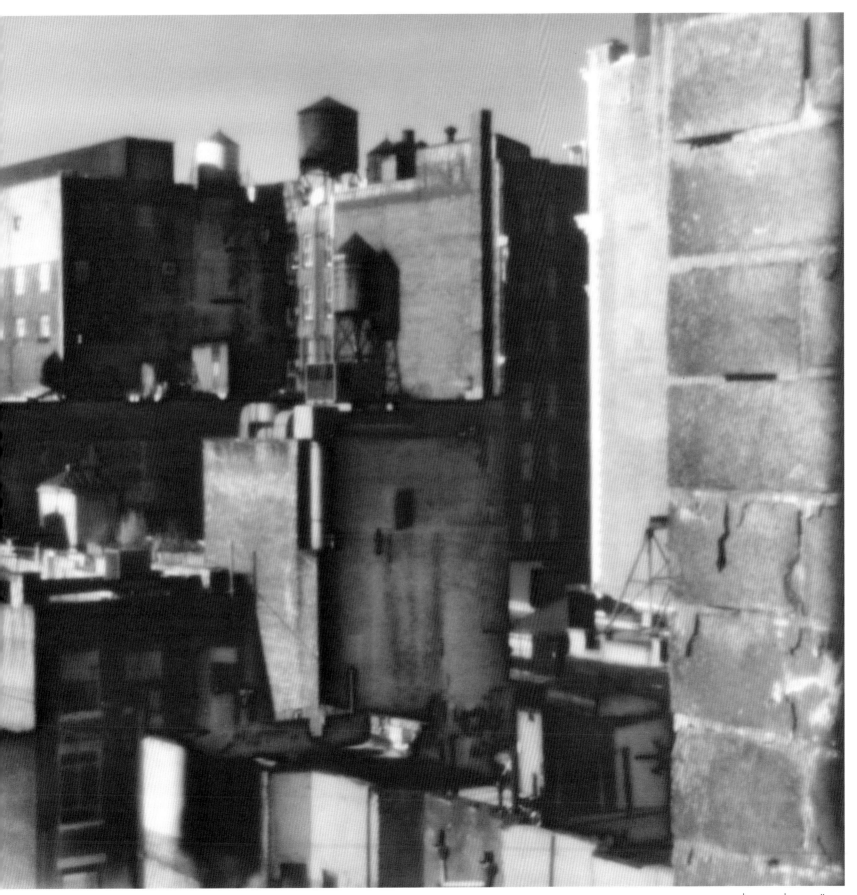

NEW YORK | 1999 | 7 x 7"

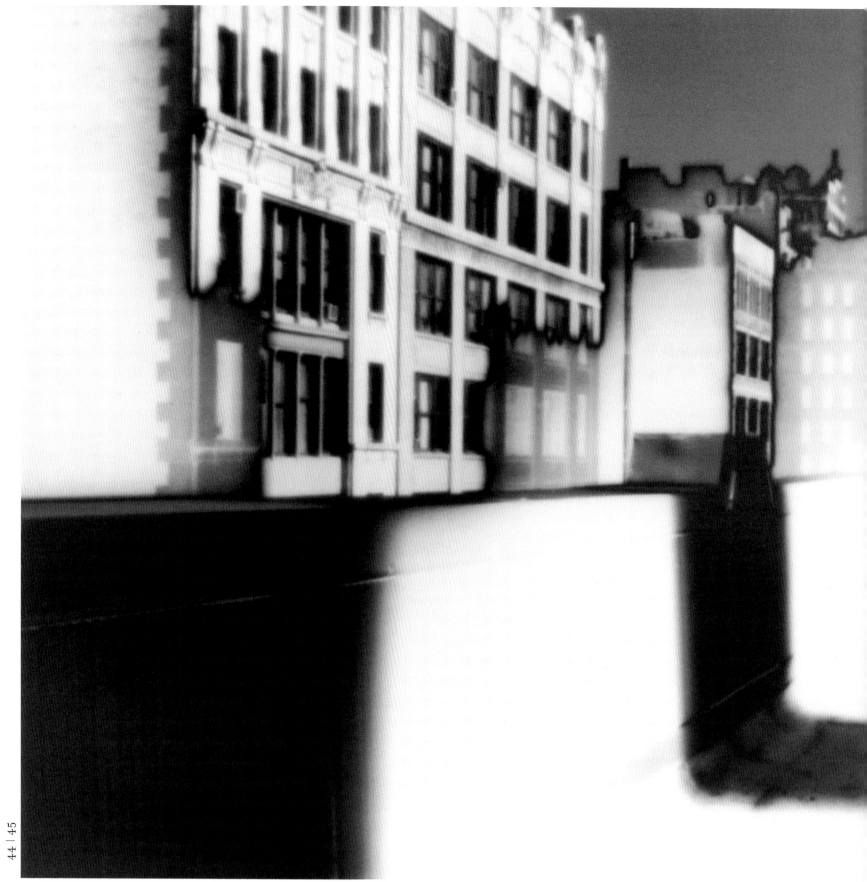

NEW YORK | 1999 | 7 x 7 1/16"

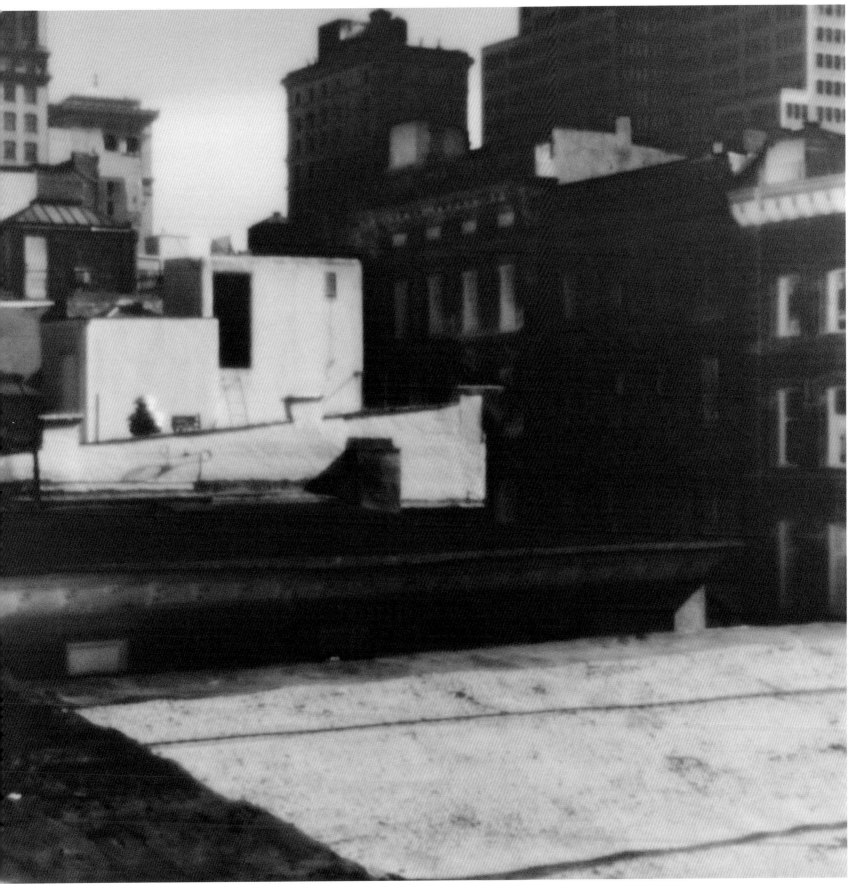

NEW YORK | 1999 | 7 x 7"

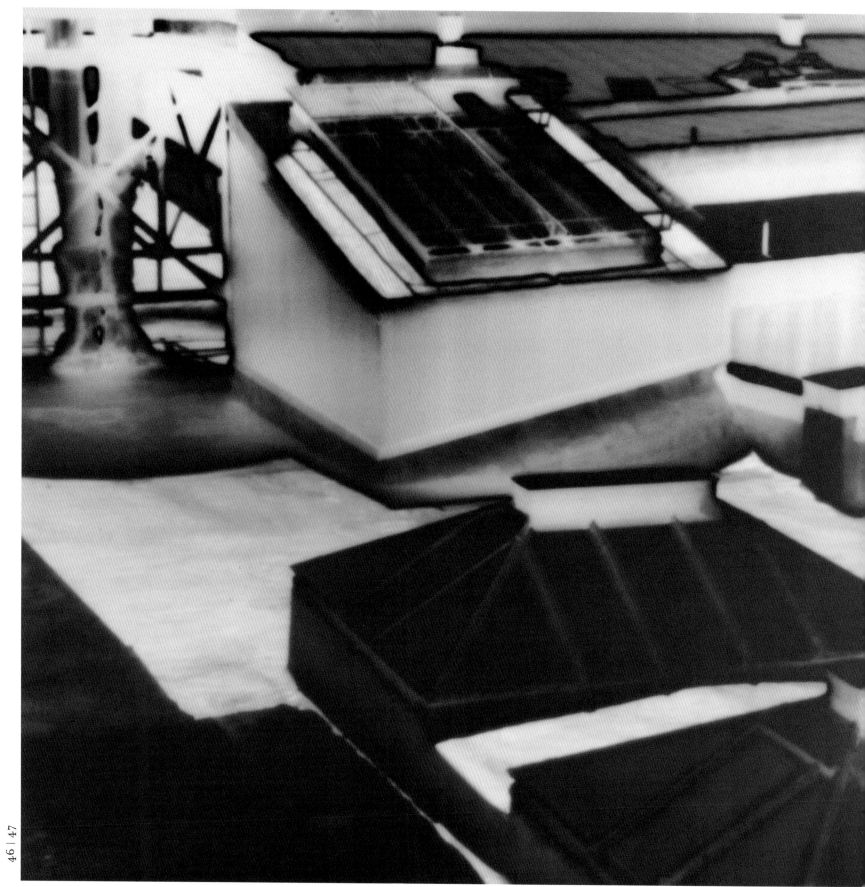

NEW YORK | 1999 | 7 x 7"

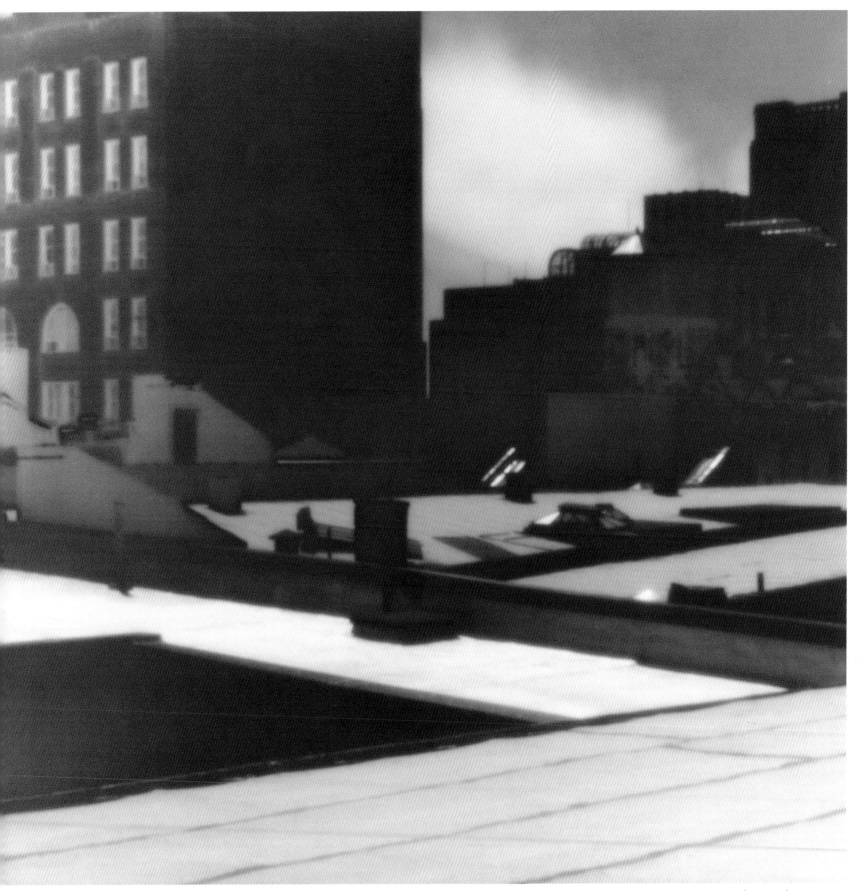

NEW YORK | 1999 | 7 x 7"

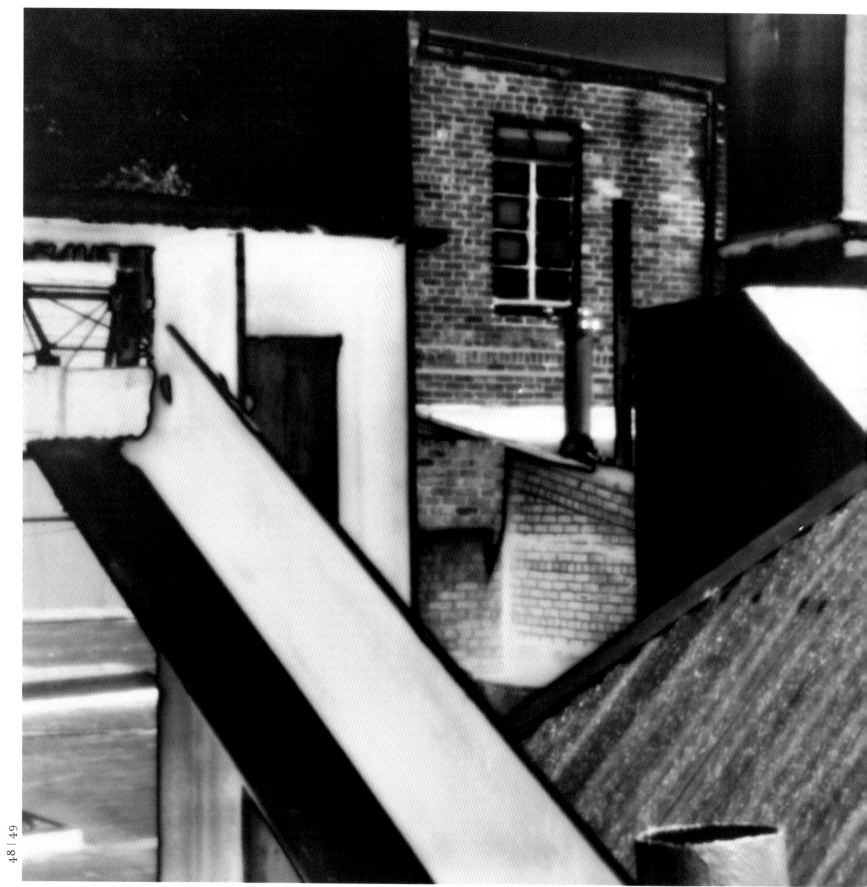

NEW YORK | 1999 | 7 x 7"

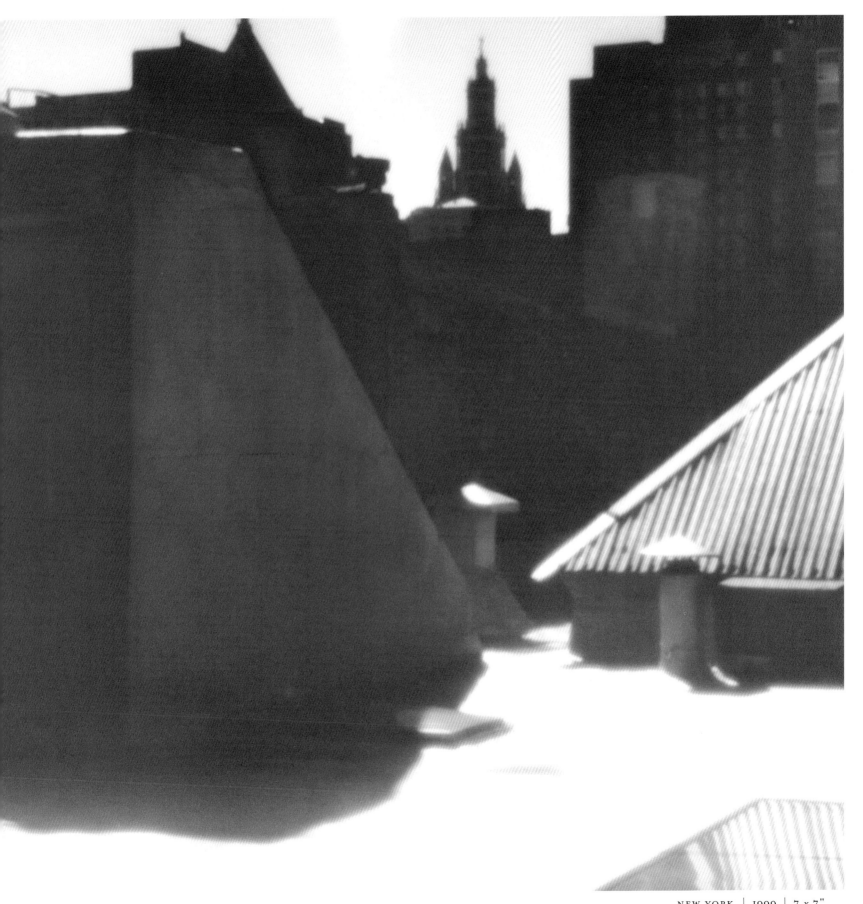

NEW YORK | 1999 | 7 x 7"

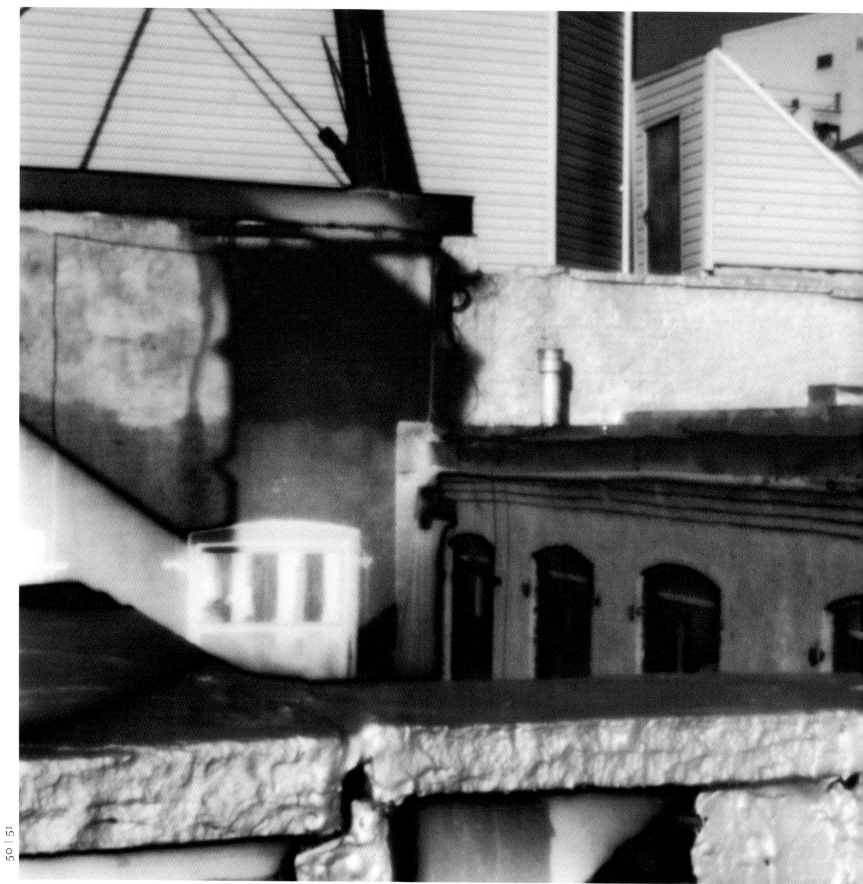

NEW YORK | 1999 | 7 x 7"

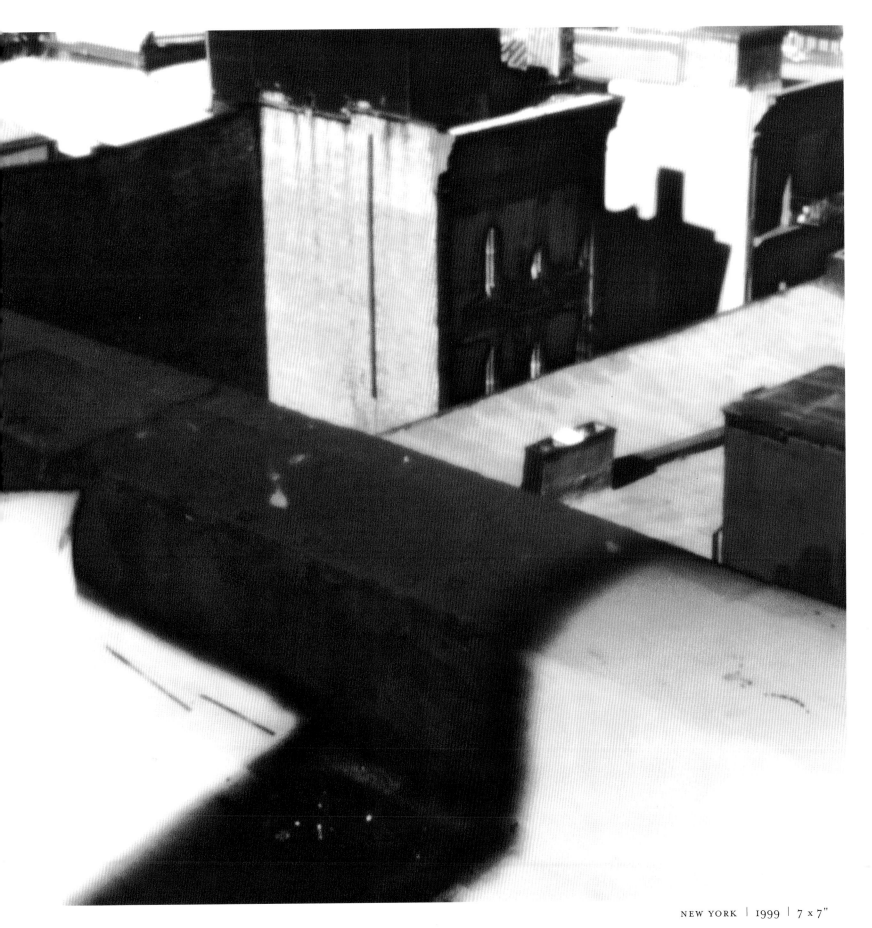

milky way

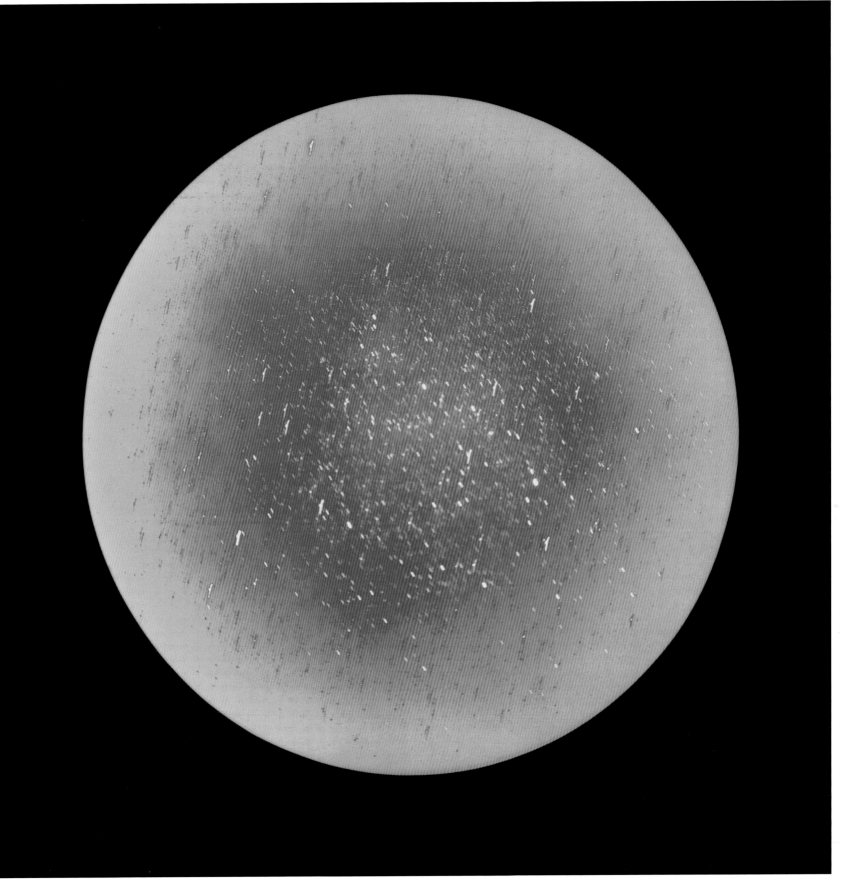

MILKY WAY | 1990-91 | 10½ x 10⅝"

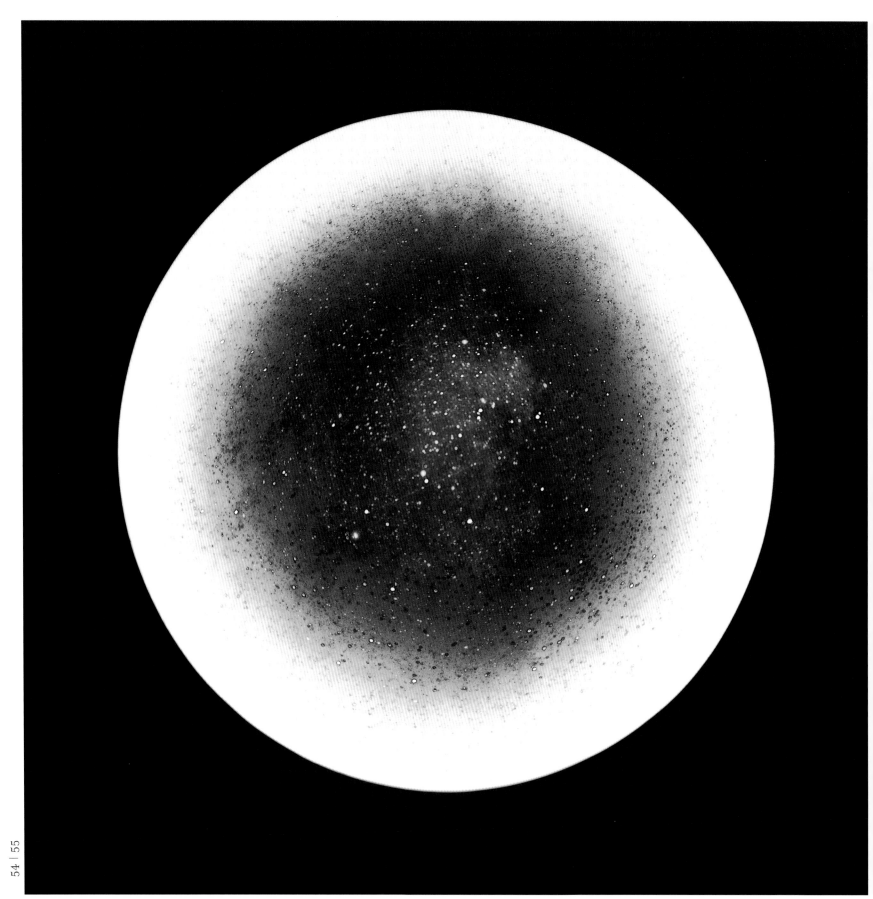

MILKY WAY | 1990–91 | 10½ x 10⅝"

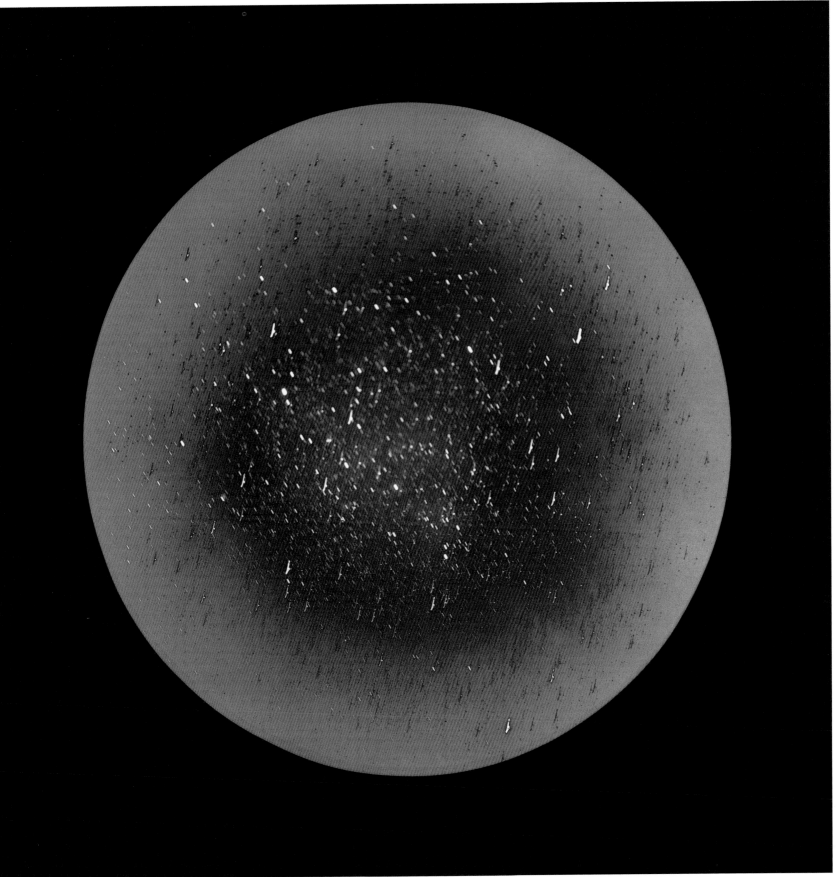

MILKY WAY | 1990–91 | 10½ x 10⅝"

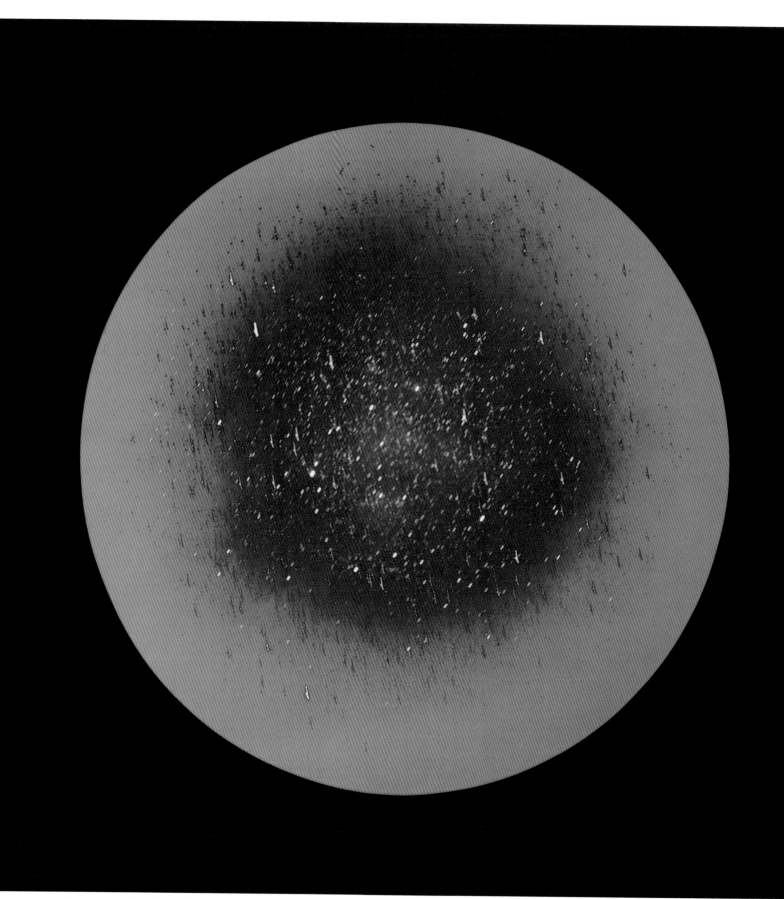

MILKY WAY | 1990–91 | 10½ x 10⅝"

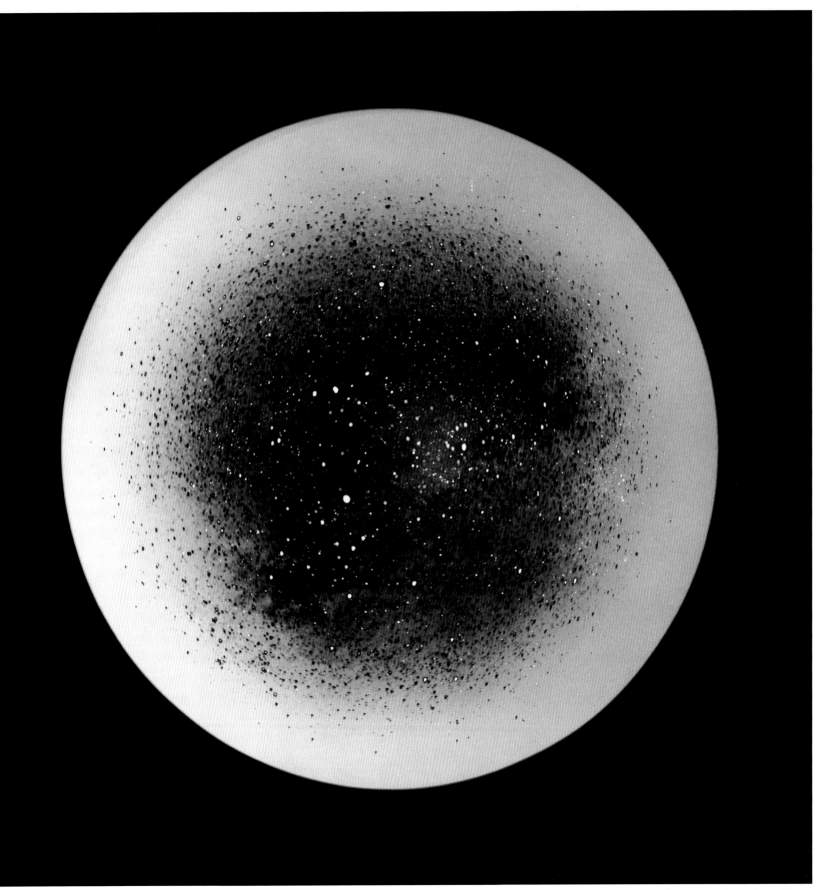

MILKY WAY │ 1990–91 │ 10½ x 10⅝"

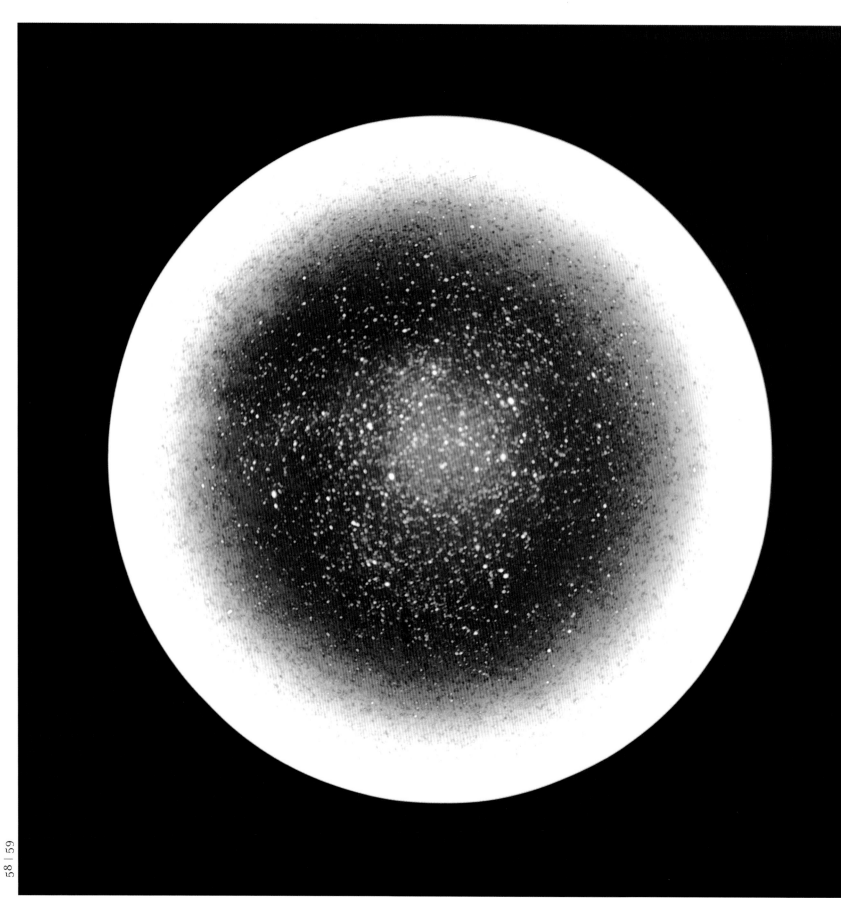

MILKY WAY | 1990–91 | 10½ x 10⅝"

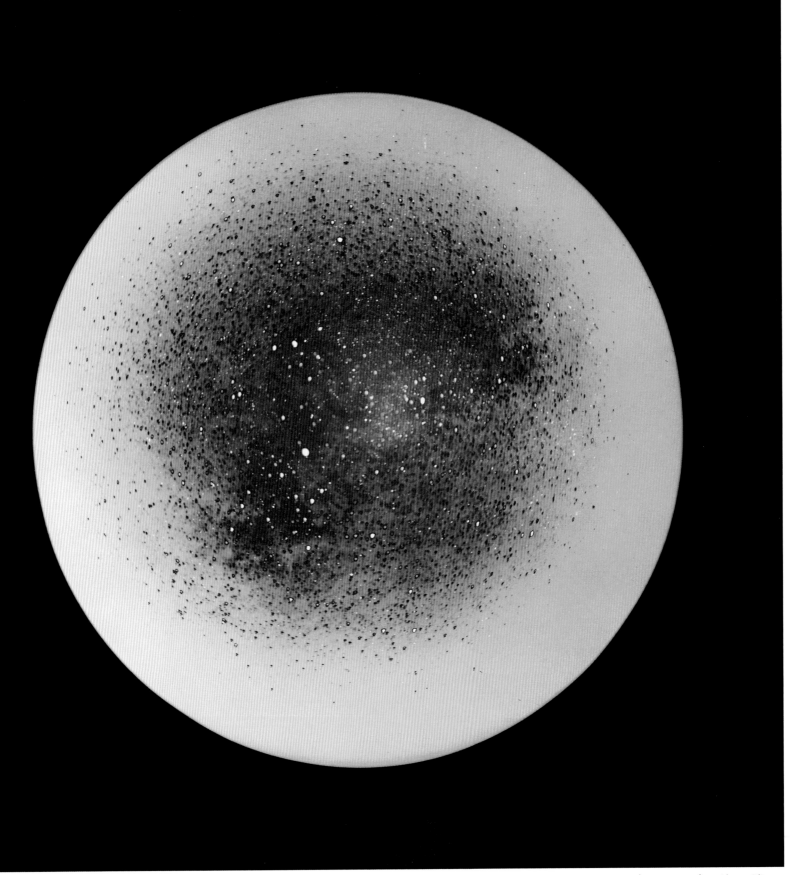

MILKY WAY | 1990–91 | 10½ x 10⅝"

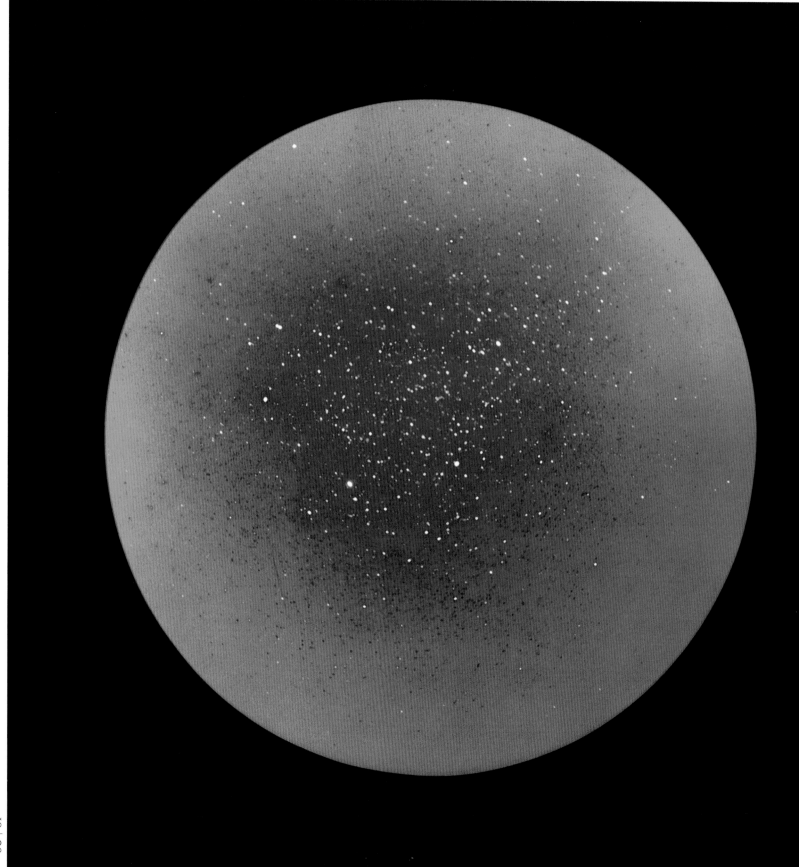

MILKY WAY | 1990–91 | 10½ x 10⅝"

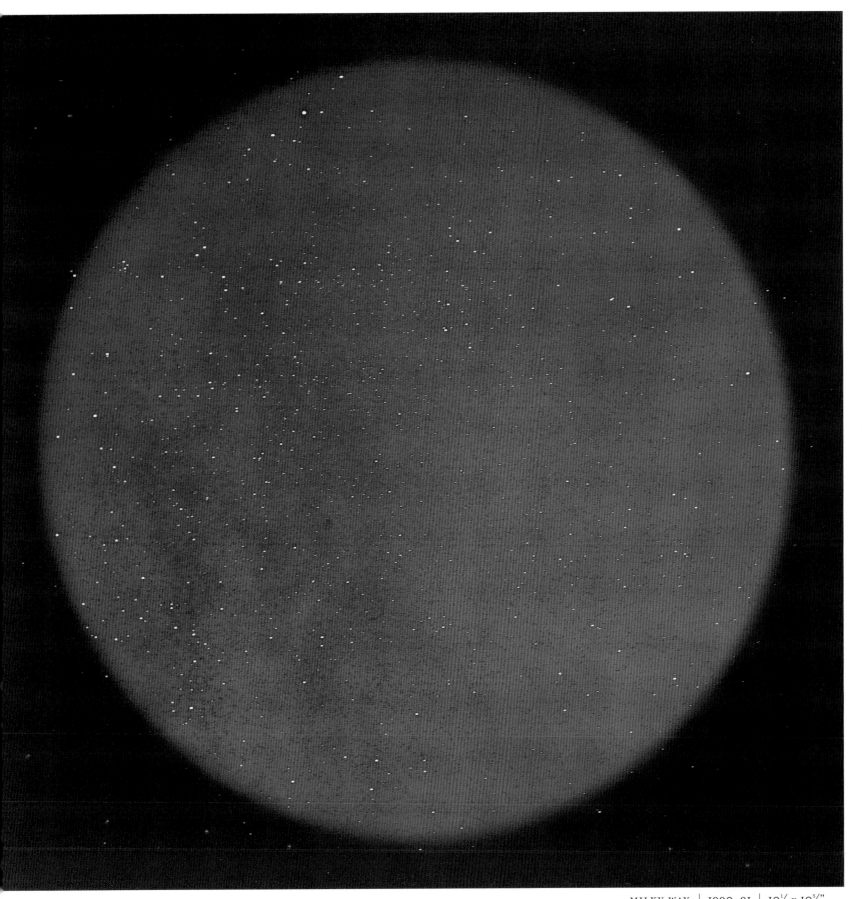

MILKY WAY | 1990–91 | 10½ x 10⅝"

reflections

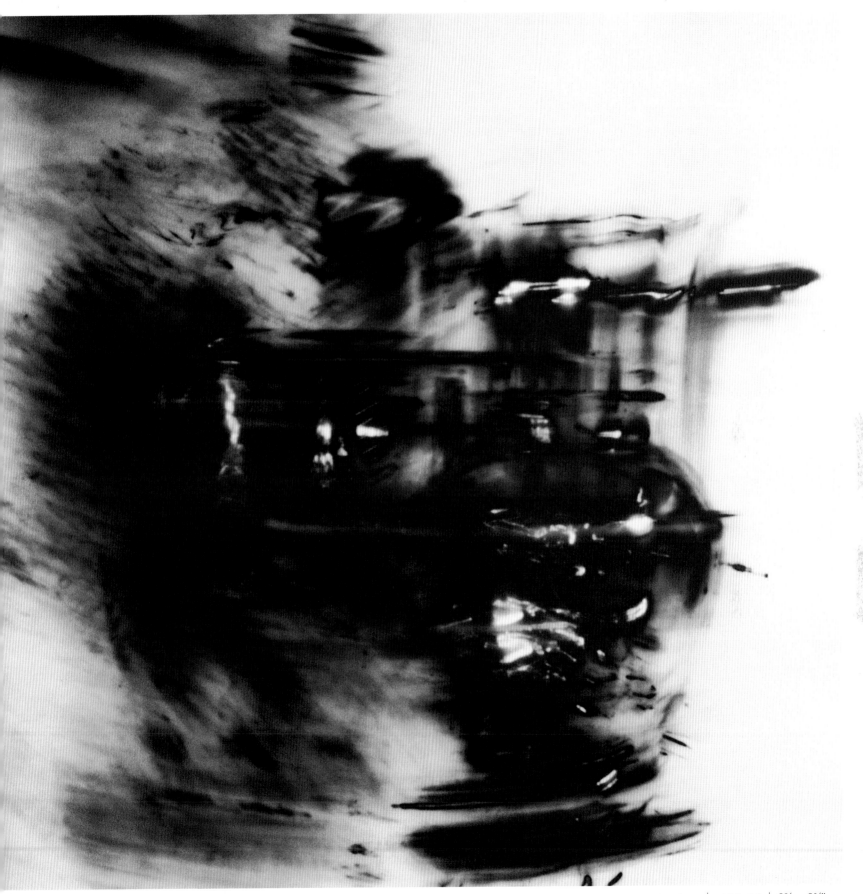

REFLECTIONS | 1994–95 | 8⁷⁄₁₆ x 8³⁄₈"

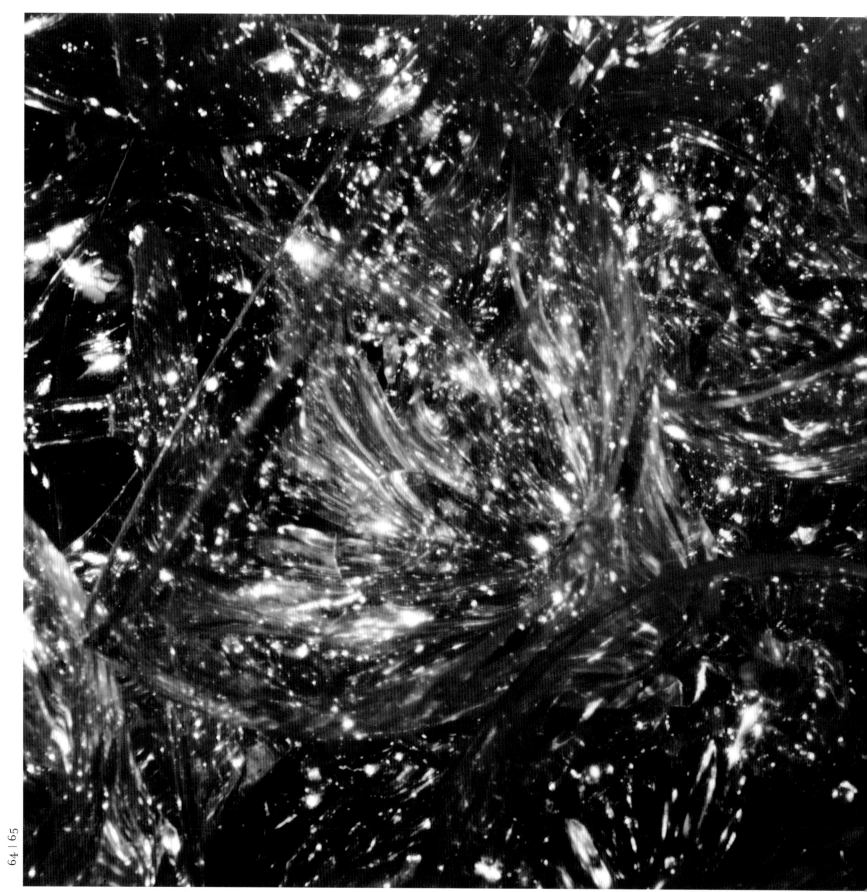

REFLECTIONS | 1994–95 | 8½ x 8⅜"

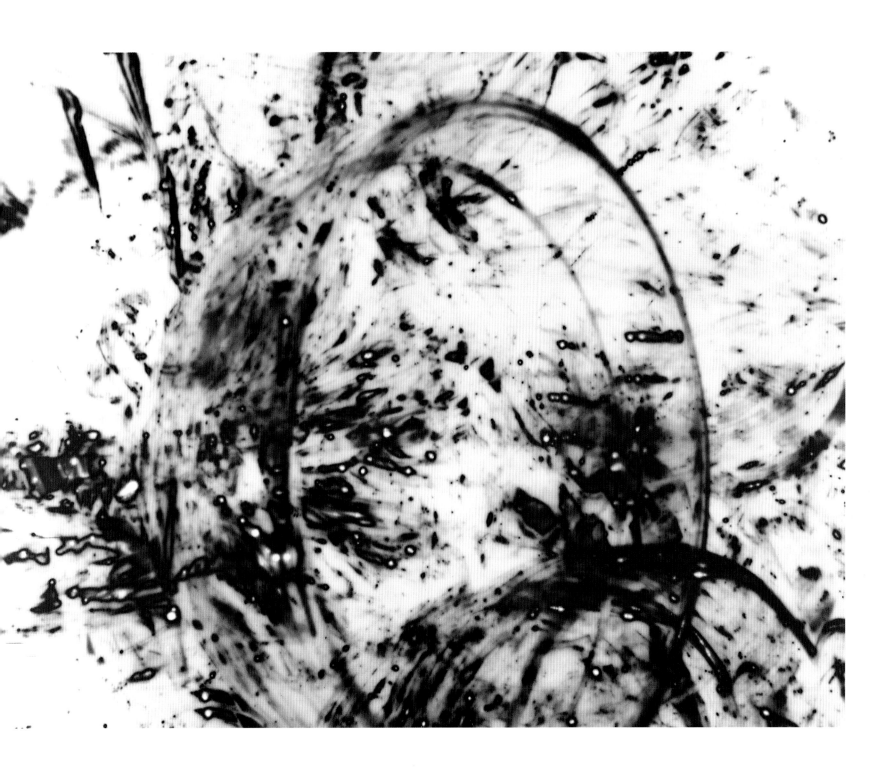

REFLECTIONS | 1994–95 | 9⁷⁄₁₆ x 7¹⁄₁₆"

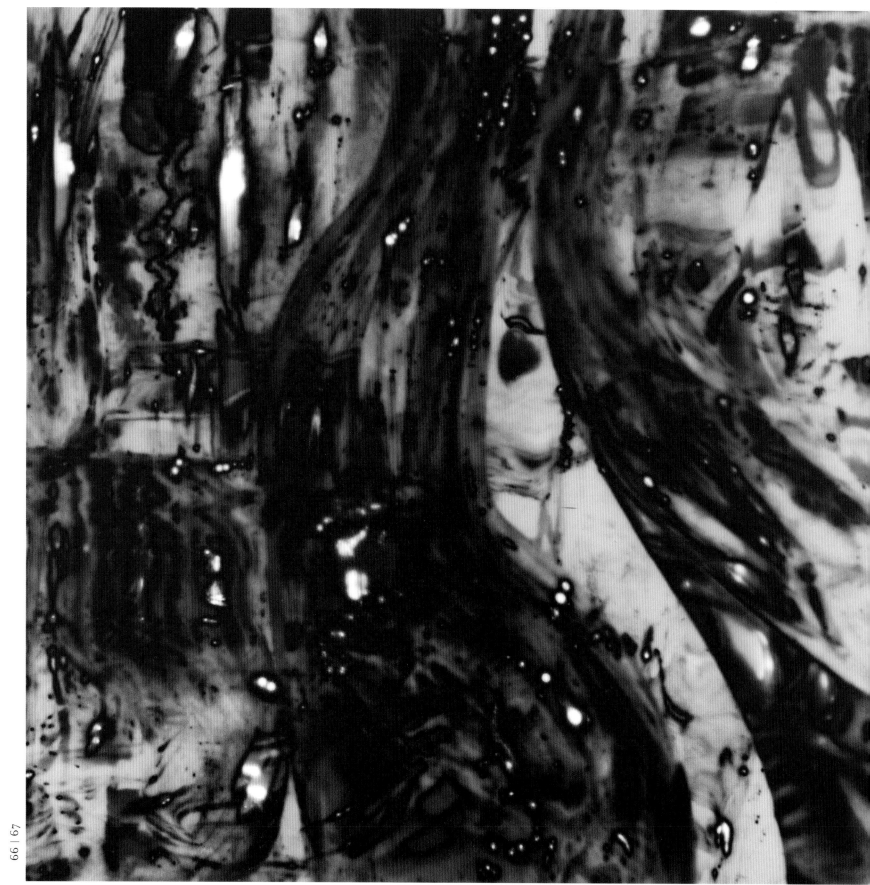

REFLECTIONS | 1994–95 | 8⁷⁄₁₆ x 8³⁄₈"

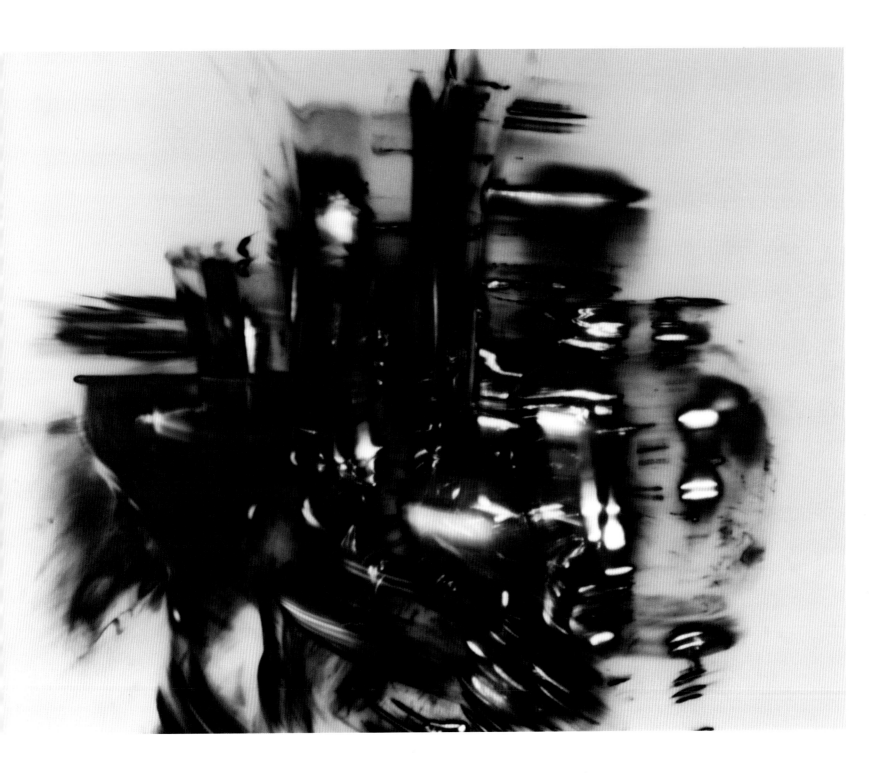

REFLECTIONS │ 1994–95 │ 9⁷⁄₁₆ x 7¹⁄₁₆"

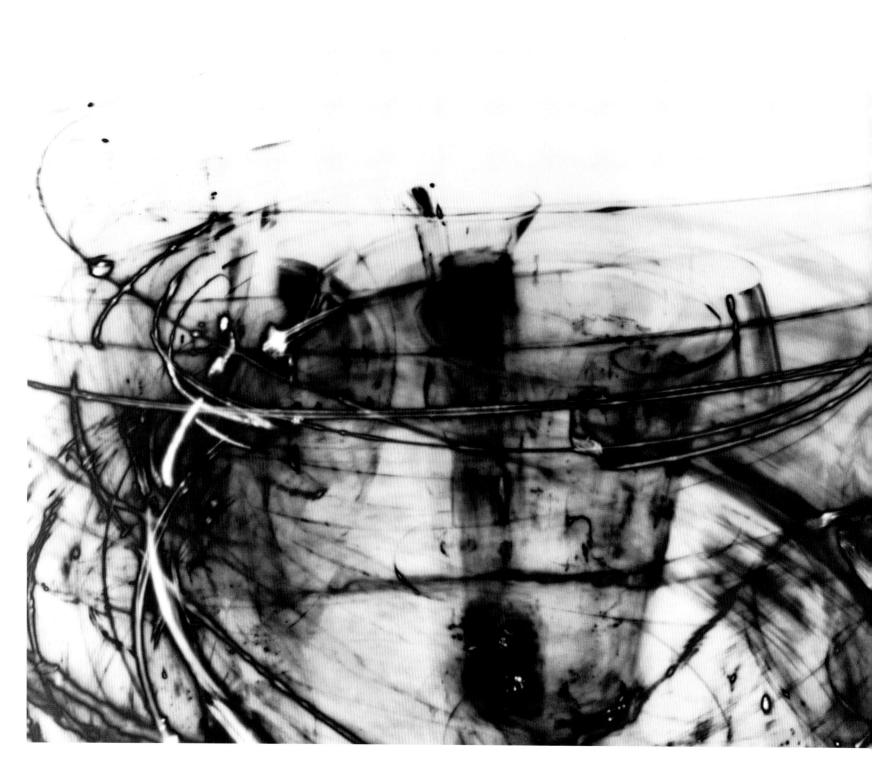

REFLECTIONS | 1994–95 | 9⅜ x 7⁷⁄₁₆"

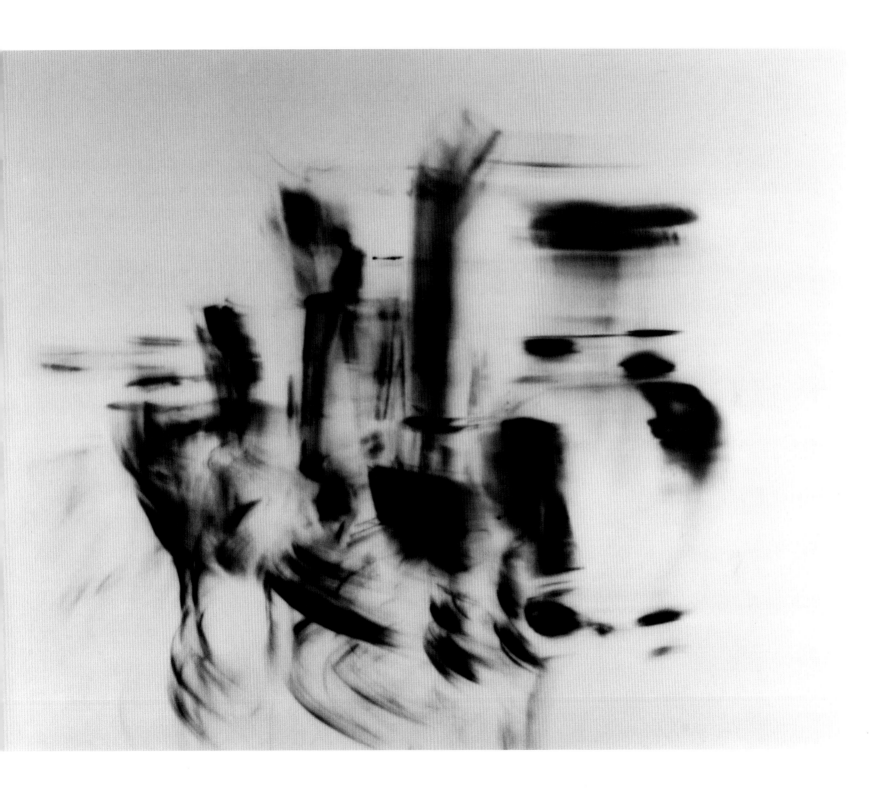

REFLECTIONS | 1994–95 | 9⁷⁄₁₆ x 7⁷⁄₁₆"

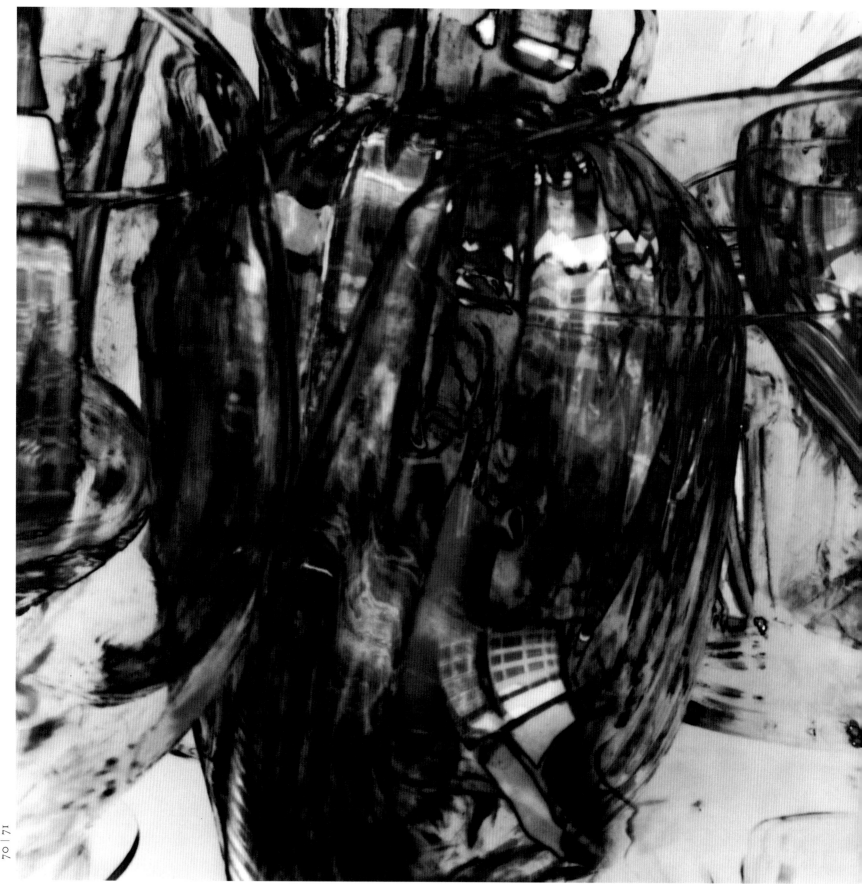

REFLECTIONS | 1994–95 | 8⁷⁄₁₆ x 8⁷⁄₁₆"

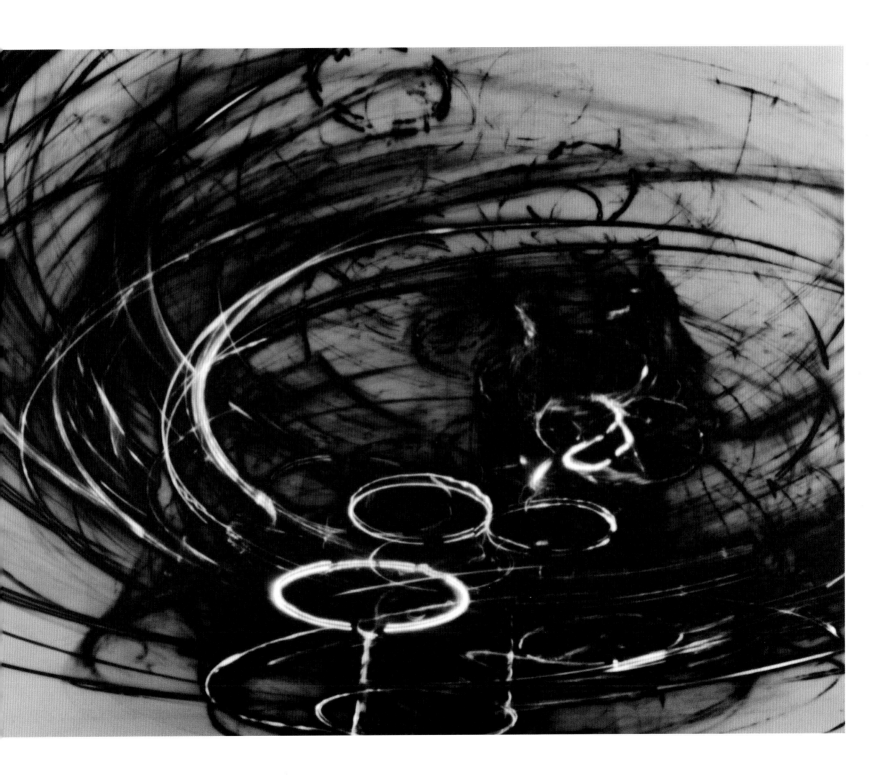

REFLECTIONS | 1994–95 | 9⅜ x 7½"

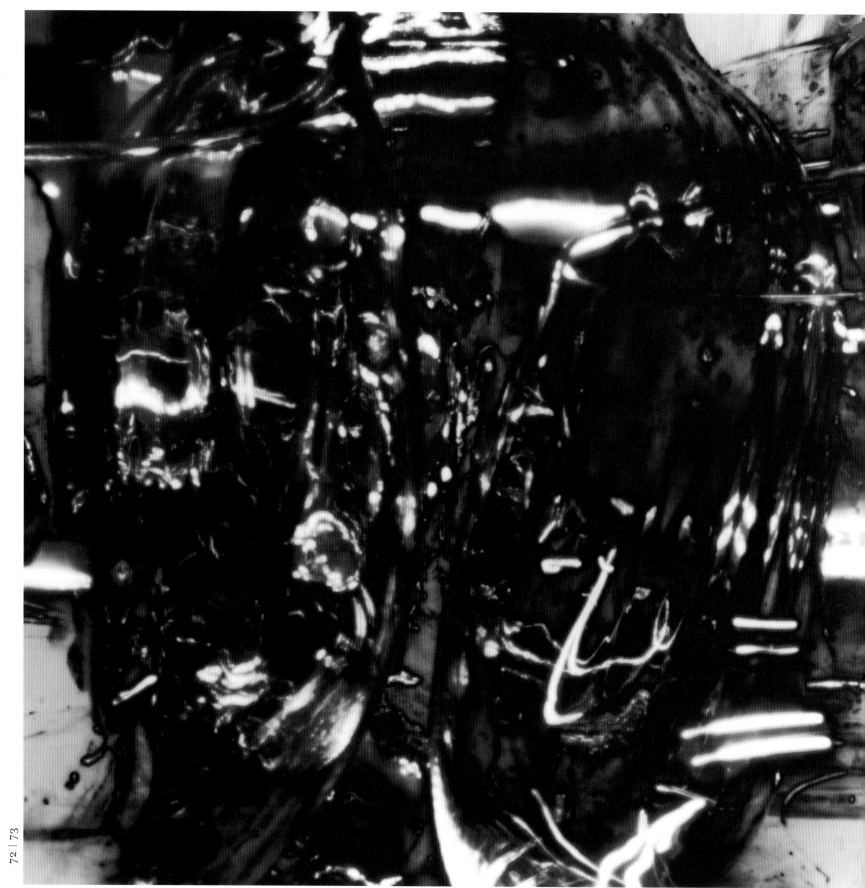

REFLECTIONS | 1994–95 | 8⁷⁄₁₆ x 8³⁄₈"

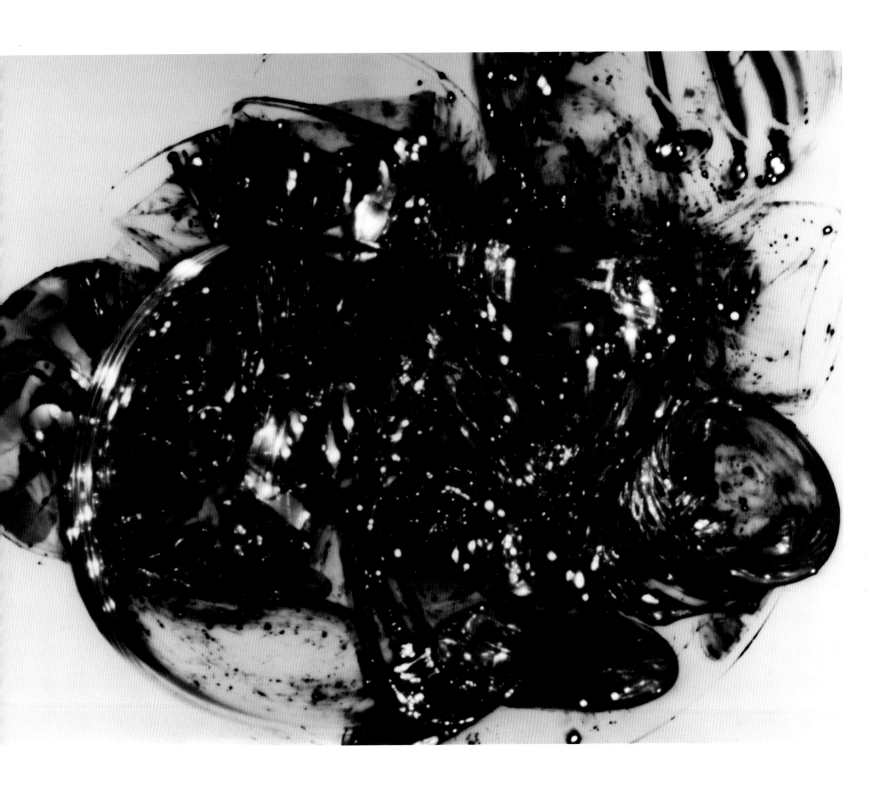

REFLECTIONS | 1994–95 | 9⅜ x 7⁷⁄₁₆"

unterholz

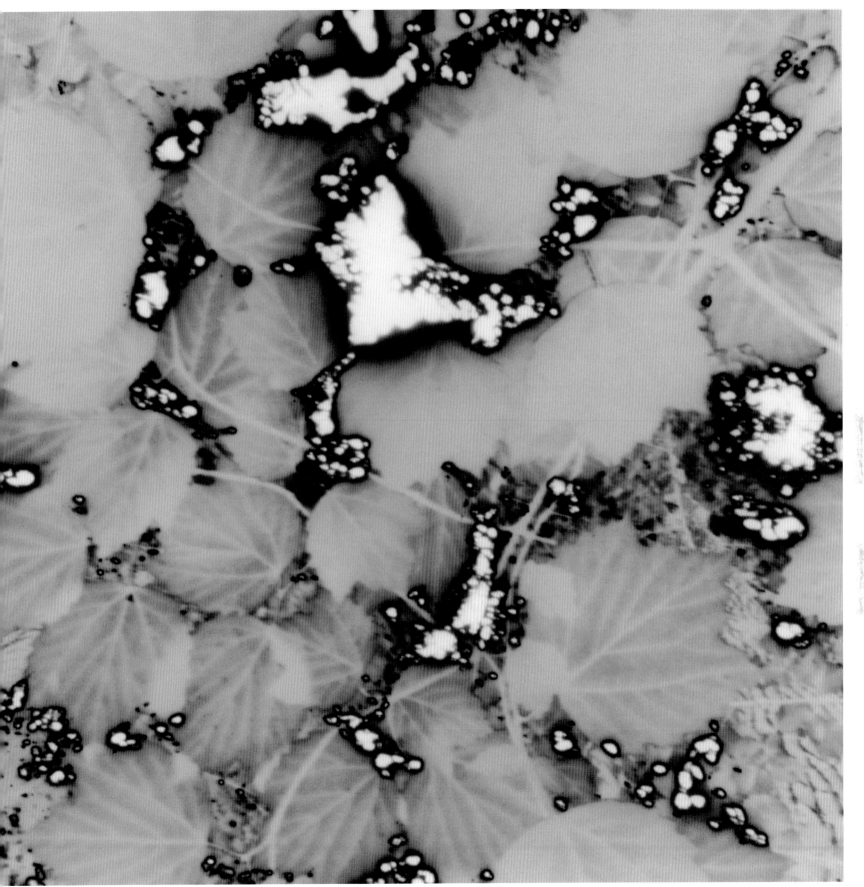

UNTERHOLZ | 1996–97 | 8 x 8"

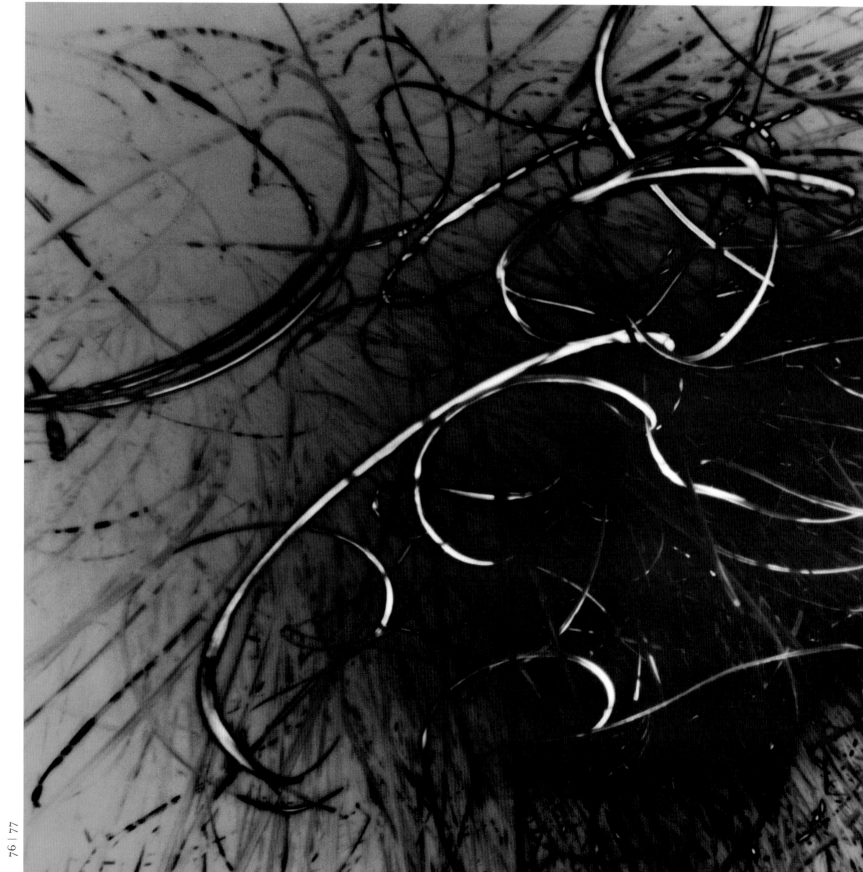

UNTERHOLZ | 1996–97 | 7⅜ x 7⅜"

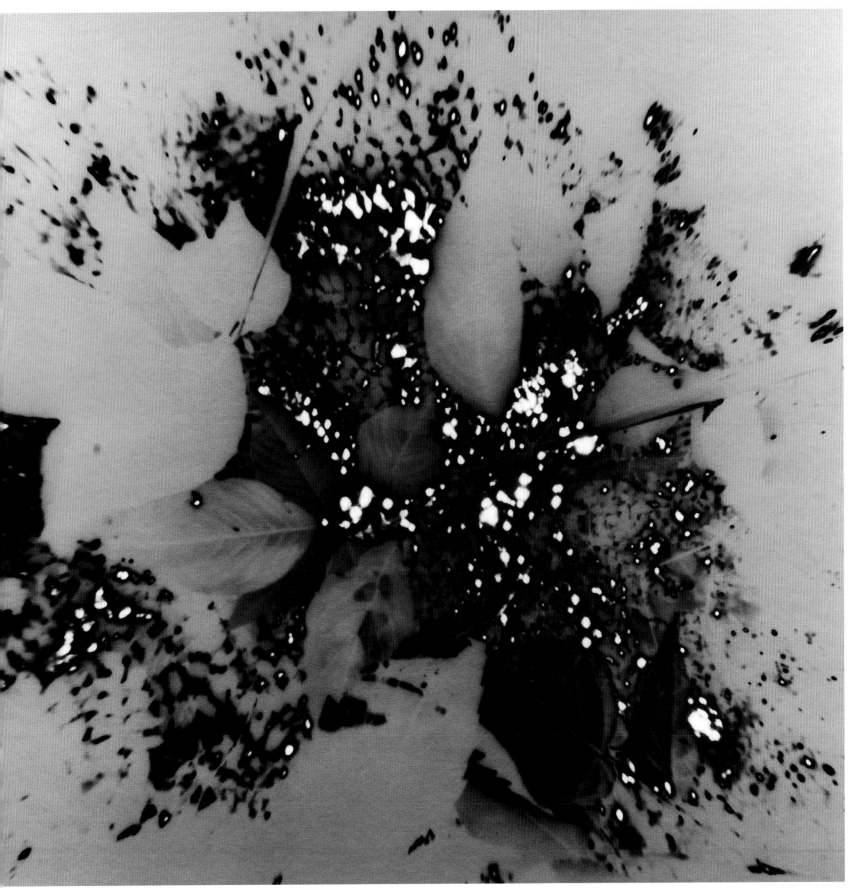

UNTERHOLZ | 1996–97 | 8 x 8¹⁄₁₆"

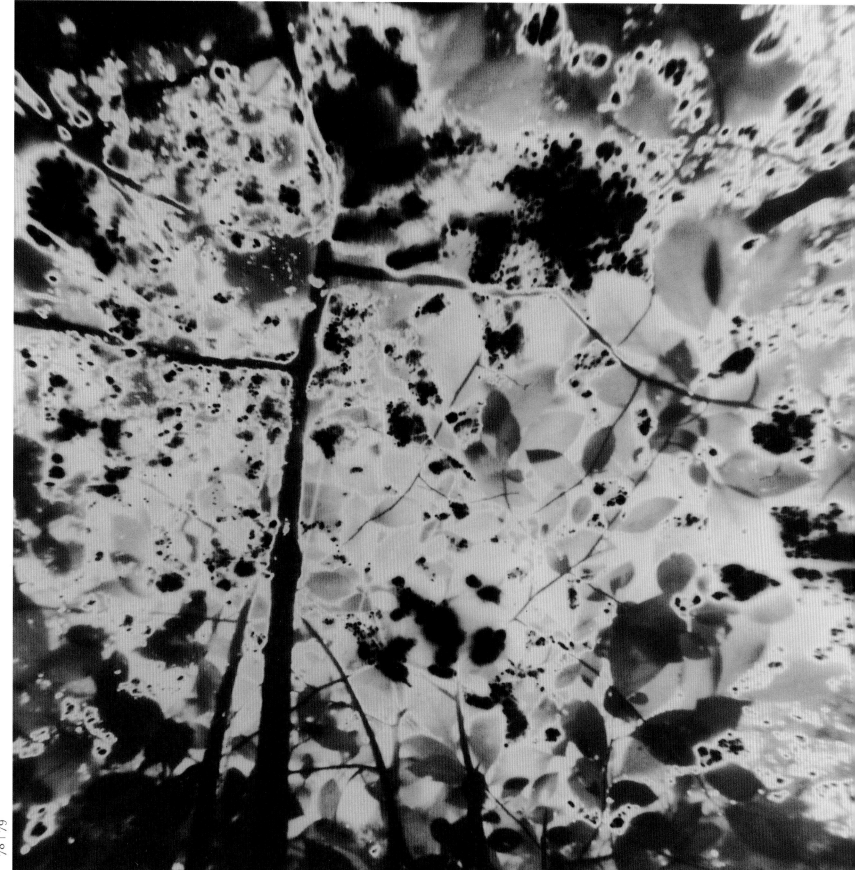

UNTERHOLZ | 1996–97 | 7⅞ x 7⅞"

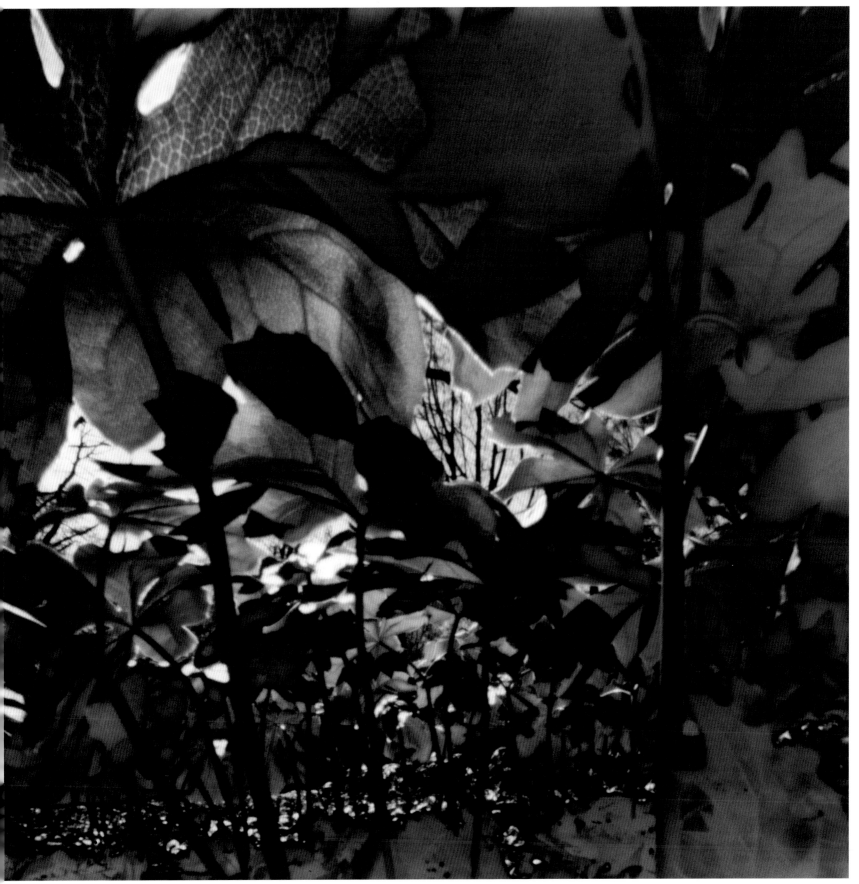

UNTERHOLZ | 1996–97 | 8⁷⁄₁₆ x 8³⁄₈"

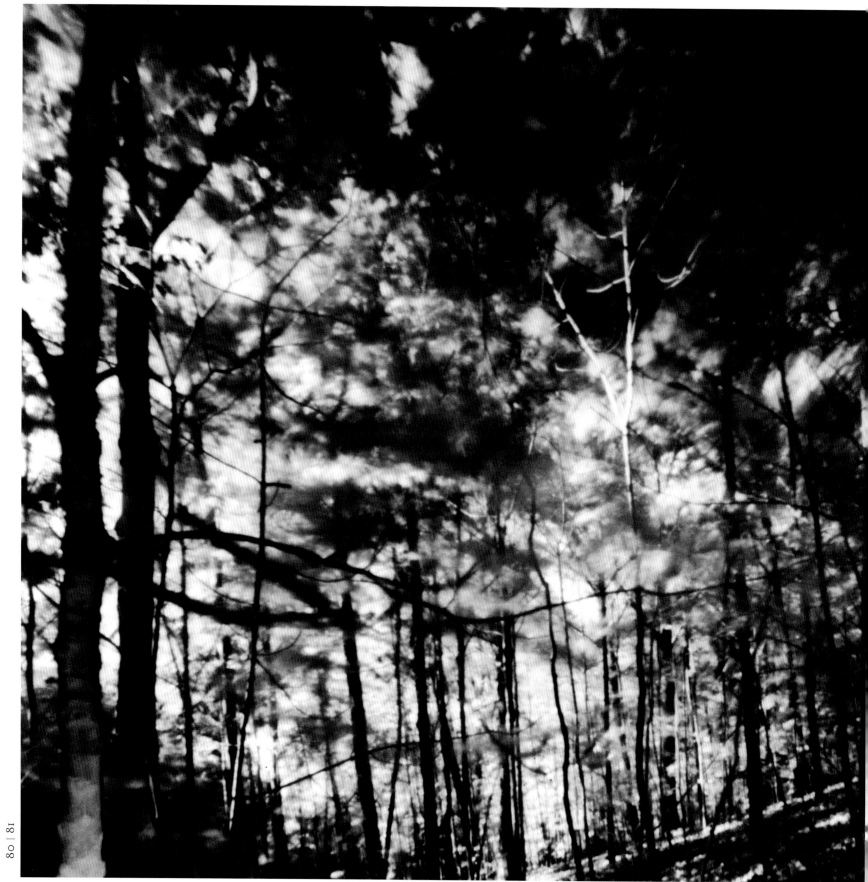

UNTERHOLZ | 1996–97 | 8 x 8"

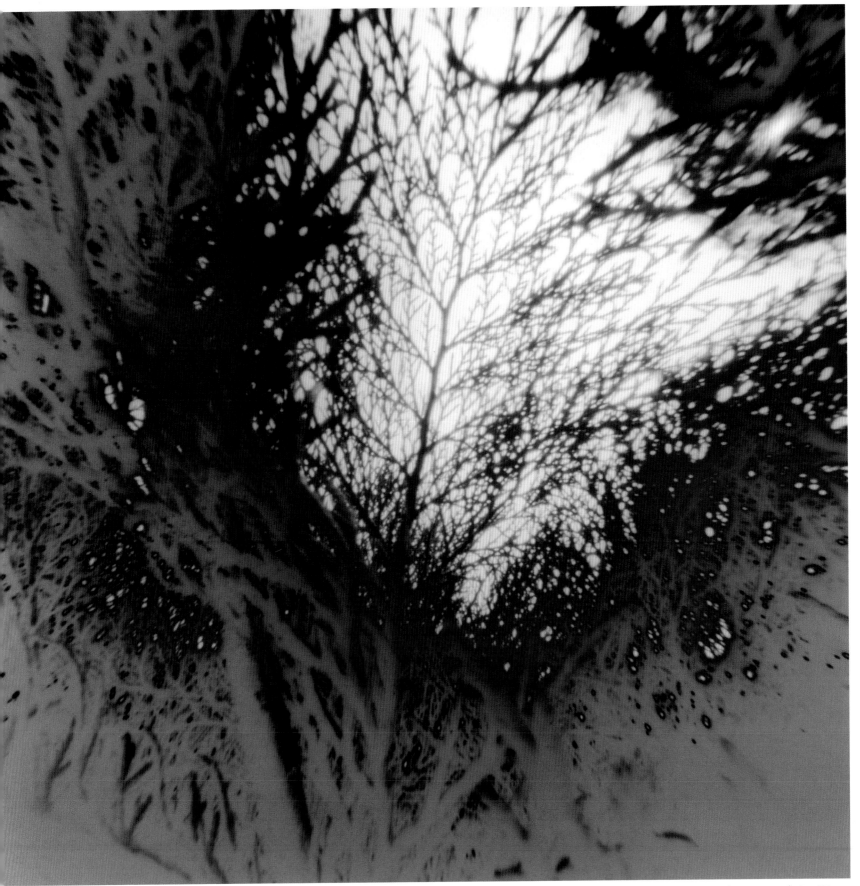

UNTERHOLZ │ 1996–97 │ 8 x 8"

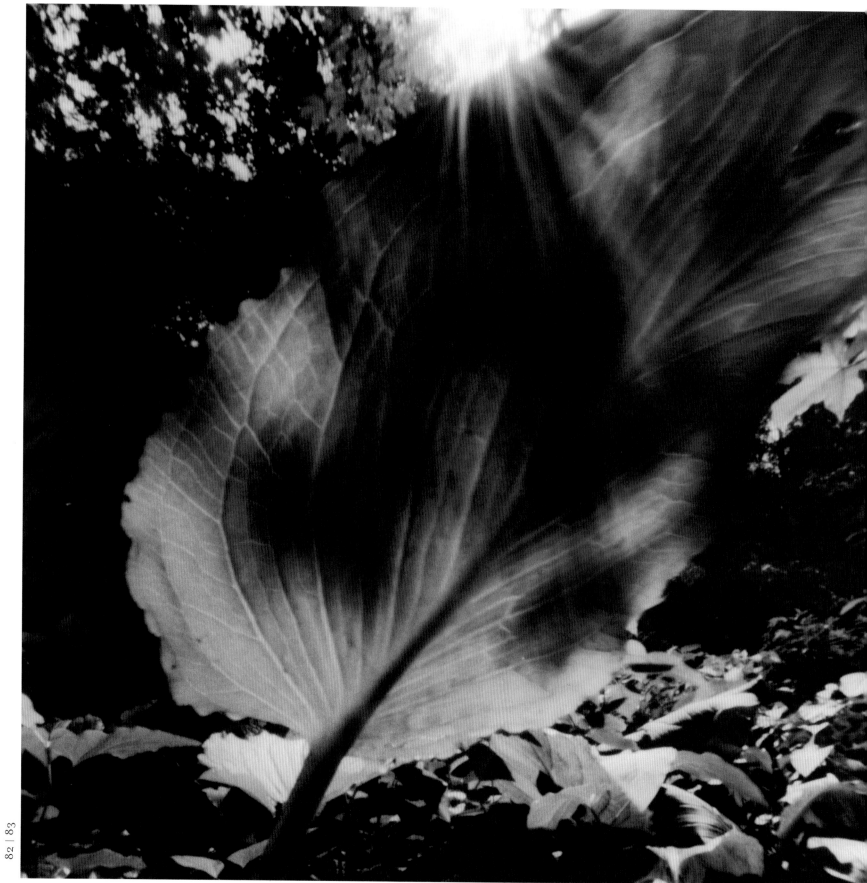

UNTERHOLZ | 1996–97 | 8 x 8"

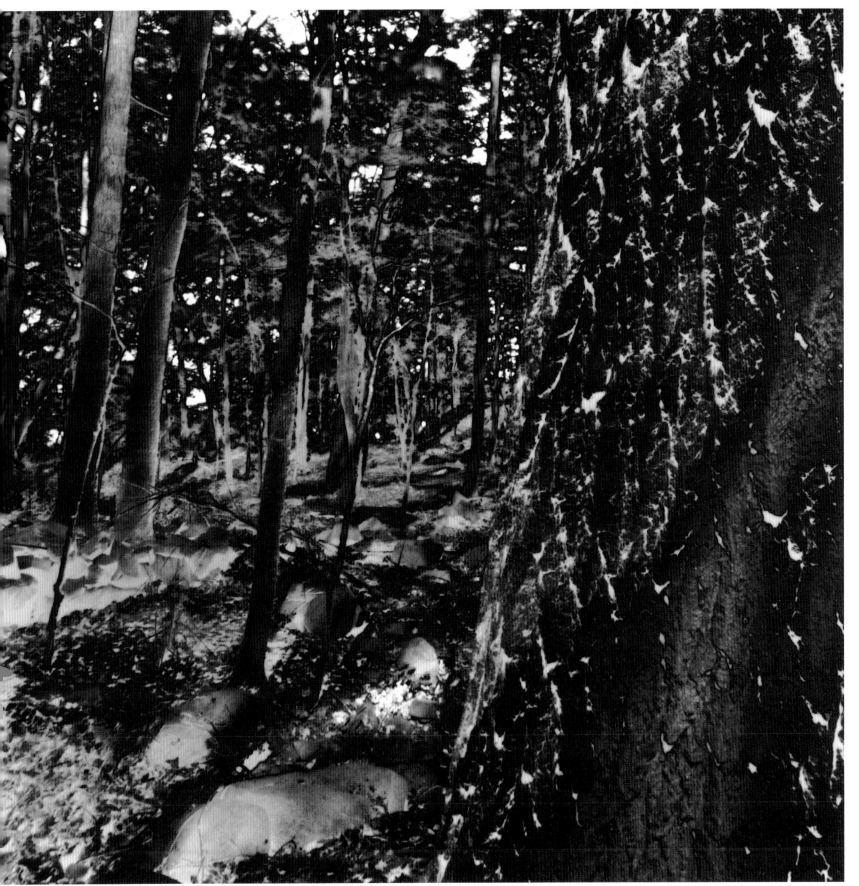

UNTERHOLZ | 1996–97 | 7½ x 7½"

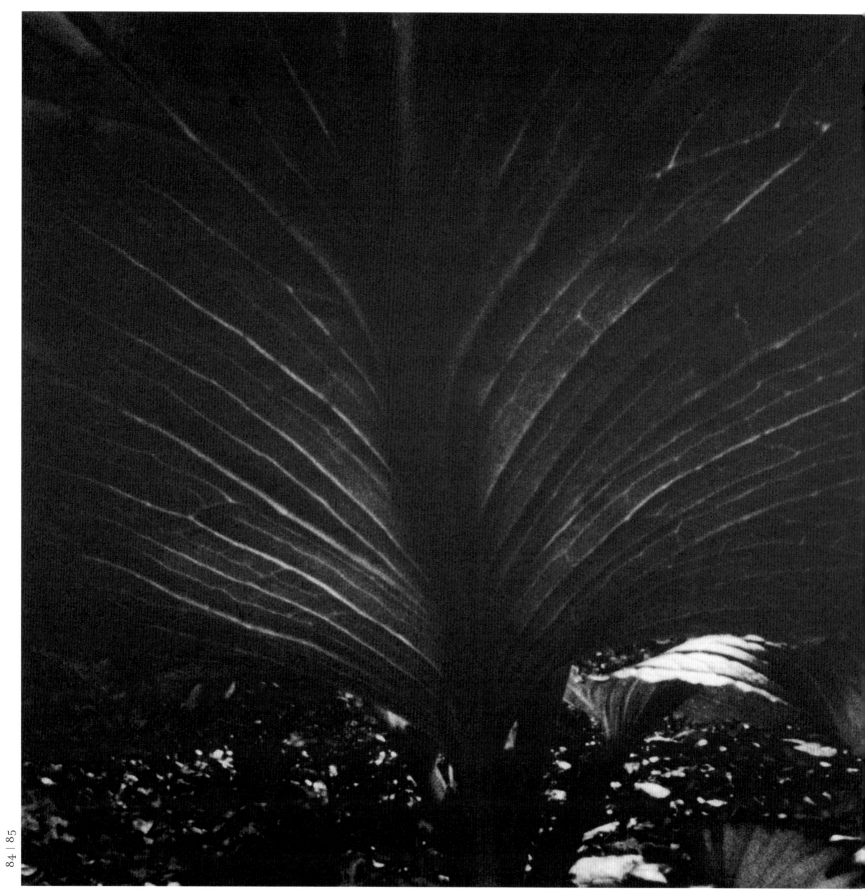

UNTERHOLZ | 1996–97 | 8⁷⁄₁₆ x 8⁷⁄₁₆"

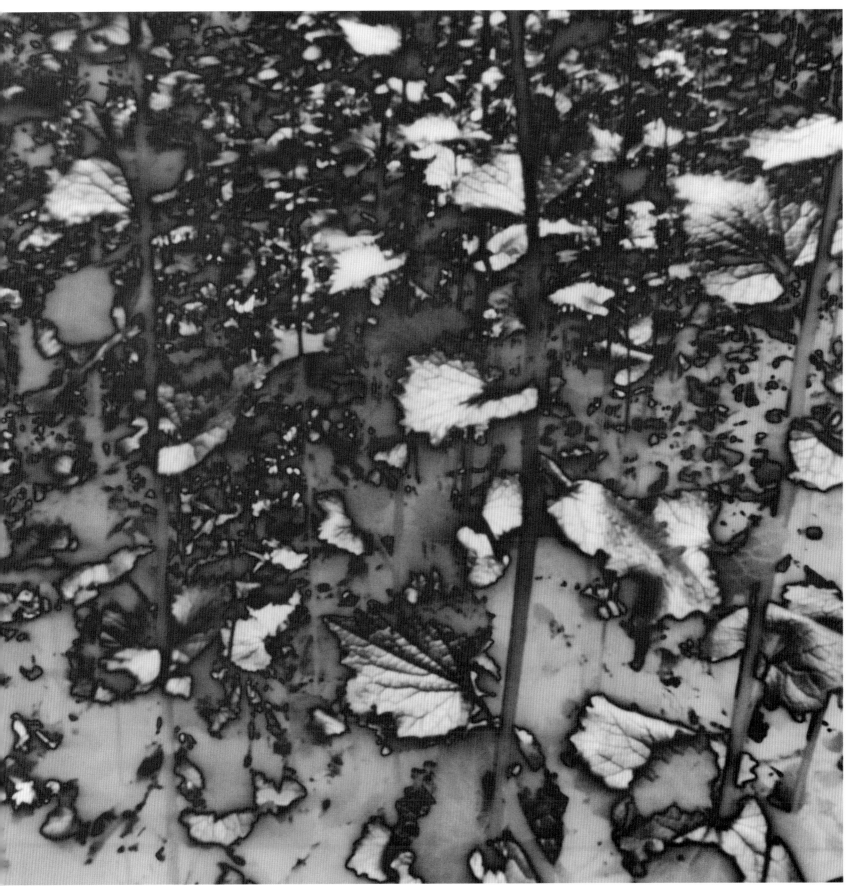

UNTERHOLZ | 1996–97 | 8 x 7$^{15}/_{16}$"

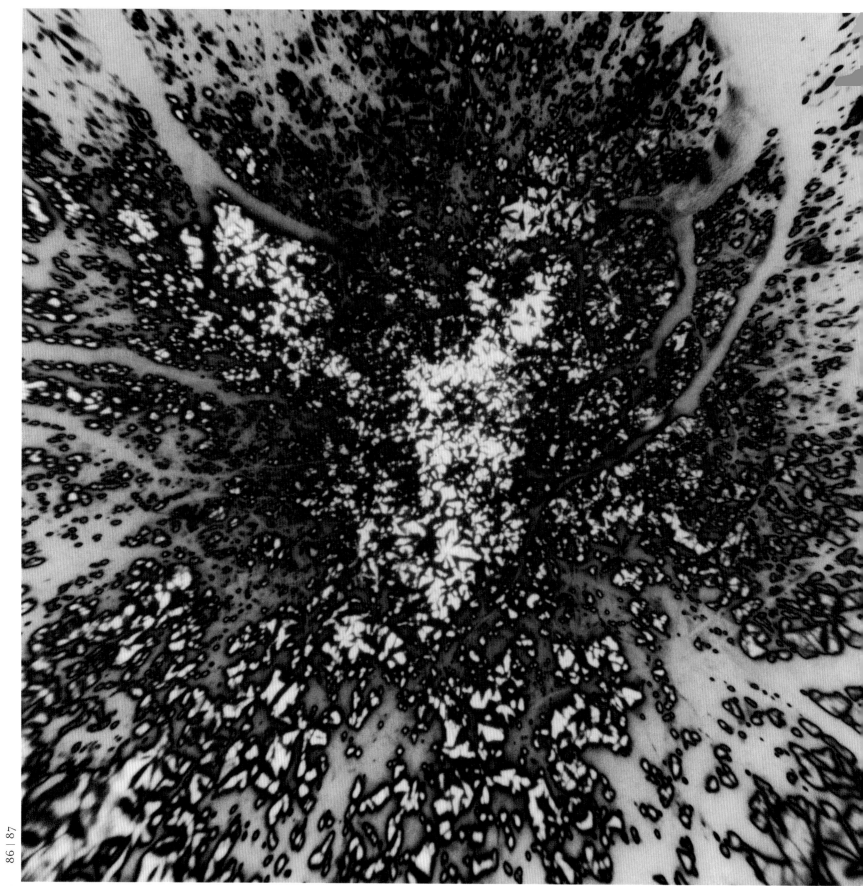

UNTERHOLZ | 1996–97 | 8 x 8⅛"

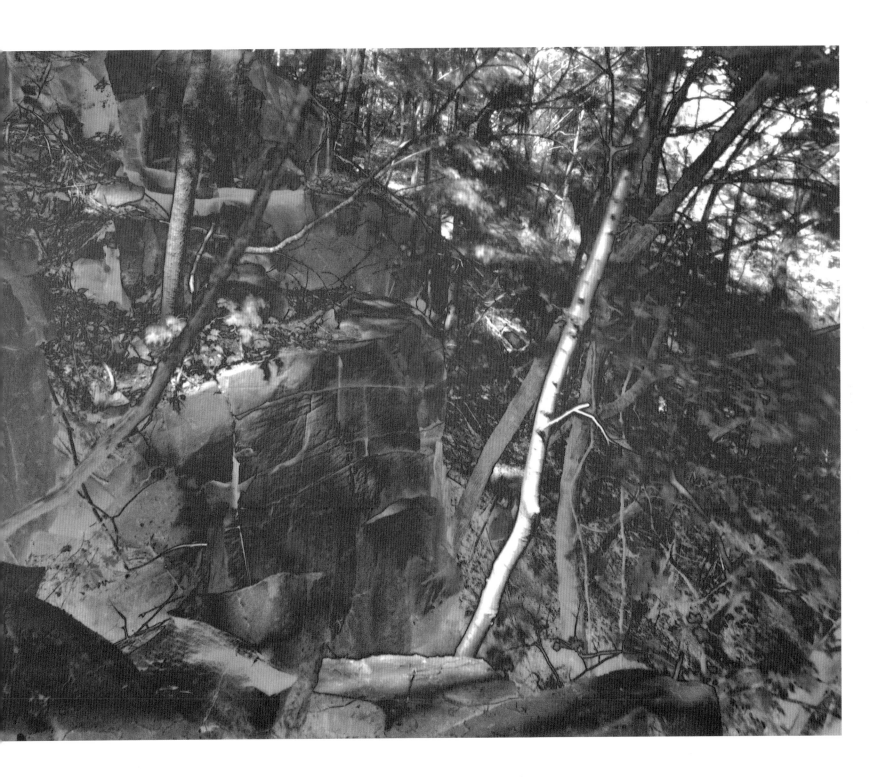

UNTERHOLZ | 1996–97 | 9½ x 7½"

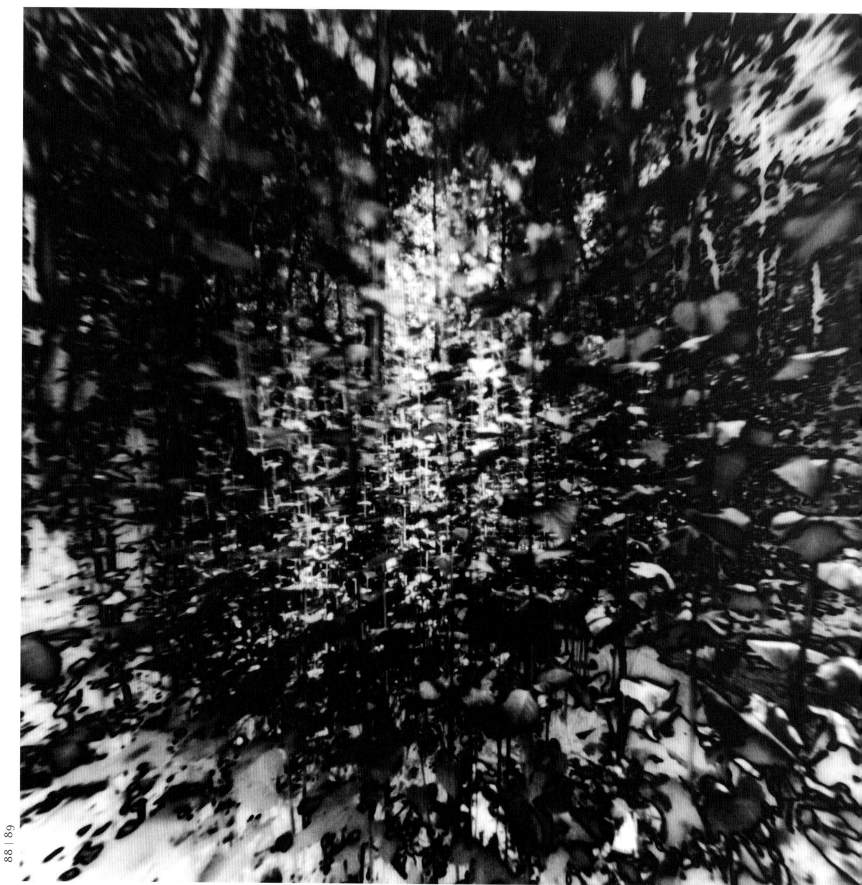

UNTERHOLZ | 1996–97 | 8¹⁄₁₆ x 8¹⁄₁₆"

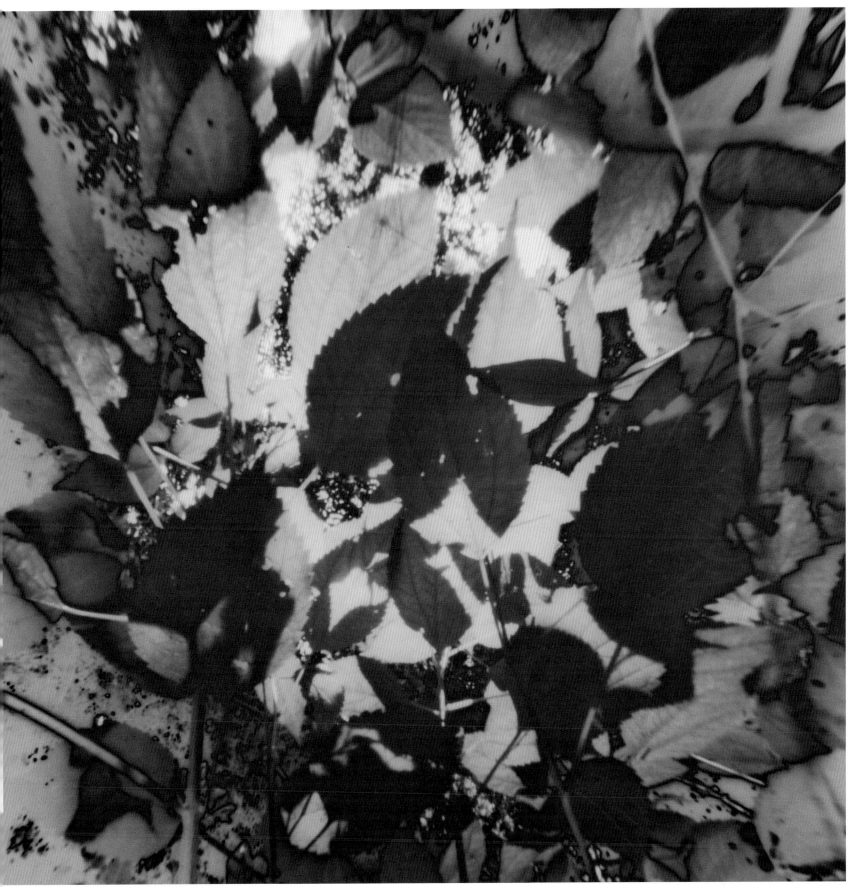

UNTERHOLZ | 1996–97 | 8 x 8"

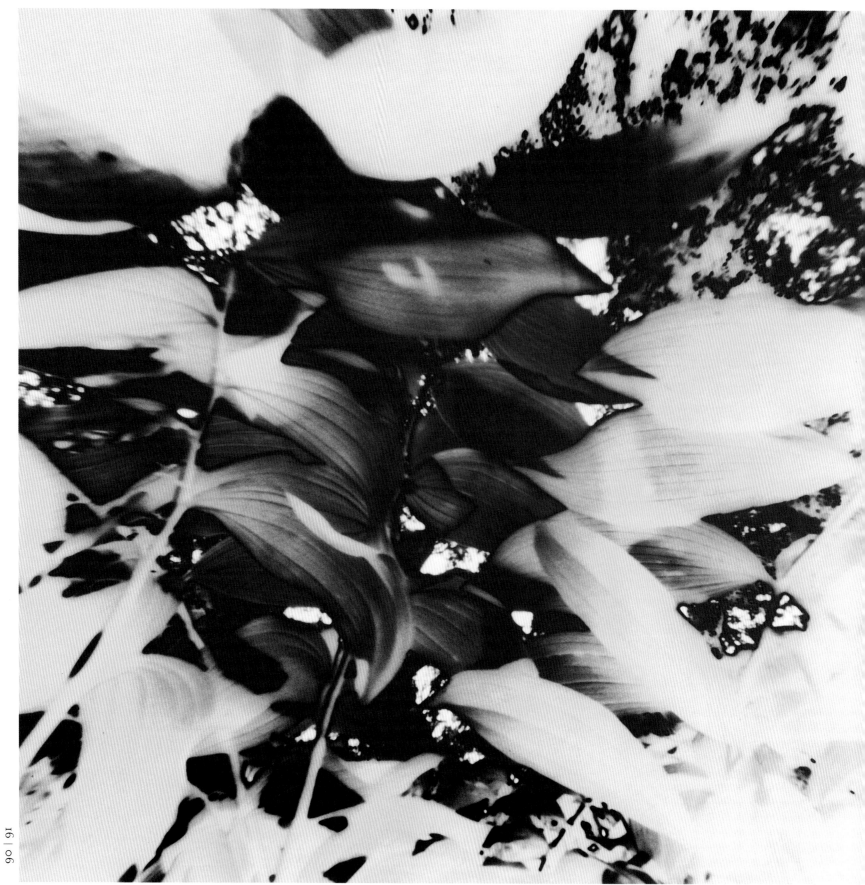

UNTERHOLZ | 1996–97 | 8 x 8"

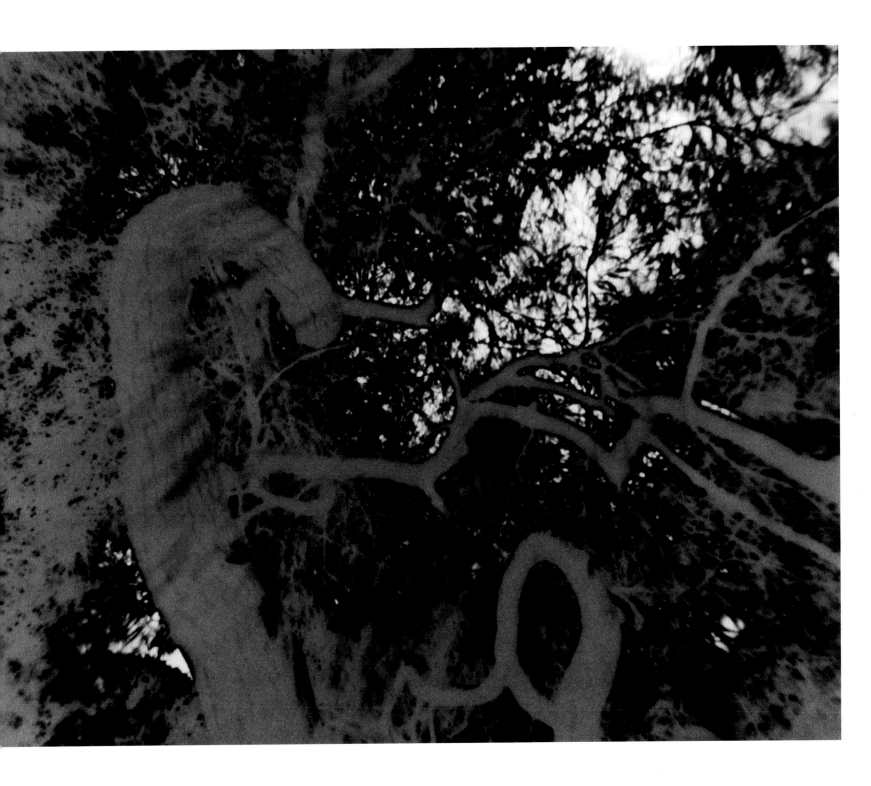

UNTERHOLZ | 1996–97 | 8⅜ x 6⅝"

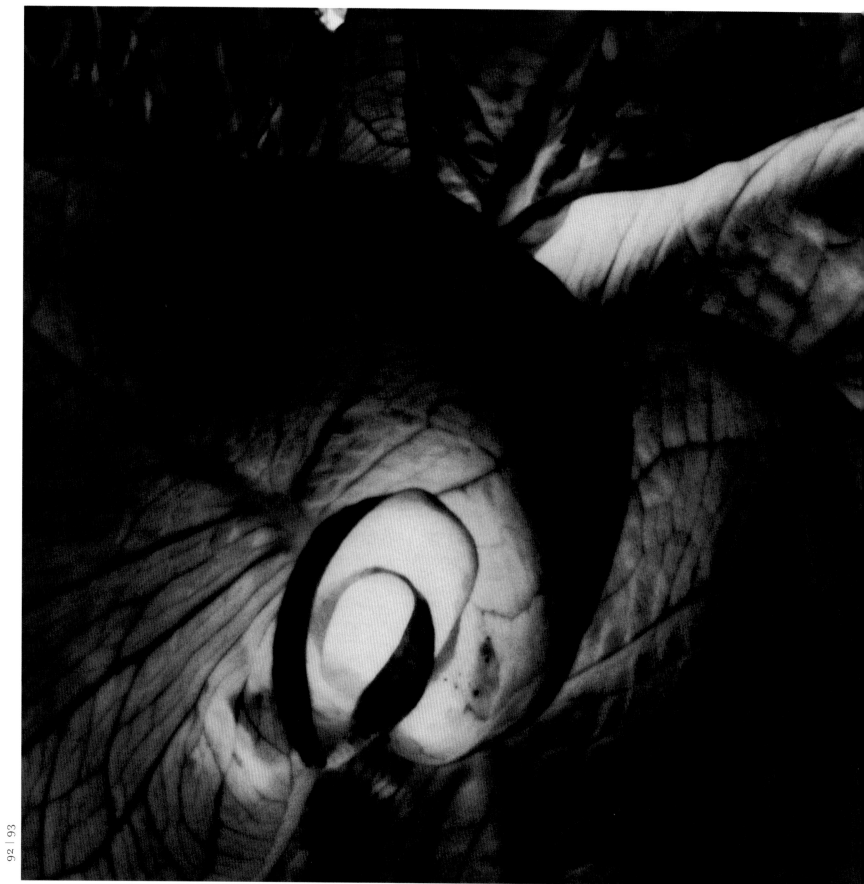

UNTERHOLZ | 1995–96 | 8 x 8"

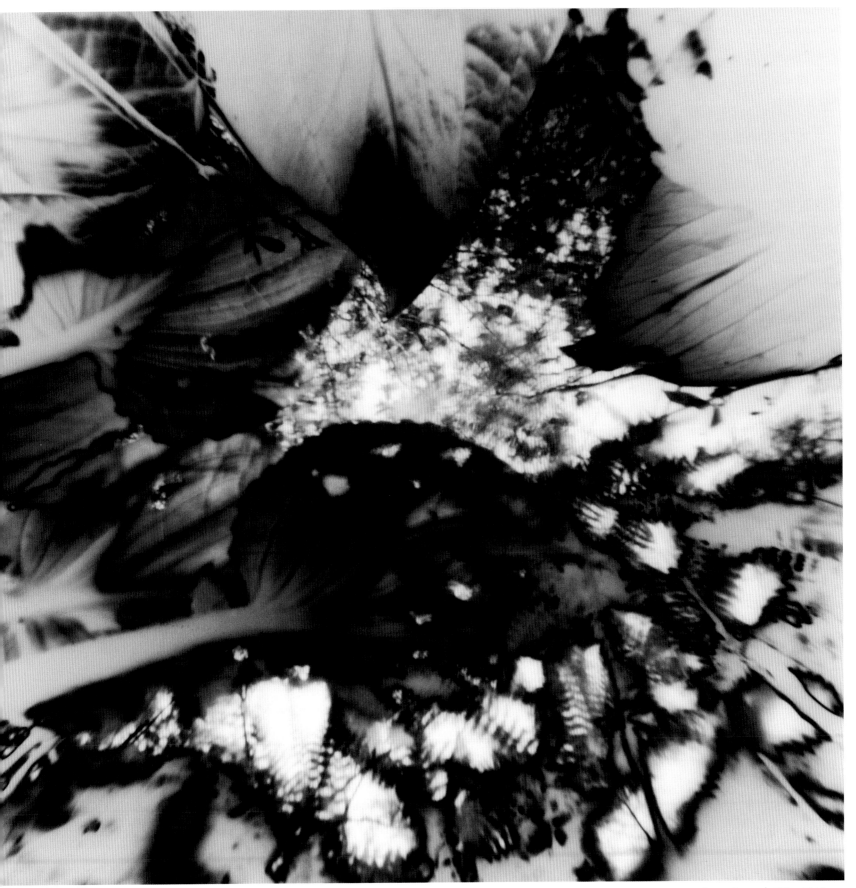

UNTERHOLZ | 1996–97 | 8¹⁄₁₆ x 8¹⁄₁₆"

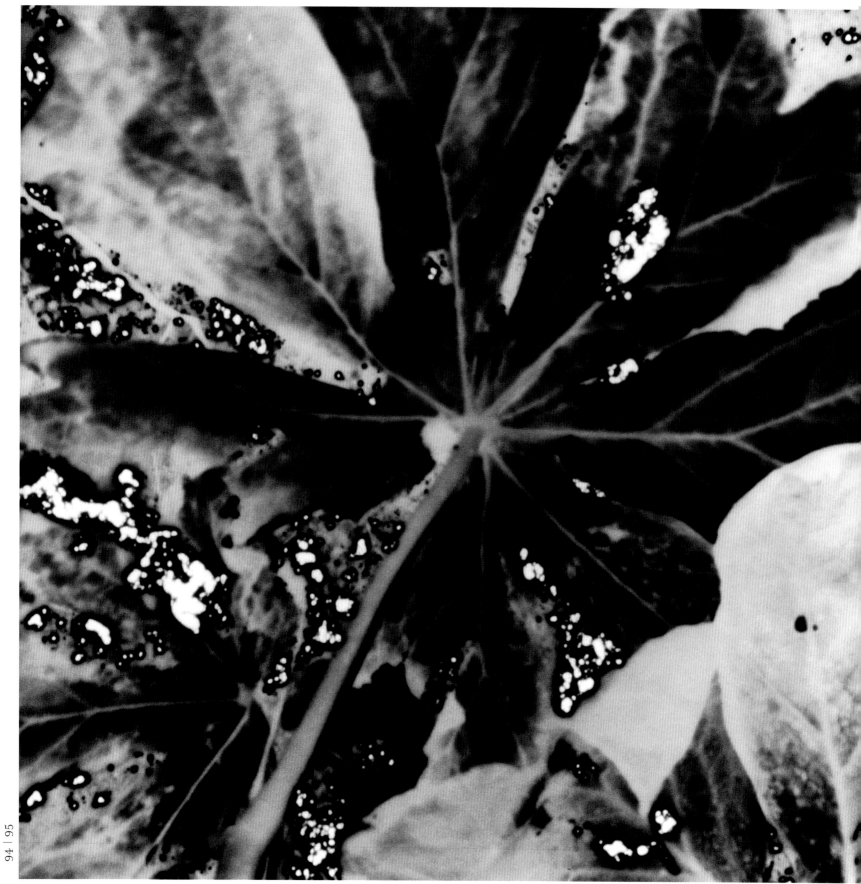

UNTERHOLZ | 1995–96 | 8 x 8"

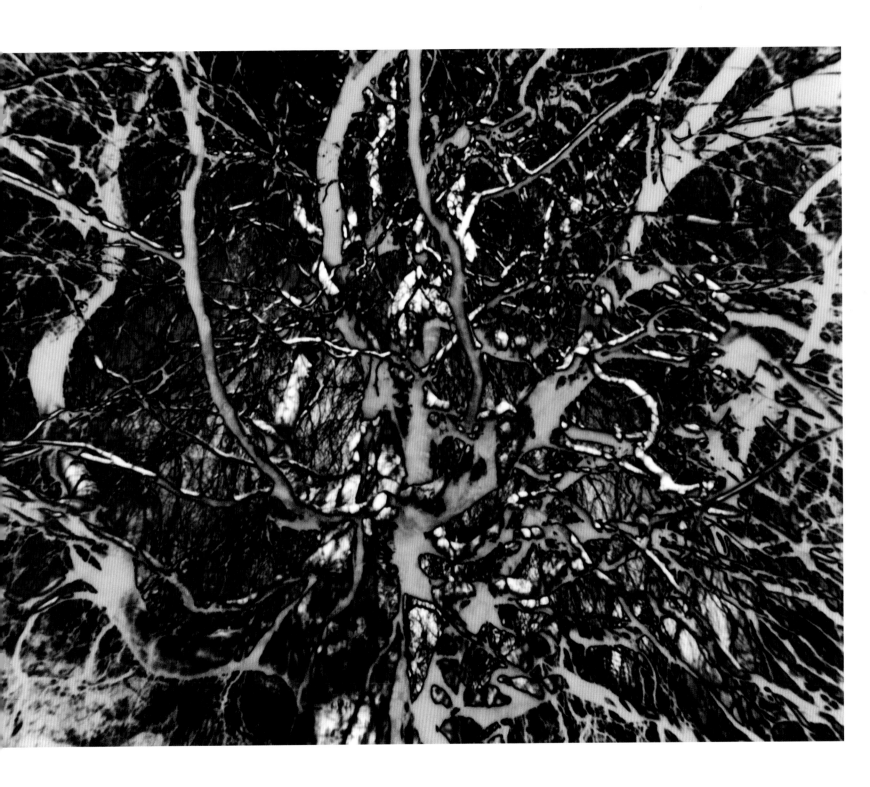

UNTERHOLZ | 1996–97 | 8⅜ x 6¹⁄₁₆"

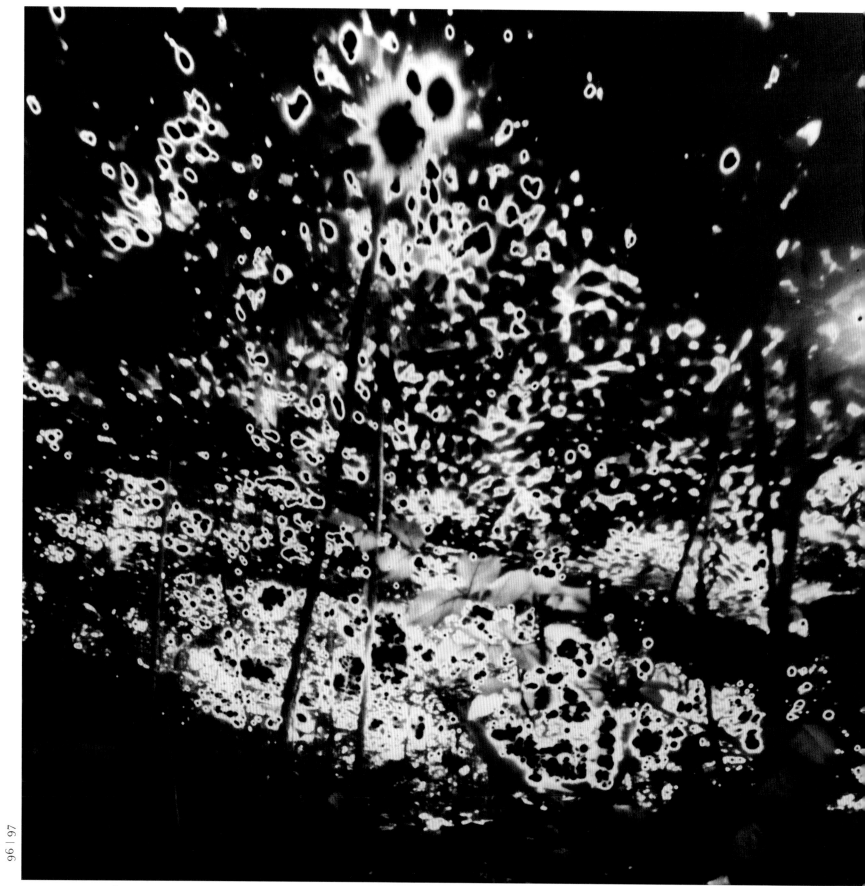

UNTERHOLZ | 1996–97 | 8 x 8"

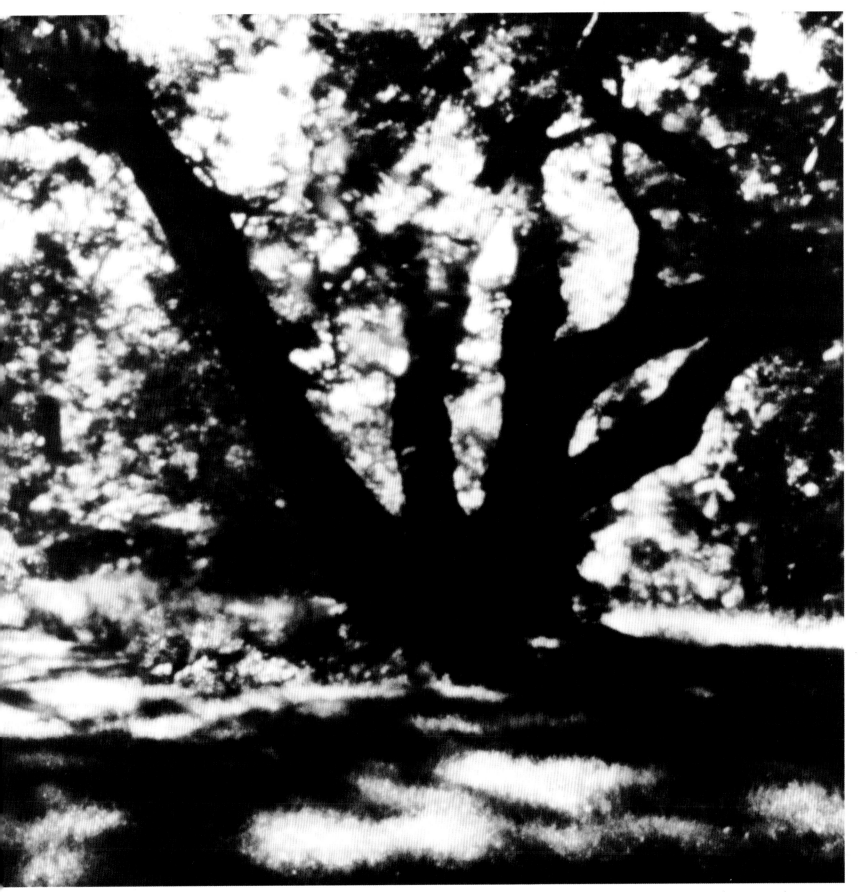

UNTERHOLZ | 1995–96 | 8 x 8"

sun and clouds

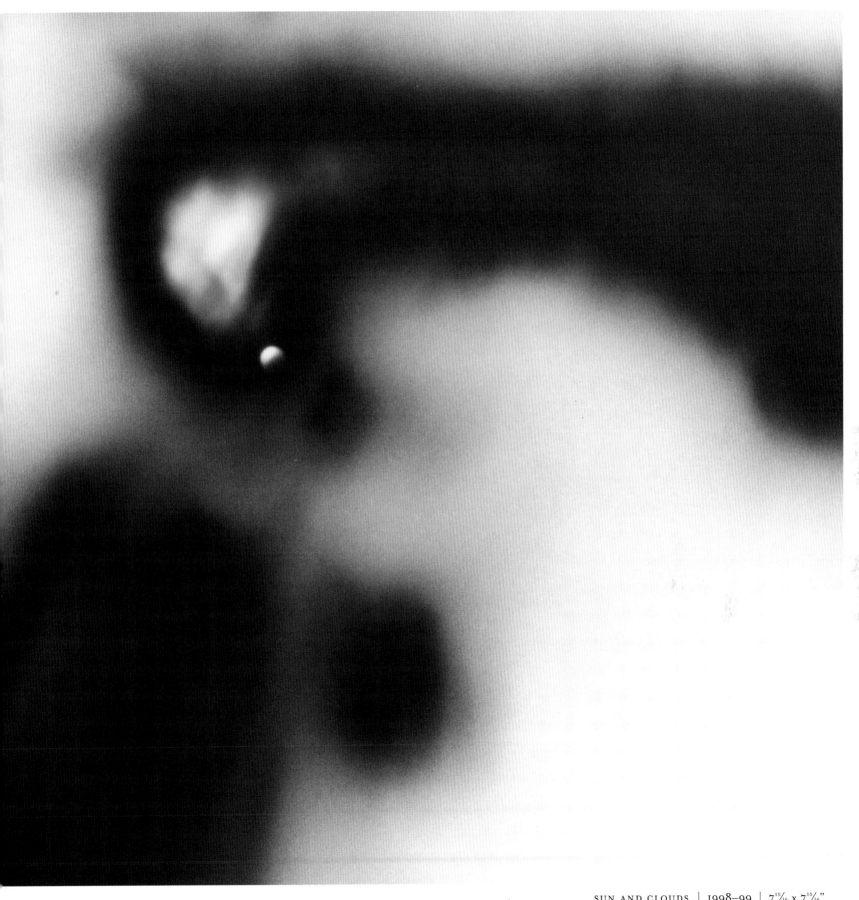

SUN AND CLOUDS | 1998–99 | 7$\frac{15}{16}$ x 7$\frac{15}{16}$"

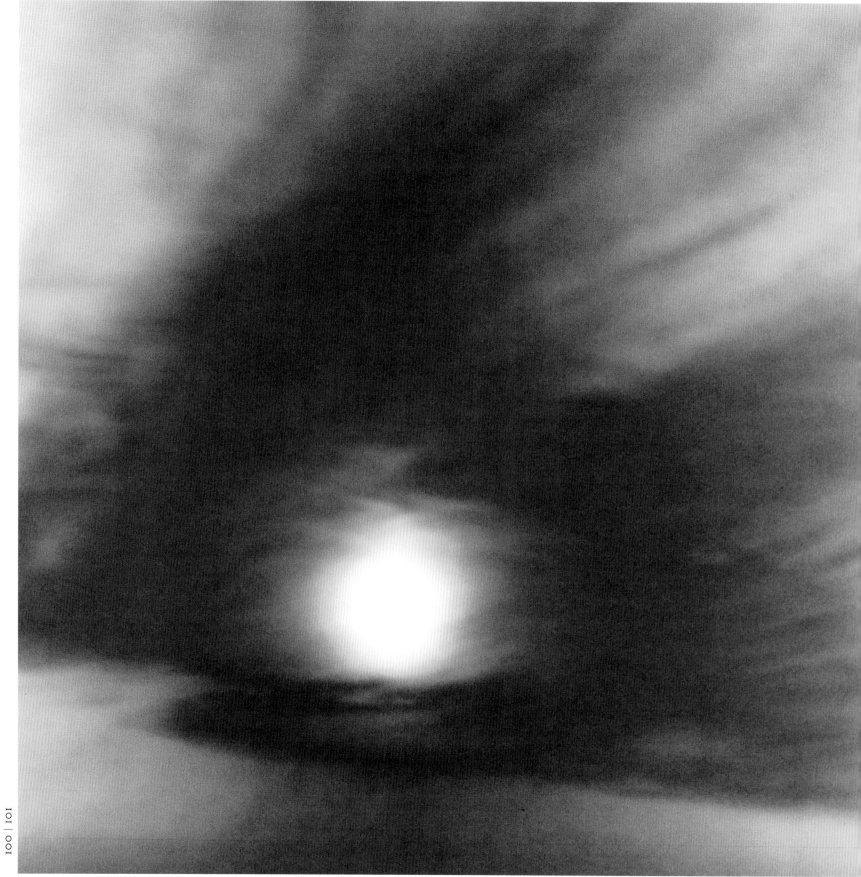

SUN AND CLOUDS | 1998–99 | 8 x 8"

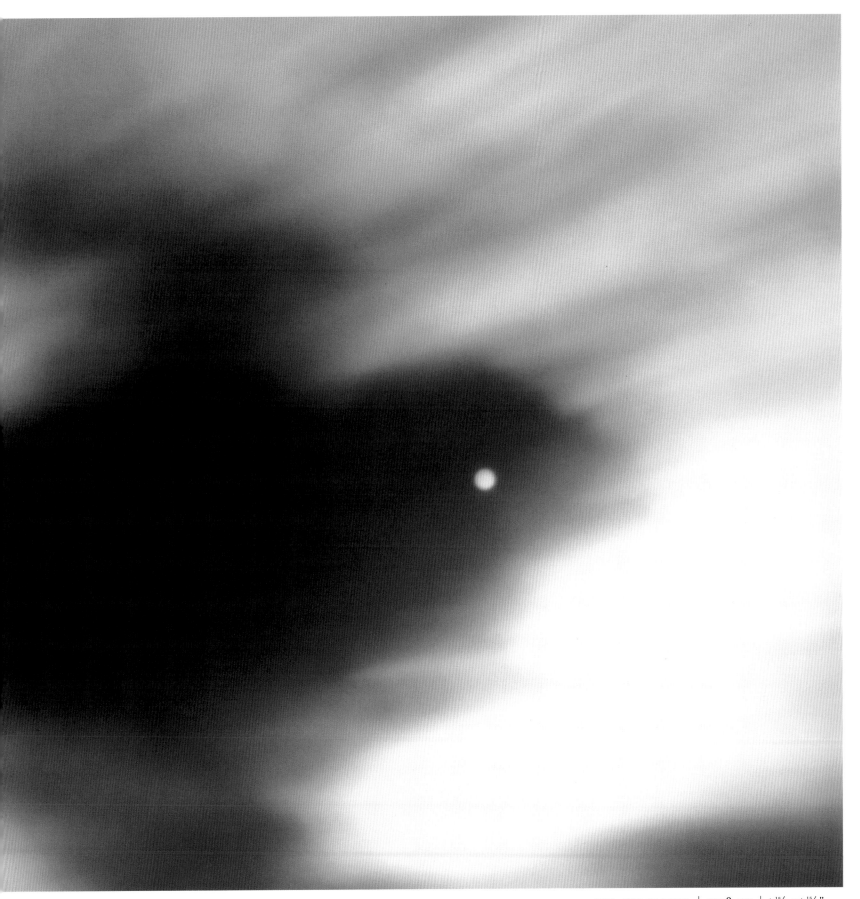

SUN AND CLOUDS | 1998–99 | 7¹⁵⁄₁₆ x 7¹⁵⁄₁₆"

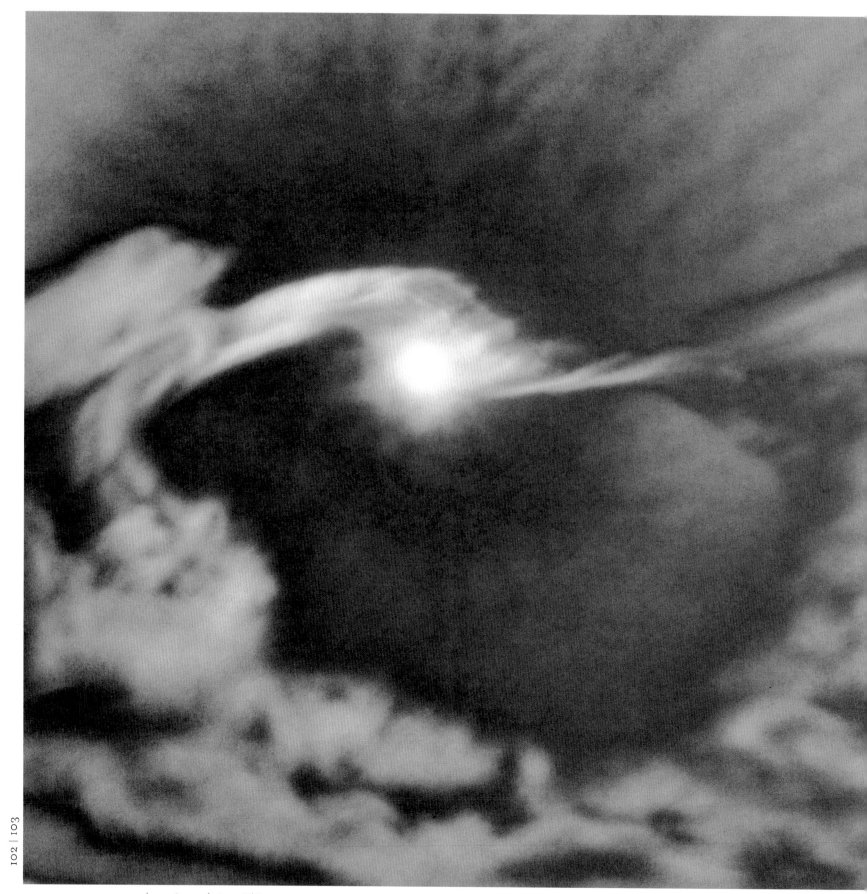

SUN AND CLOUDS | 1998–99 | 8 x 7¹⁵⁄₁₆"

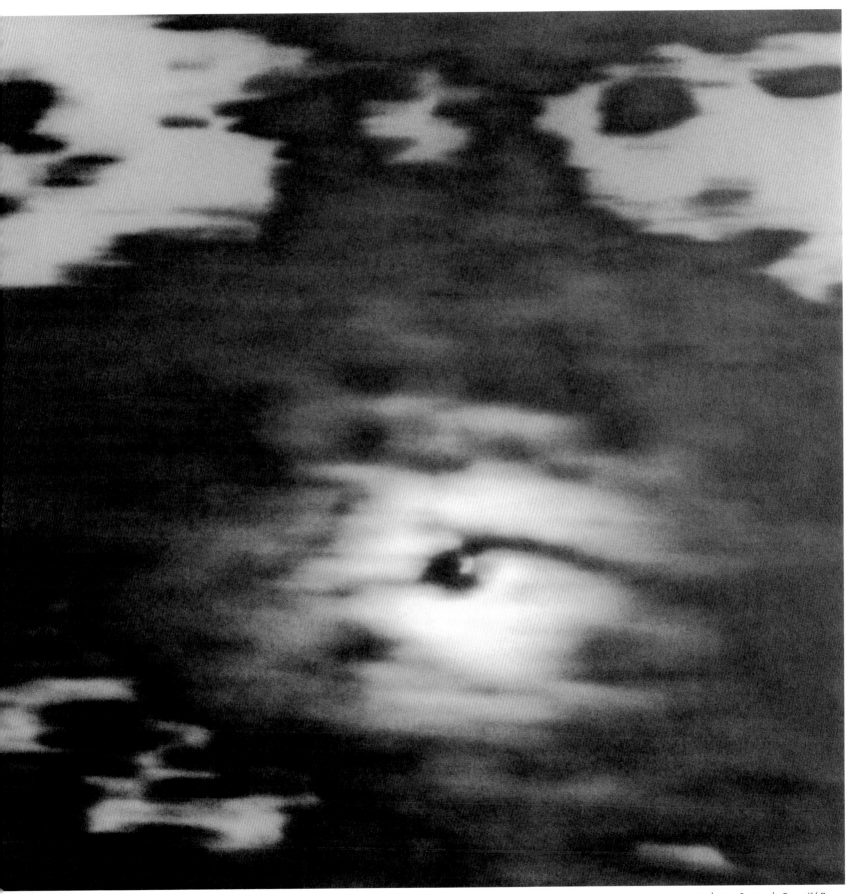

SUN AND CLOUDS | 1998–99 | 8 x 7^{15}⁄$_{16}$"

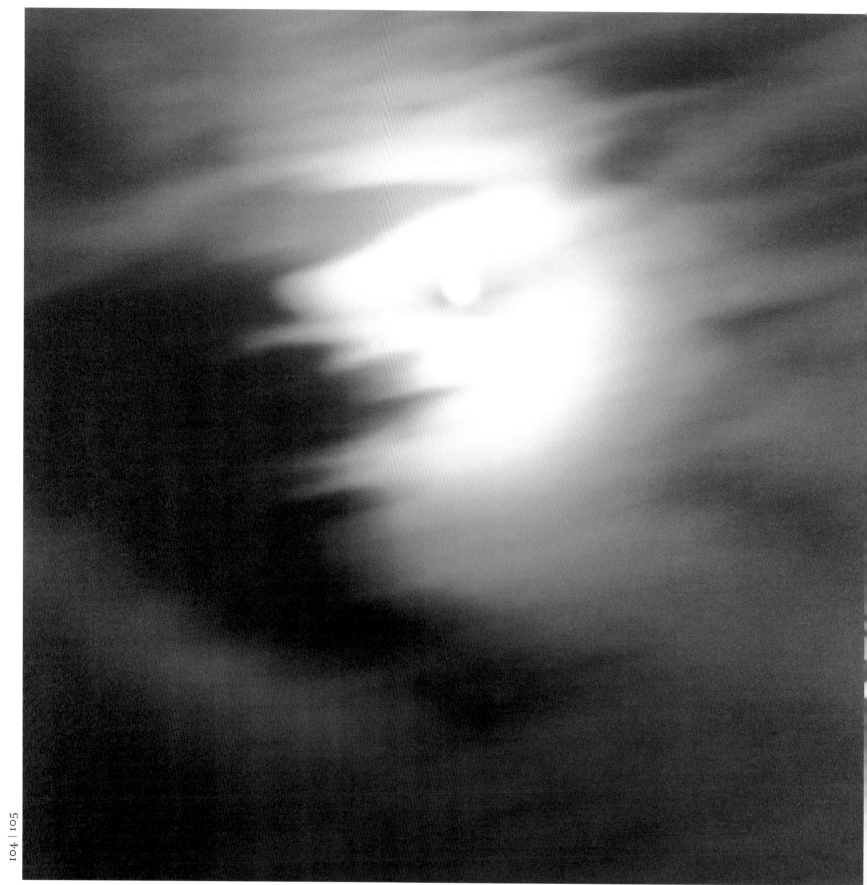

SUN AND CLOUDS | 1998–99 | 8 x 8"

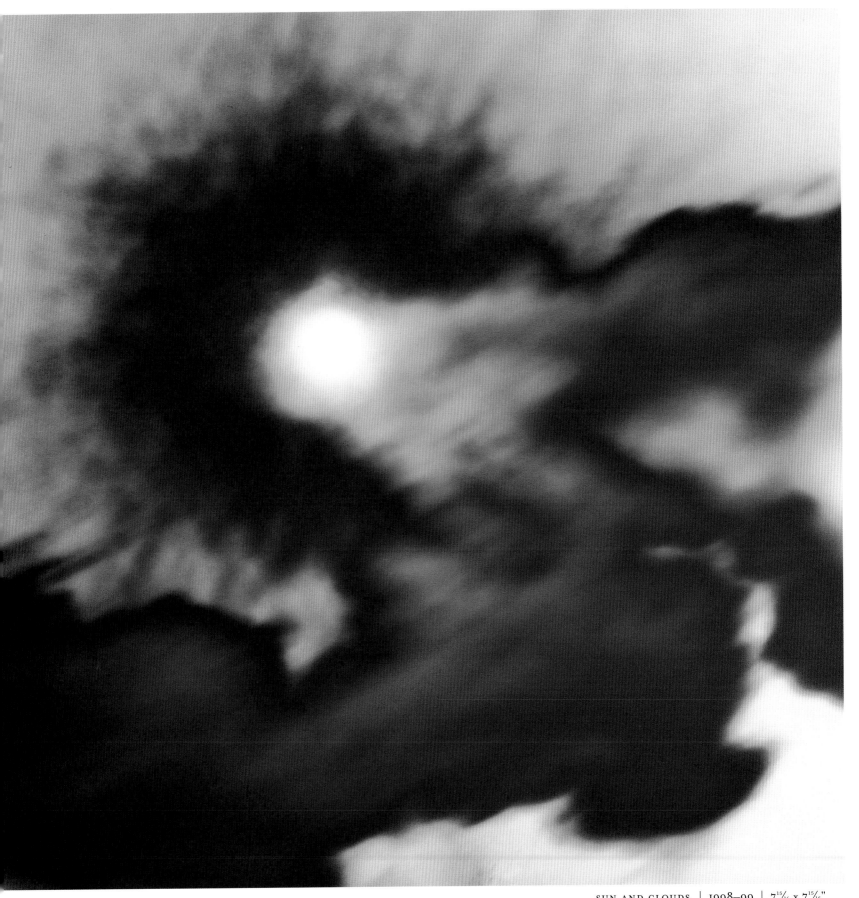

SUN AND CLOUDS | 1998–99 | 7$\frac{15}{16}$ x 7$\frac{15}{16}$"

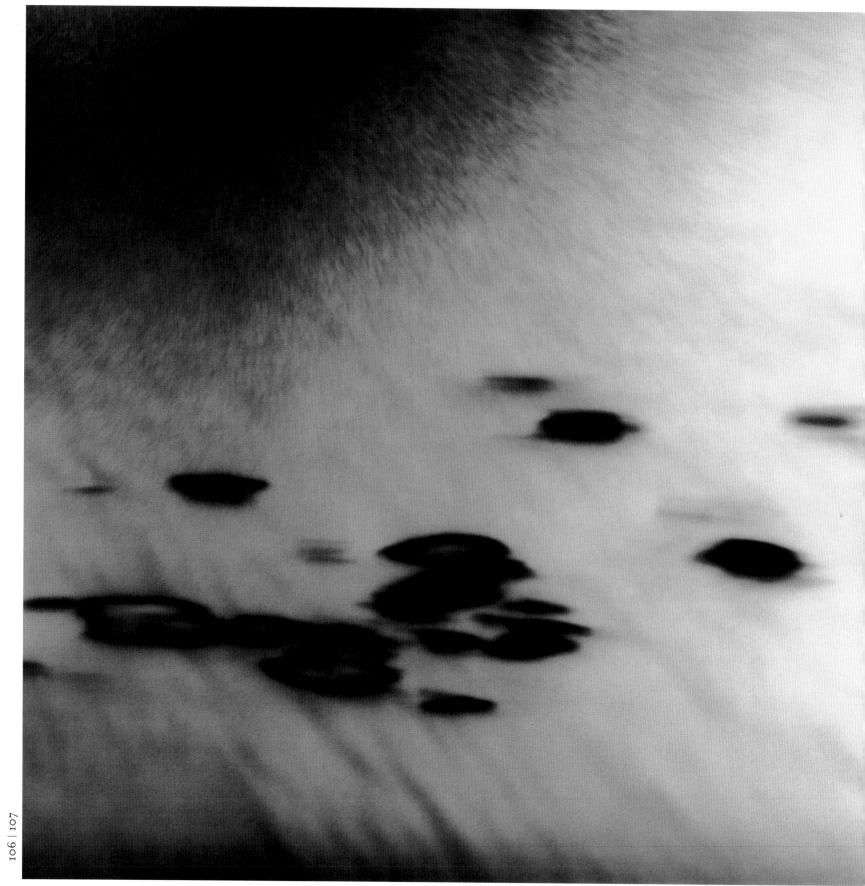

SUN AND CLOUDS | 1998–99 | $7\frac{15}{16}$ x $7\frac{15}{16}$"

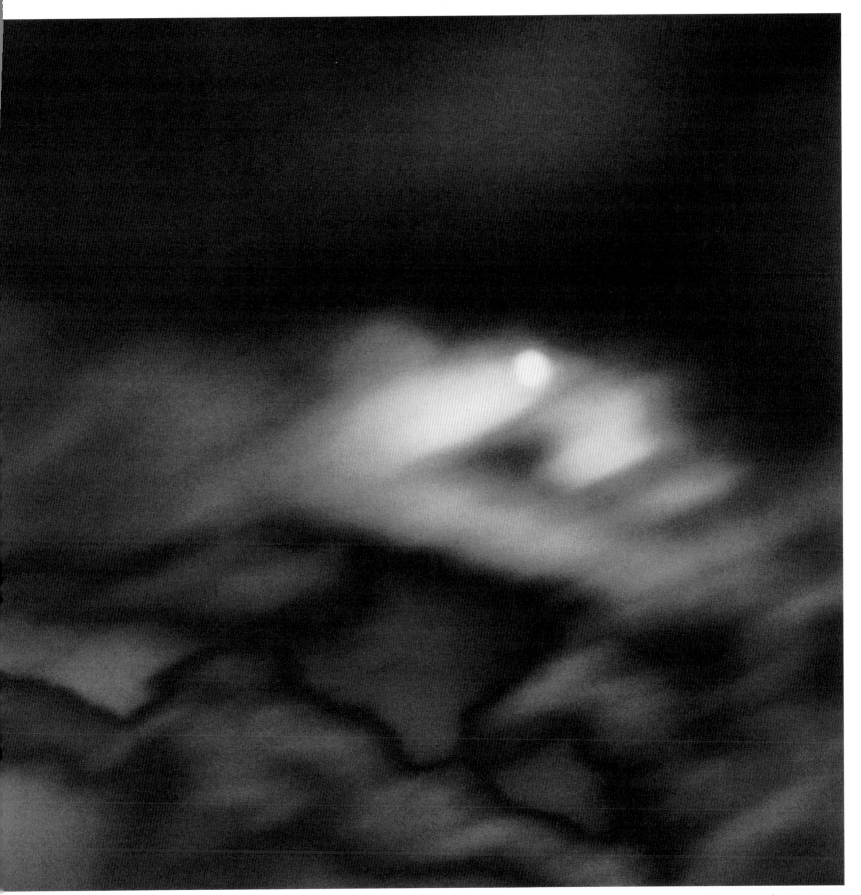

SUN AND CLOUDS | 1998–99 | 7¹⁵⁄₁₆ x 8"

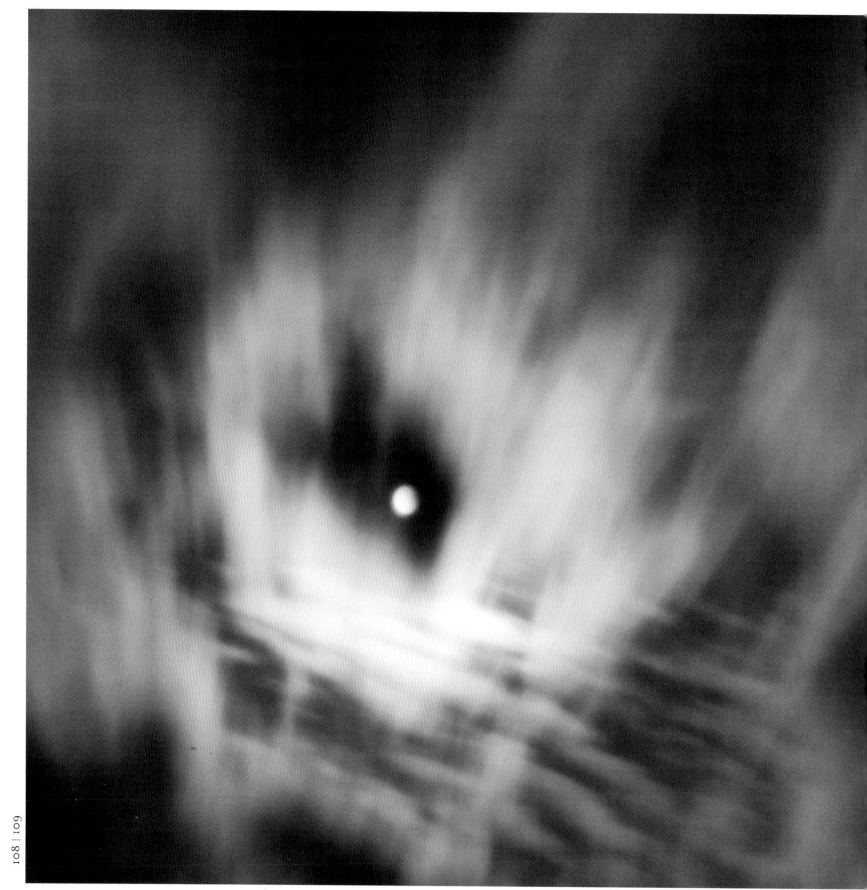

SUN AND CLOUDS | 1998–99 | 7⅞ x 7⅞"

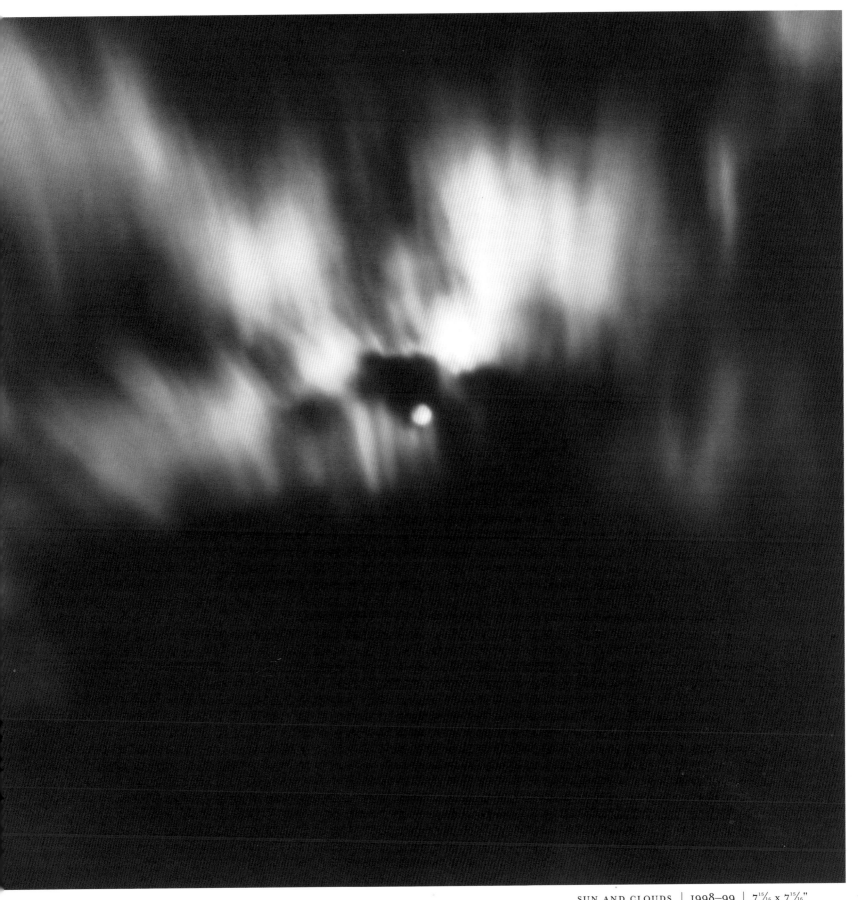

SUN AND CLOUDS | 1998–99 | 7^{15}⁄₁₆ x 7^{15}⁄₁₆"

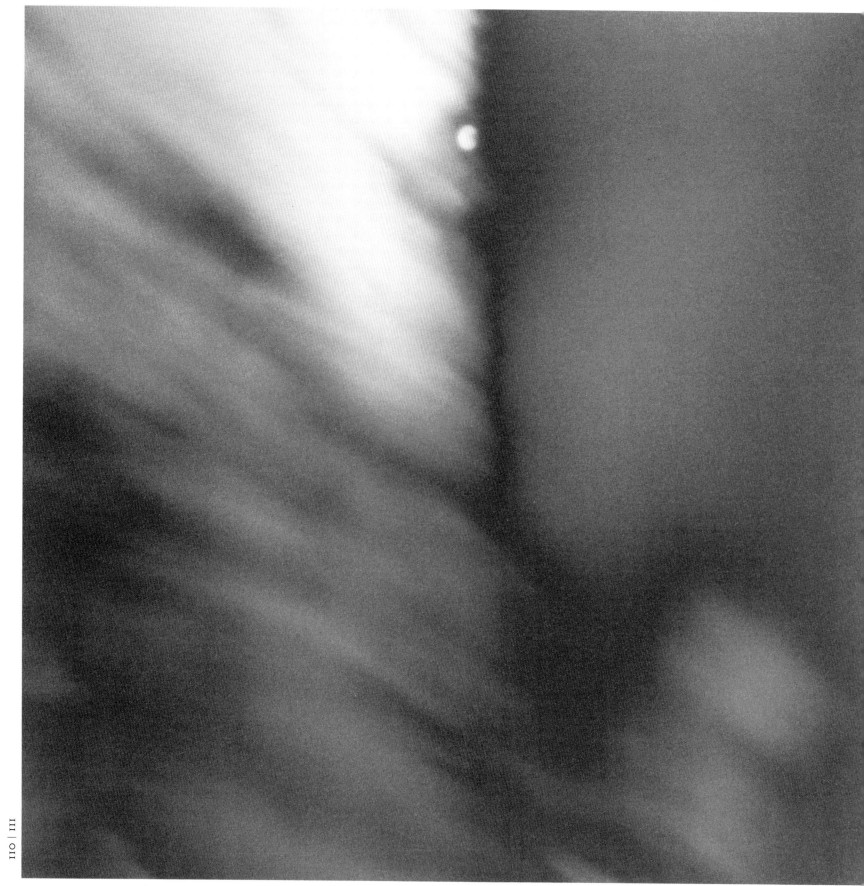

SUN AND CLOUDS | 1998–99 | 7^{15}⁄$_{16}$ x 7^{15}⁄$_{16}$"

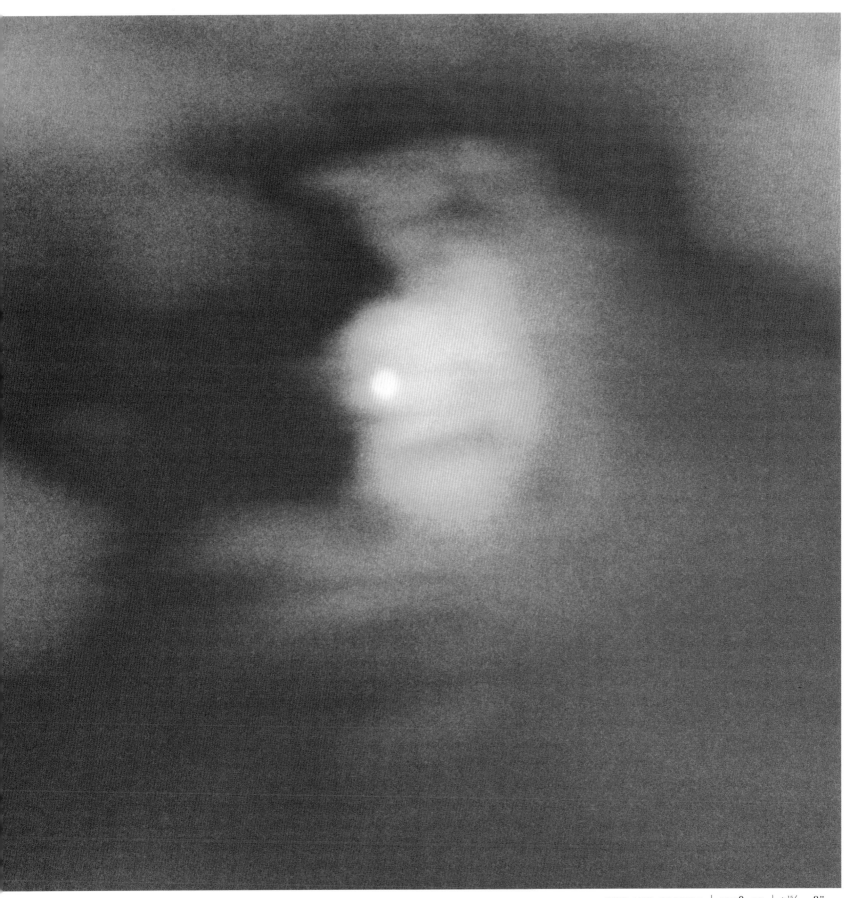

SUN AND CLOUDS | 1998–99 | 7¹⁵⁄₁₆ x 8"

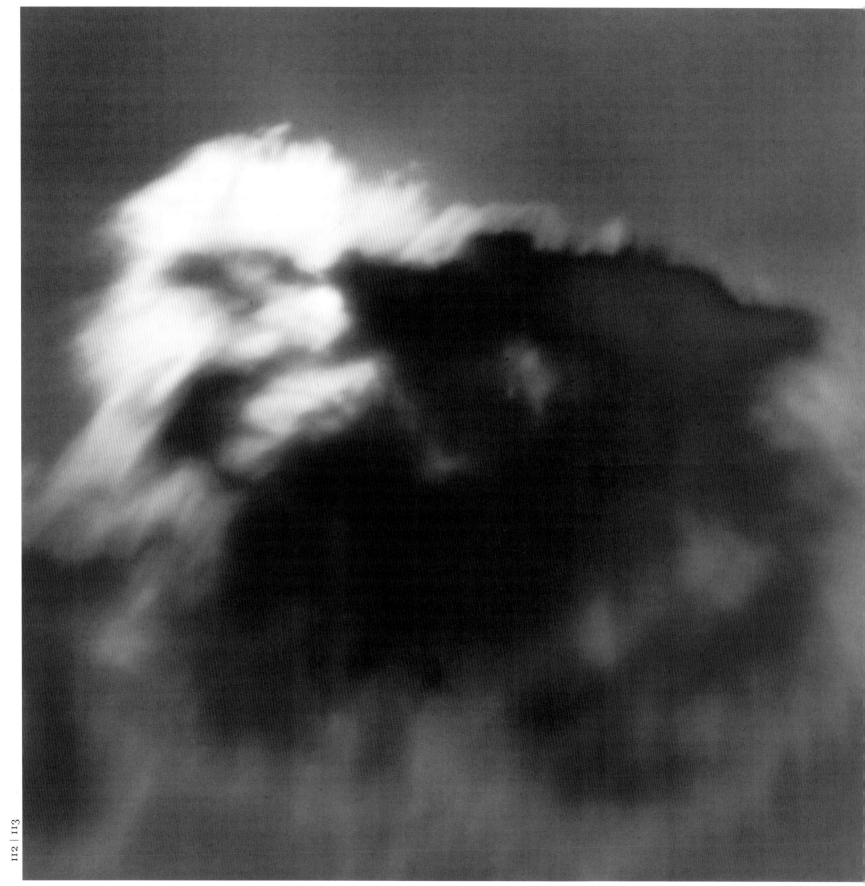

SUN AND CLOUDS | 1998–99 | 7¹⁵⁄₁₆ x 7¹⁵⁄₁₆"

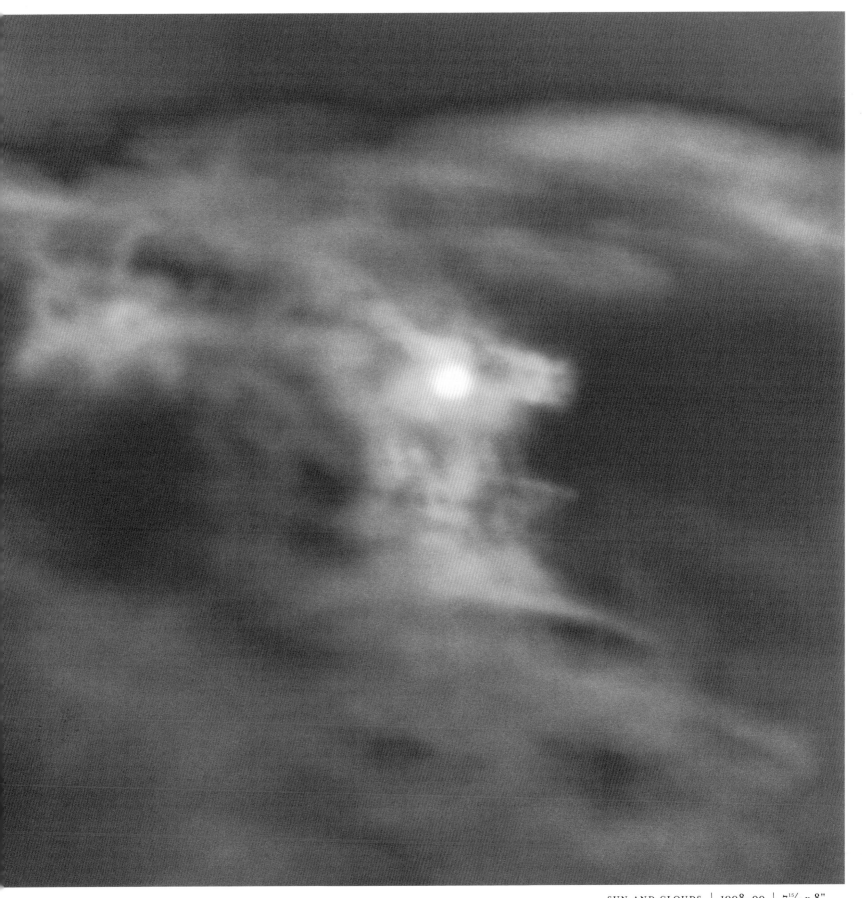

SUN AND CLOUDS | 1998–99 | 7$\frac{15}{16}$ x 8"

sky

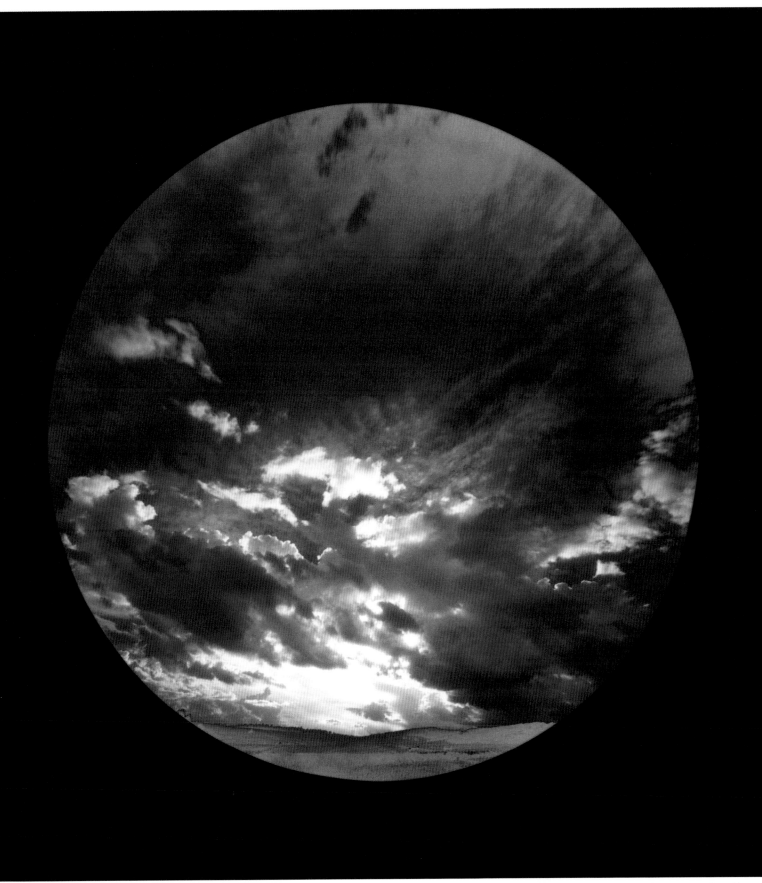

SKY | 1990–91 | 10½ x 10½"

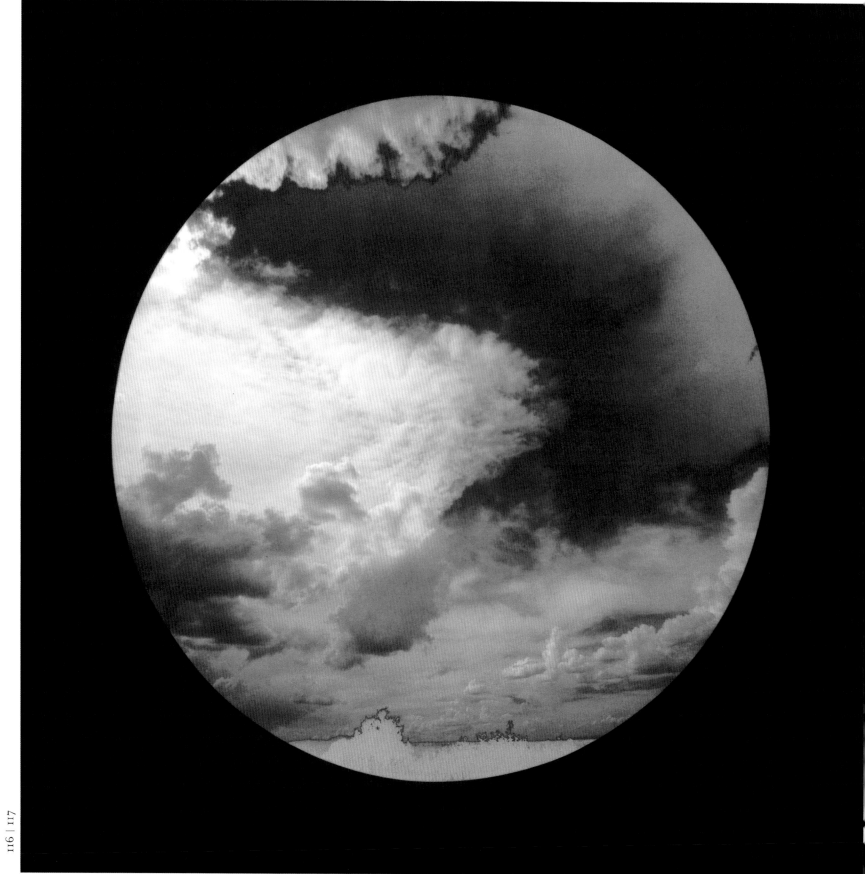

SKY | 1990–91 | 10½ x 10½"

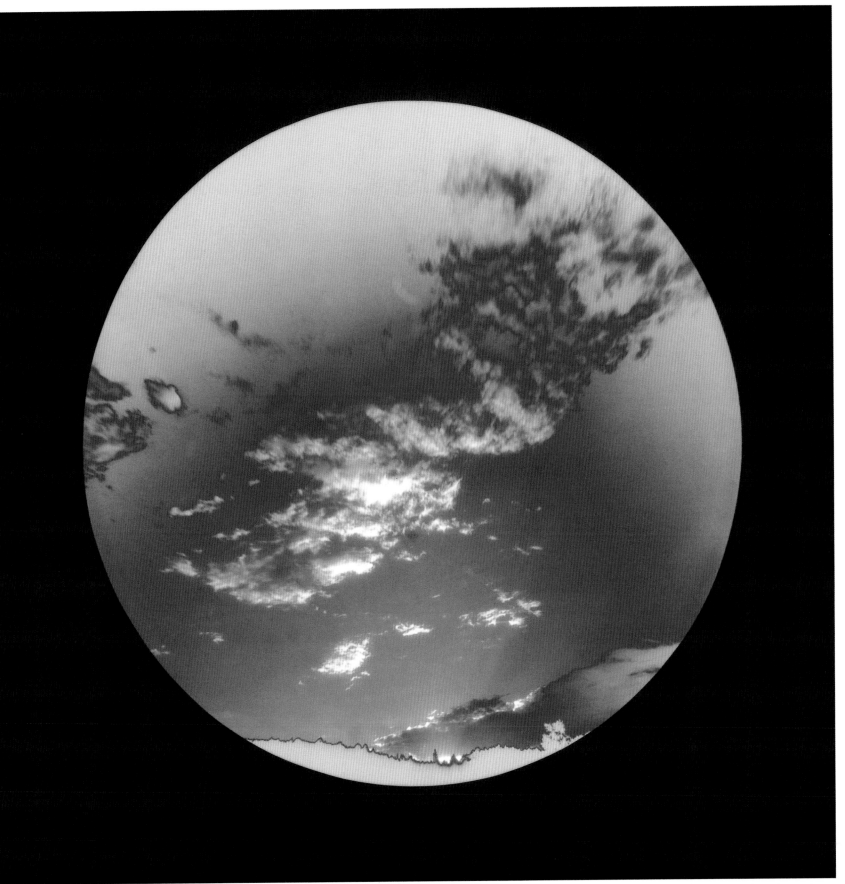

SKY | 1990–91 | 10½ x 10½"

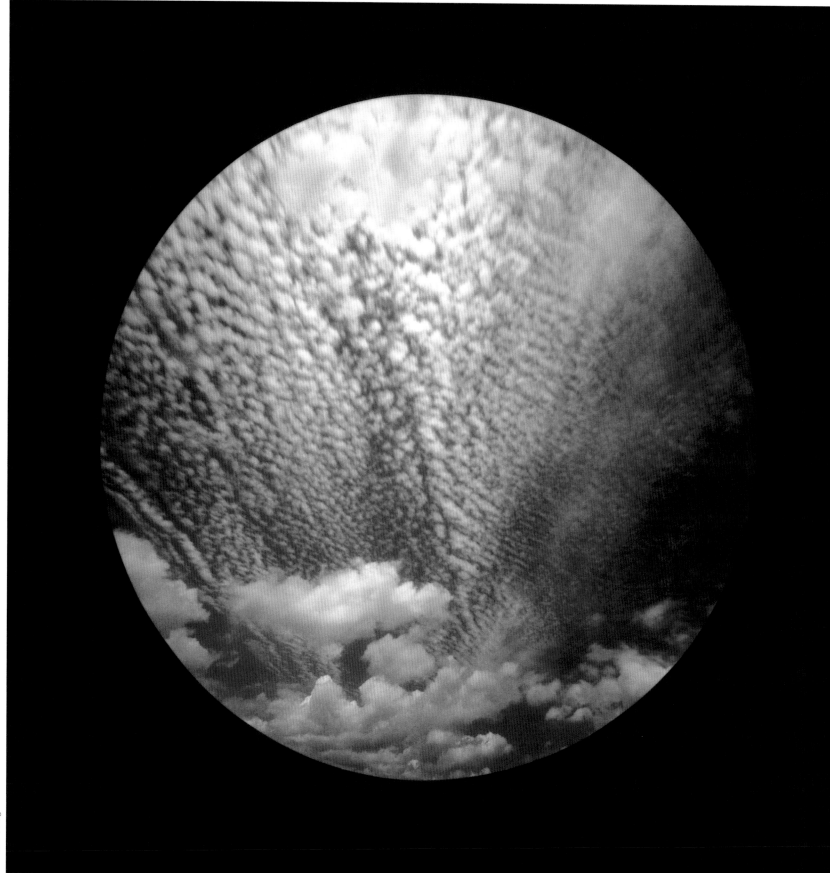

SKY | 1990–91 | 10½ x 10½"

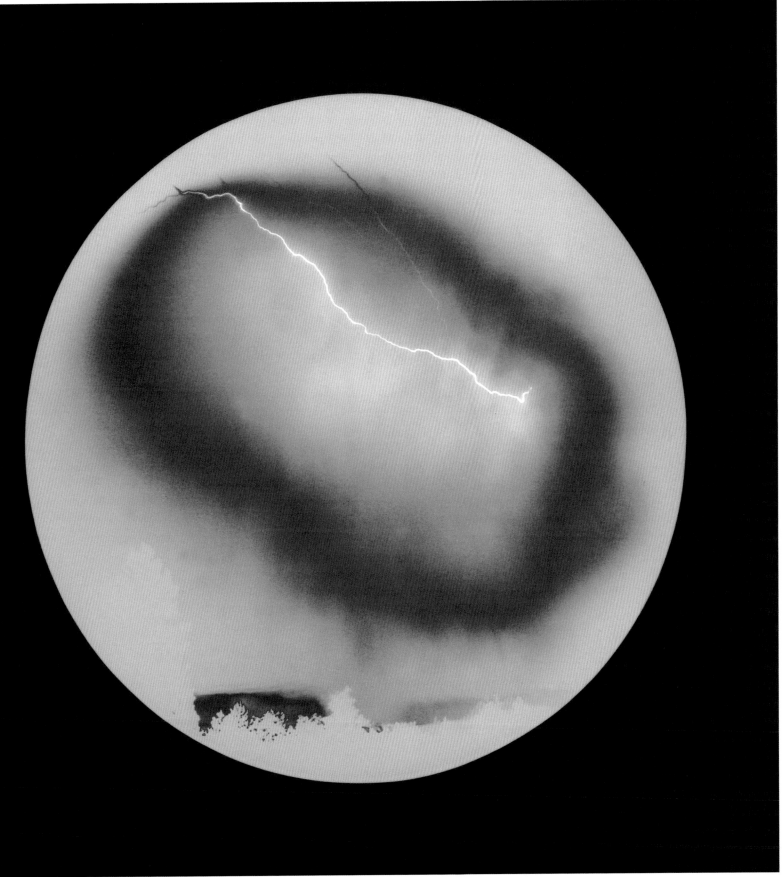

SKY | 1990–91 | 10½ x 10½"

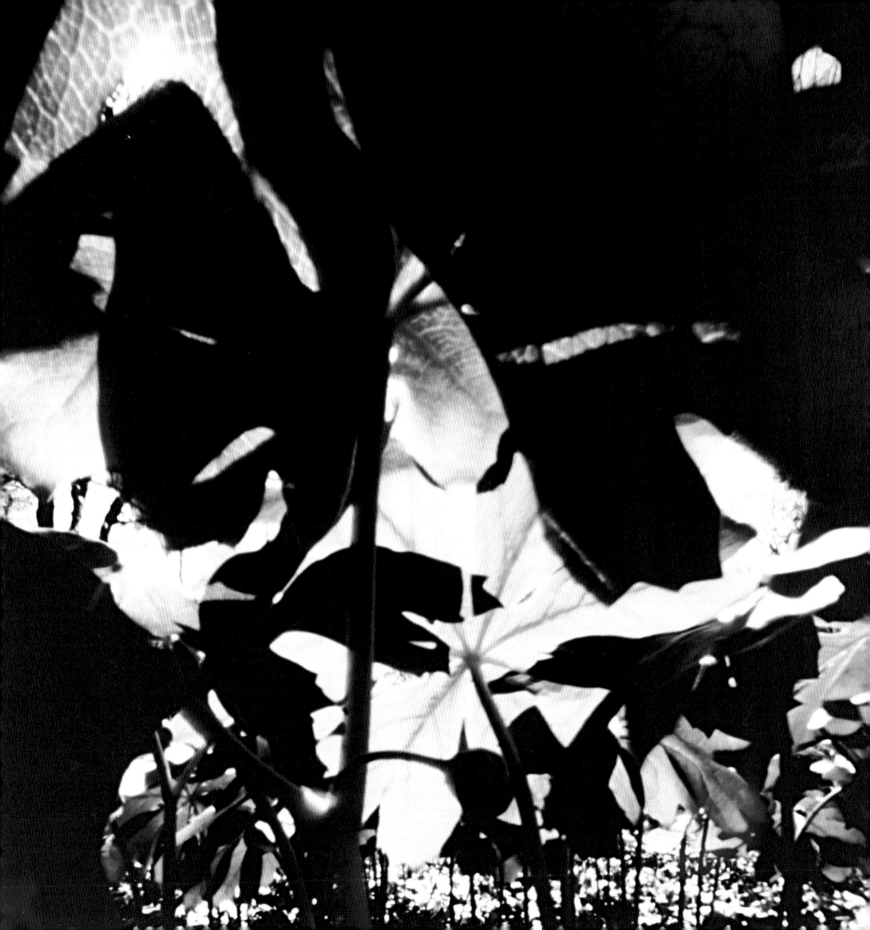

a discussion with aaron rose

(Alfred Corn) Tell me about your early life. Where were you born?

(Aaron Rose) Right here in New York City. According to my older sister, it would be in either 1939 or 1940.

And what were the circumstances?

My mother came over from Poland in the 1920s because of the persecutions there. There was a Jewish organization that would find husbands or wives for immigrants, and they paired her with a German-born Jew named Rosenzweig, my father. Their two children were my sister and myself. After my father died, my mother had some kind of mental breakdown and was hospitalized at Bellevue. I was first placed in the Brooklyn Hebrew Orphan Asylum and then in a series of foster homes here in New York. Basically, I was brought up under the auspices of the state of New York. But I was on my own as soon as I could be.

At what age?

I would say about fourteen, fifteen years old. And so I started pursuing things, and coming across life and all of its complexities. Being a foster child, an orphan mostly among strangers, is very different from being embraced by a blood family. Many foster parents in my day wanted their charges out of sight and mind. Often they were merely making a profit from the monthly allowances they were given. Consequently, I spent a good deal of time wandering freely about the city.

Wandering made an excellent education. It opened up the world in a way no child of concerned parents could ever experience. The city gave me a sense of democracy because I soon found out for myself that in people goodness or meanness were based on no ethnic factors. Not having parents, with their endless agendas for their children, left a lot of time for thinking. A foster youngster is rarely interrupted from whatever he or she is doing, so the faculty of concentration is also developed. Most important, I learned to examine objects close up: big and small ones. One of the first possessions I had as a kid was a flashlight. It was blue and gold and a brand called "Blue Star." To me, this flashlight was my first examining tool. I could focus light on a particular object, illuminate it, and look at it. I think I was given that flashlight early on, when I was four years old. I have been examining things as long as I can remember. I guess I had to, for when you're in strange homes with strangers around, you better look before you

leap or ask for anything. A foster kid learns the hard way to keep out of trouble, for he's not going to be rescued quickly from it.

You turned fourteen about 1954. What kind of city was New York to you then?

Amazing. Fucking amazing, really.

When did you take your first picture?

When I was fourteen. I was working for a photographer named Maurice Stecker, following him around and just being his assistant. He didn't pay me but he was good to me. He was a portrait photographer who used to go around to people's houses, photographing babies and the mothers. He used natural light and his photographs were very beautiful. Particularly the women, he made them look beautiful. Every one. He let me in on something; he let me see how something is done.

At that time I was attending the Manhattan Vocational High School, where a teacher named Mr. Hirschberg encouraged my photography and persuaded me to switch over to the High School of Performing Arts, which had just opened its first photographic course of study. I was the first photography student there under Mr. Salzman.

During and after high school, I worked for all kinds of photographers: photographers that just did scientific work for Bell Labs, photographers that did studio work, fashion, illustration. The whole gamut. I also played hooky to hang out in museums. You spend a couple of hours in museums, especially after you had a little smoke (which you shouldn't be doing), and you go back into that gallery, and then all of a sudden you'd rather be there than in school.

That's when I discovered the Chinese vases at the Met. That was my opening. I don't know why, but somehow when I got close to one of those vases — and I had very good vision as a kid — I could see the purity and the milkiness of that thing. You know what I mean? It was so alive, it looked like skin to me.

Even then, I could look at the craft and know there is no way you could imitate it. Later I even went around looking for imitations, so I did learn a certain amount

about porcelain. When I got into the Chinese jade, that was even more mind-boggling because by that time I already knew how hard jade was and how difficult it was to carve, and I couldn't imagine one person devoting so much time, maybe a whole lifetime, to producing one masterpiece. I saw that the great pieces weren't filled with misery, they were filled with life. And that led to a lot of things.

For example?

Well, I became a collector myself by the time I was in my early twenties. I started collecting antique tools and scientific instruments. In time, I came across a store, called Sidney Strange Antiques for Men, on 28TH Street and Lexington Avenue. In its own heyday it was quite well known. Strange sold mostly antiques that would be called "curiosities" — mechanical, scientific, and technical instruments. Things that he felt would make good gifts for men, because women were constantly looking for interesting things like old compasses and globes. Amongst them he had tools, and I was collecting tools.

We formed a great relationship. He was getting on in age, he had done all his collecting, he had a shop in New York, and it was uncanny how two people who really *should* be crossing roads, just crossed roads at the right time and the right place in life. He needed someone who was young and ready to go out and find all of this stuff for his shop. I learned a lot from him.

I started to travel. I was collecting early American tools, and as you get earlier and earlier collecting in America, you find yourself with European stuff. Europeans who traveled to America took their tools with them. So it was a natural line back to Europe, and to collect the best tools, I had to go there. During the 1960s I visited every major museum in Europe that had anything pertaining to tools. After a while I got to know where all the major fairs were, where the major collections were, where the major libraries were. I went through old illustrated books, like the six volumes of Diderot's *Encyclopedia* that have the plates, so I could learn the visual language of the forms. It's like looking at an architectural plan, it's like looking at a musical

score. If you're a good musician, after a while you can figure out what that sound is going toward. I learned to tell the difference between a Scandinavian ax and a German ax, a French ax and an English ax, and an American ax.

For almost a decade, I'd visit Europe for a few months each year. The longest trip was seven months, starting in Norway and heading south, just going through antique shops and combing the countryside and following leads that people gave me. For example, someone might say he recalled an old farmer who had a collection of tools, but it's all the way in the north, the very north of Scotland, and that's why nobody goes to see him. Well, I'd go there. I wanted to discover things and I wanted to go places away from the beaten path, but not just as a sightseer or a tourist. I had to have a reason, a purpose. And then, yeah, I did find things. Sometimes, very ordinary objects. I did get fooled a few times, but those were very valuable lessons, and those lessons were always about the same things they always are. Whenever you fool yourself, it's because of greed, you know what I mean? I was greedy, not really for money but for an object without really getting to know what it was. I thought I was getting something. A lot of times people were very happy if I replaced their old tools with new tools. I got to know a lot of people in a lot of countries who were just as eccentric as I was. Wherever I went, I was looking for something real. What do I mean by that? Probably something that was true for its time.

So the object has the dimension of time in it, intrinsically?
Yeah. When you're looking at art that's twelve hundred or a thousand years old and you kind of can understand something about it, it makes it easier to get a certain sense of context. I needed that perspective to see what my own time was.

You were a commercial photographer then, too?
Yeah, in the early sixties. I was quite successful at it. By the time I was in my early twenties I had a nice studio of my own. I thought there was a way that you could compromise and do something for a commercial reason, a

normal, healthy, good, supporting and commercial reason. That you could apply that craft and take it as far as you wanted for your own purposes. There were conflicts about that, though, and I came to the conclusion that I had to give it up to do my own work. It was difficult, because my little short-lived commercial career did very well for me. Although, ironically, it was the collecting that ultimately gave me the independent means to pursue my own vision in photography.

I was going to beautiful locations, fancy hotels, pretty girls all around. Models from New York, account executives, I was part of a whole scene, I was part of a big wheel. And I got there, and that's the number that did me in. I would be in some amazing place, and here I was, photographing some make-believe, trite subject. I was angry with myself. I wasn't looking for that. I didn't want to satisfy that part of me. All this effort to go for something that was not substantive enough for me to care about. So I had to find another way to be a photographer and practice my art. To the outside world it looked like the photographer's dream job. And a lot of my friends who were photographers and art directors got pissed off at me when they saw I was quitting. They thought I was — like, who the fuck are you? They were angry, almost, really.

Your involvement in photography took a different direction?
Well, in 1965 there was a large auction of daguerreotypes at Parke Bernet. It was the first important photographic auction in America, and there were at that auction several thousand photographs, mostly daguerreotypes and ambrotypes. From that time on photographic auctions became more and more and more successful. I was at that first auction, and I bought six hundred beautiful daguerreotypes. I still have remnants of that collection. And even the remnants are very beautiful. Maybe I have two hundred left. It started me thinking about photography as a nineteenth-century science.

So your study of photography moved on two parallel tracks: one with photography as history and technology, and the other with photography as art.

Yes. I would say as an art and a science.

Talk about your sense of photography as an art. How does that develop? What photographs, what photographers interested you early on?

Definitely Weston. I saw his photographs in a show at the Museum of Modern Art in the late fifties. There was a certain purity about his vision that I just found very appealing. And then Stieglitz always got to me. His prints were so beautiful. But the people that caught my eye the most intensely were the early pioneers of photography. Why? Because there was something about that imagery that depended more upon light and chemistry. Starting with Daguerre and Fox Talbot, they had the idea, the ultimate idea, that I was looking for: to be able to see the light, to put it down. To me, those early attempts were very truthful. Like the tools I collected, they took me back in time. I could be in that village, I could see that Paris street. That time thing was real. Even though it's very innocent and has nothing to do with aesthetics to begin with, that can be the art itself.

The art of photography developed hand in glove with the technology of the moment.

Exactly. When the 35mm camera came out, it allowed a whole new vision. That's what Walter Benjamin knows how to make you aware of: that someone created the form, but the form came from a process. Getting to know different processes was important to me. Why? Because then, if I could find my own thing, it was only because I had first found my own process. I experimented a lot with different cameras from the past. It turned out that the cameras didn't make that much difference, but the optics did.

Learning optics was very revealing. We think optics is an objective science, but it's not necessarily so. What was considered optically beautiful and perfect in, let's say, the latter part of the nineteenth century, was passé by the time the 1930s and forties came around. Standards change and optics had many different standards. And within these different ideas about good and bad optics, I saw a whole world of interpretation.

What was the change in standards as far as optics go?

The earlier lenses were definitely designed to make people look beautiful, and they did. They didn't permit the lenses to show as much contrast as contemporary lenses. They were deliberately made soft. They had certain kinds of distortions that would enhance a face. Most lenses today are designed to be correct over a flat field, but these lenses were deliberately rounded in such a way that they gave you the roundness of the face more. The person making that lens was putting his own interpretation into how the results should look in the same way that an instrument maker, a musical-instrument maker, would put his own idea of how an instrument should sound. So that itself has very nice subtleties to it.

So you have used the older lenses.

Yes. And I always get something nice. I use contemporary lenses too, for example, when I do my night pictures. I took a lens that was strictly designed for 35mm use and built it into a 4 x 5" camera to photograph the Milky Way. The camera gives you a view of a large section of the nighttime sky, taking in much more of an area than a telescope would see. For the most part in the last number of years I haven't been using lenses at all. Most of my images are light and chemistry.

Do you mean, something like Man Ray's Ray-o-graph?

No. I don't use lenses, I use small apertures, pinholes. Sometimes I combine pinholes with very simple types of lenses. But I really don't rely on lenses to get pictures.

Why did you give them up?

As beautiful as they were, there was nothing nicer than not having an object interfering with the rays of light. It gives me pleasure to think that every day, the sun is creating millions of natural photographs the same way that I do.

I also like the idea of using time to take pictures. So many commercial studios use fast cameras, but I don't see life in a twenty-fifth of a second, or fiftieth or sixtieth of a second. I don't contemplate things that way. I like to look at things and observe things. And so a pinhole allows me to do that. My exposures are anywhere between a minute and several days. A lot of those views of New York are done with a pinhole.

Long exposures?

Yeah. But it's nice, because that time actually had another effect. You're looking at something and you begin to observe things over a period of time – five minutes, ten minutes, fifteen minutes, thirty minutes, an hour. It's amazing, the things that change. The light is changing constantly. You have to be in focus if you want to observe these things. But if you can, you can actually see how the light is going around everything. And it's quite phenomenal.

I don't see things like a conventional camera does. I don't see in a tenth or fiftieth of a second. And light over a period of time is totally different, I can tell you. And more than that, it's an experience. It's *the* experience.

A meditative experience?

Contemplative. It's quite an extraordinary place to be, let me tell you that. Because now you're not just visiting, you're not just clicking away at something, you're not blindly passing through things: you have to become part of that scene. And that's what happens. Just by simple observation you can become aware of many other things; other senses become involved. And in some incredible way that goes into the picture. All that becomes part of the picture.

Since there are always two steps in photography, I wondered how that binary nature of photography figured in your thinking about the process.

I'm very much in tune with it and in control of it. I like to start with a negative because the negative gives me latitude. It gives the ability to observe a thing, to study it, but if I had to take exactly what I got at that moment, I would feel very restricted. In a way, the negative is like getting all the raw elements to cook up the final image. When I get my initial exposure on that negative, I have a very good sense of how much light hits it and how much density there's going to be. And then I figure, "How much do I want to cook this piece for?" In the darkroom, I have to be ready at very short notice to make a decision on when to stop a process or when to reverse it.

Actually, my images are neither positives nor nega-

tives. They go in between. They vary according to how I want to use the space. I use a technique I call "controlled solarization," which causes areas of a certain density in the negative or print to be "reversed," so in the negative they become positive and vice versa in the print. Solarization is evident in photographs going back to the beginning of photography, and was looked at as a defect that had to be rectified by the photographic supply companies. But it has always appealed to artists. Degas, for example, used it in his photographs to achieve something like the effect of limelight in the theater. In the 1920s and thirties, photographers, notably Man Ray, started experimenting with it.

The assumption in black-and-white photography has always been that deeper blacks and whiter whites are better. When the technique of photomechanical printing emerged, prints with greater contrast were preferable because they retained a graphic quality when printed in ink. Photographs needed to be as "legible" as type lest they fail as visual language. Photographers had to be conscious of this requirement or their work would be unreproducible. That's no longer such a concern now that printing technology has improved, and by introducing solarization, I was able to bring a sense of balance to the work. I'm always looking for a balance, but I don't know quite what that is going to look like. That is the mystery.

You've talked about light. What about chemistry?

Again, I wanted to find my own way of making a photograph. I had a pretty good knowledge of photographic techniques from an historical perspective, but in order for me to get my own language, I had to reinvent the process for myself. I spent years experimenting with photographic papers and films, and I quickly realized that I couldn't match the quality and consistency of these commercial products with materials I made for myself. When I was first starting out in the field, I had little money and got into the habit of pruchasing outdated photographic paper. I soon discovered that the older the paper, the friendlier it was to the subtle shade of gray that appeared in a negative. The blacks would

not be so overpowering. Since that long-ago realization, I always "aged" my papers, buying batches I liked and storing them under the proper conditions for years. But I did learn that I could use my own chemistry to control the prints in other ways, so that in the end I wasn't using commercially available black-and-white or color techniques. Metals in solution combine with the silver in the emulsion to produce as many colors and tones as there are in the spectrum. I tried iron, mercury, gold, tin, nickel, vanadium, cobalt, uranium, and a good number of the other metallic elements in the Periodic Table.

You could compare it to alchemy.

You could, especially when I'm making my prints. But the essence of every art form should be simplicity. It should become easier and easier. Eventually, I realized that in order to simplify the process, I would have to limit myself to fewer metals — gold, iron, mercury, tin — that I mostly use today. I feel like I can actually see gold and silver coming together and that I can control it.

It connects you with the basic structure of the matter.

Right. And I'm doing it with light and chemistry. That is the part that I love most about it.

Of the two processes, of getting your negative and then processing it, in which do you feel more in control?

Both, equally. Even the exposure, the original exposure. It doesn't mean that I get everything I'm looking for all the time. But I don't really ever have a bad day, I'll be honest with you. Maybe sometimes I go too far with the chemistry or some contamination happens, but very rarely do I waste a day. And even when I'm out shooting I never come back and say I don't have anything. I don't bother shooting unless I'm ready to work.

What does being ready to work entail?

A good night's sleep. I need that. You get a certain kind of impudence from something that you do the day before that makes you go on the next time. It's your own work, believe it or not, that becomes your impetus. You could spend the rest of your life doing that thing. It will take you to a lot of places if you trust it — if you don't have any ulterior motive. If you don't have any other

reason, except the simple love and joy of doing something, everything will come to you.

You began taking photographs as an art in the sixties, but you didn't seek to make a career out of being an art photographer.

Yes, I always sought to be an art photographer.

But to make a career out of it.

I did, but I had no idea how that was going to happen. I never expected it to be a means of income because it wasn't a time where photography was seen in its proper perspective. I guess it was still new to a lot of people, and the world of academia was locked into some old ideas of what art was to begin with. So photography was excluded.

Did you seek to show your pictures, your art pictures?

No. I really tried to avoid it. For a long time.

For what reason?

Well, I just felt it would be a distraction for me. To go through all the effort and spend the time arranging for some kind of a show. I didn't really want that thing to have an effect on the continuity that I was trying for in my own art. I was looking for continuity, getting up every day and always having something ahead of me, not always doing something for a show. I want my life to be a continuation. All my life I lived in areas where there were artists, I lived with artists all my life. I saw how many shattered lives there were because of their expectations. To look for those kind of expectations to me was kind of masochistic, to be honest with you. What's important to me is the possibility of my own work. When you're tired at the end of the day from doing your work, but then you hang it up and it really hits you that you did that image, there is nothing like it. No one can pat you on the back as much as when you can say to yourself, "Wow, I'm glad I did that." And then that happens every single day of your life. It goes on and on and on. That kind of reward nobody sees on the outside, but here you are in your own world, and from everything that you do you get some kind of nourishment. It makes you feel good. When I'm on to something, I don't need a clock to get me up in the morning. It's work that gets me up in the morning.

You must have shown your work to friends.

Over the years, yes, a lot of people have seen my work and a lot of institutions as well. People knew about me or heard about me or recommended me. These were people from the gallery world to collectors to museums to publishers. I was never unreceptive, it never bothered me to have the work shown. But I didn't want to get distracted. And right now, if nothing else happens, my work has its own cause, it has an energy of its own, it's there. And I loved doing it, so I came out ahead. All the other stuff, all the experience that led me to my work, what the hell, that's really insignificant, honestly and truthfully. I'm not saying that stuff isn't really important, but it's not really in my own vocabulary. Anything that gets me out of focus, it's harmful for me.

I didn't want my art to be dependent upon what everybody else was saying. It was important for me to find myself even if it meant working alone, but that loneliness is not a bad trip because you get to like it, and you're a writer so you know something about that, I'm sure. I guess in some ways I didn't even need an audience, I needed seclusion. Let's say the stuff that I learned in photography does combine the history of early photography with something very contemporary. Some people had difficulty trying to classify my work. It is what it is. It's whatever I'm doing. It is its time.

To go back to this issue of early photography. The very first photographs were unique prints: there was only one. And then at a certain point in the nineteenth century it became possible to make several prints. Because you only make unique prints, your work has a relationship to the very first daguerreotypes, which weren't duplicated.

Well, I do make more than one print from the same negative.

Okay, no two are exactly alike.

No, no, very rarely are two exactly alike.

Why did you make that choice?

Because if you have the opportunity to create an image, why would you want to repeat it? I've already got the image, I made it as beautiful as I could, I put my heart and soul into it, it will never be that way ever again. I'll never be able to print it that way again because I'll never remember what chemistry I used that particular morning, what feelings were going through me. It was all dependent upon my state of mind at that time in my life, that's what that picture is. And for me to try to go back and recoup something is actually as uncomfortable as can be. I can't do it. Using my time to repeat an experience I already know about would be wasting time that I could put into another experience that I *don't* know about — having a different kind of experience. But I make a few variations only because each variation deserves attention, it's beautiful.

What is the maximum number of times that you have used a negative?

Look, the variables that I have within the developing process are enormous. The first time I experience that negative in the enlarger, that's the first time I'm seeing it full size. And then I look at it, I get into it, and I do my whole interpretation at that moment. Sometimes I'll make the first print, sometimes I'll even make the second print, and then I'll make a third print deliberately to bury something. I'll sometimes do that for the fourth print, too. I probably never go back to the negative unless I ruin the first prints, but that happens very, very rarely.

Do you keep all of them, those three or four prints you make?

Yes. Sometimes I will have to make five or six or seven to get three or four. But I discard the others.

Each one slightly different.

They're all unique. I'm taking an accumulated knowledge of photography and reducing it to my language. It's inconceivable that it could ever be done again.

You've photographed starlight and the sun, you've photographed crystal and glass, you've photographed trees, and you've photographed leaves. And it occurred to me that one could think of those different subject matters as analytical, breaking down the elements of photography — light, glass (lenses), wood (because the old cameras are made of wood from

trees), and film (because film is a photosensitive object and so are leaves). I wondered if this analogy has ever occurred to you.

Yes.

Also, your eye is a little camera.

Right.

It has a lens and it has a photosensitive thing, the retina, so it's really like we all have little cameras in our head.

And we can observe with them.

We can't make permanent prints except in the form of memory. But memory is not a perfect reproduction of what happened.

Which is one of the things I like about working with the pinhole. I wasn't interested in the details of everything. I was interested in the memory of what I saw. When you think about any imagery of your past or your present, you don't look at the image in perfect detail; there's something else that comes to your mind that's the form of the thing. When I look at whatever I'm photographing, I'm looking at the essential thing. If I tried to look at every detail, I wouldn't see the form, I'd only see the details. So I try to look at the whole form. So that's why the sharpness of the lens interferes. It brings in a lot of superfluous things that I don't need, particularly its own complexity of design.

You've made your work have a relationship to the history of photography and its technological development. We've now entered the era of digital photography, and yet you have not wanted to go on to that development. Can you explain why?

That's another art form. It took me a long time, most of my life, to master what I've already learned. To try to understand that with the same amount of time I've devoted to historical photography, well, I don't see that ever happening. I think it's amazing, the digital image, but at the same time I'm glad that all of my imagery is photographic. Photography does have something that a digital image doesn't have. Just because of the inherent nature of the process.

So it would be like taking up another art form.

Yeah. I think it's amazing, it's definitely here to stay. Photography as I know it is going to phase out.

Except as an art form.

There will always be people interested in it as an art form because it does have certain kinds of magical qualities that you can't get from electronic imagery.

Even within the realm of light photography, you've never done color, am I right?

Well, my work uses color, since most of the images are printed in tones. The color that you get in commercial photography is the color that the companies, like Kodak and Fuji, give you. It's their dyes. It's not really your color. The other thing I don't like about it is the impermanence of that color. I did do color photography years ago, so I know how colors start to fade. After ten or fifteen years it's gone. It's possible to take silver and combine it with other chemicals and get permanent color. I like making something that is there to stay and that does have its time and its own place. If anything, the older it gets, the more beautiful it will become. With gold, nothing deteriorates. Instead, it will build up a patina of tone and just get more and more magical — just through the surface of the paper changing over time. The image is not going to be decomposed. My images can't be broken down anymore. I like to use tonality for, say, a mood or a feeling I want to portray, but I'm really not trying to say anything colorful. Because that would be looking for the color instead of looking for the form. I like black and white form, I like the way things are interpreted.

You've used the word "magical" several times, and "contemplative" as well. Should we also say spiritual?

Yeah, I hate to say spiritual because people think that you're getting too schmaltzy, but it is spiritual. Why not? My imagery is about things that I'm experiencing, just like a poet's. And you want to leave something behind, you want someone else to share something. You can't get the total experience of what I'm getting, but I can leave the essence of my experience in the form of a photograph. And in that way, if it reaches somebody and they say, "that's really beautiful," then that's your spirit.

Because you're in touch with yourself, you can convey something. That's a very nice feeling in itself. But if you go out there with the motive, I'm doing this because I want this person to like it or I want to sell or I want to show, no. It's not going to happen that way. It has to be your own experience. It has to be something that, after you're done with that experience of light, you feel fulfilled. You don't feel hungry, you don't want anything. You just feel fulfilled. You go to bed that night, glad you went wherever you went and did whatever you did. And then you've got the other part of the process, which means taking it into the darkroom where everything goes; that whole world of chemistry that you can use to give some essence of what you're doing or what you did.

I never make a picture in one day, it's always done over a period of days in different stages. But the final stage, when I'm looking at the print, I'm not only back there in that place where I was when I took it – and I remember that – but here it is now again, I'm seeing it in the print form and happy with it and content with it. I got that experience. You know you had to work to get it, and you know how elusive it can be, and you know if you fucked up one way or another, if you were in the wrong place or the wrong time, it would have never happened. There's always a certain amount of luck involved, always that little factor. But even though it happens over and over, you're always thankful for it.

chronology

1939/1940: Aaron Rose is born in New York City. He is made a legal ward of the State of New York and placed in the custody of the Brooklyn Hebrew Orphan Society (BHOS).

1940–1944/45: Housed at the BHOS foundling home.

1945–1954: Is resident in a series of foster family homes in Queens, Brooklyn, and Manhattan.

1954–1956: Attends one year at Metropolitan Vocational Trades High School (at the time, the only high school in New York with a course of photographic study). Receives a merit transfer to the High School of Performing Arts where he is placed in that school's first photography study program.

1954–1961: During and immediately after his high-school years, works in a number of portrait studios, commercial establishments with considerable reputations. He is a general assistant at first and then is promoted into the realm of the studio and the darkroom. His studio work includes setting up of cameras, lights, and other equipment. The darkroom affords hands-on learning guided often by skilled, experienced senior darkroom technicians. Continues his own photography and begins to build up a portfolio of private work. New York scenes, New York people. Occasionally, formally recognized in photographic media.

1958–1961: Marriage and divorce.

1961–1963: Begins in earnest to build up a portfolio of private work, almost always in series: New York at night, Coney Island life, etc. Studies with Lisette Model, Alexey Brodovich, and Joseph Breitenbach.

1960–1968: Develops an interest in ancient tools and early scientific, optical, and mechanical devices. Begins collecting tools and antique ironwork in earnest and supports his collecting excursions throughout the northeastern, southeastern, and southwestern United States by selling the scientific equipment he discovers to a leading dealer in this field, Sidney Strange.

1963–1967: Begins a brief, successful career in commercial advertising photography and uses the proceeds and the opportunities for travel to further his collecting. Broadens his scope into Mexico, Central America, northern South America, and Europe, including the

Communist Bloc countries. His museum-quality tool and antique ironwork collection includes articles dating from the Bronze Age in ancient Persia. The major segment of his collection provides a comprehensive view of the tools and forged iron artifacts of the western world from the fourteenth to the nineteenth centuries. Collects pre-Columbian art and amasses a large collection of nineteenth- and twentieth-century photography.

1966–1969: Begins and completes a number of photographic series within the U.S. and abroad: American anti/pro-war factions and protests, hippies, subjects in Central America, and Europe. Travels throughout Europe with Tony Ray Jones. Ceases to accept commercial photographic assignments.

1970: Tool collection is purchased by the Eli Lilly Corporation. The collection is also exhibited at the Hallmark Gallery on Fifth Avenue.

1969–1975: Finds a building in the old industrial district of New York. Secures first right of purchase with a deposit of valuable, old locks. Is able to use part of the proceeds from Lilly sale to make down payment and begin renovation. Becomes a legal contractor and does the majority of the work in the building himself. A few odd jobs for friends in the commercial realm help finance the construction. Builds, first, a darkroom. During these early years in SoHo, construction work limits the time he is able to devote to photography to perhaps a third of his normal commitment. In 1975, he gains one of the first certificates of occupancy in SoHo, paving the way for the growth boom in downtown New York. Leases space to leading art galleries, industrial designers, weavers, and architects.

1976–2000: Full-time photographic work: New York City views, nature, astronomy, still lifes, interiors, and other subjects.

1997: Work in the Whitney Biennial, Whitney Museum of American Art, New York

1998: Solo exhibition, Paul Kasmin Gallery, New York

1999: Solo exhibition, Paul Kasmin Gallery, New York

EDITOR: Eric Himmel
DESIGNER: Ellen Nygaard Ford

Library of Congress Cataloging-in-
Publication Data

Rose, Aaron.
 Aaron Rose : photographs / essay and
 interview by Alfred Corn.
 p. cm
ISBN 0–8109–4224–0
1. Photography, Artistic. 2. Rose, Aaron.
I. Corn, Alfred, 1943– II. Title.

TR654. R6785 2001
779'.092—dc21 00–049334

Published in 2001 by Harry N. Abrams,
Incorporated, New York

Printed and bound in Hong Kong

Harry N. Abrams, Inc.
100 Fifth Avenue
New York, N.Y. 10011
www.abramsbooks.com